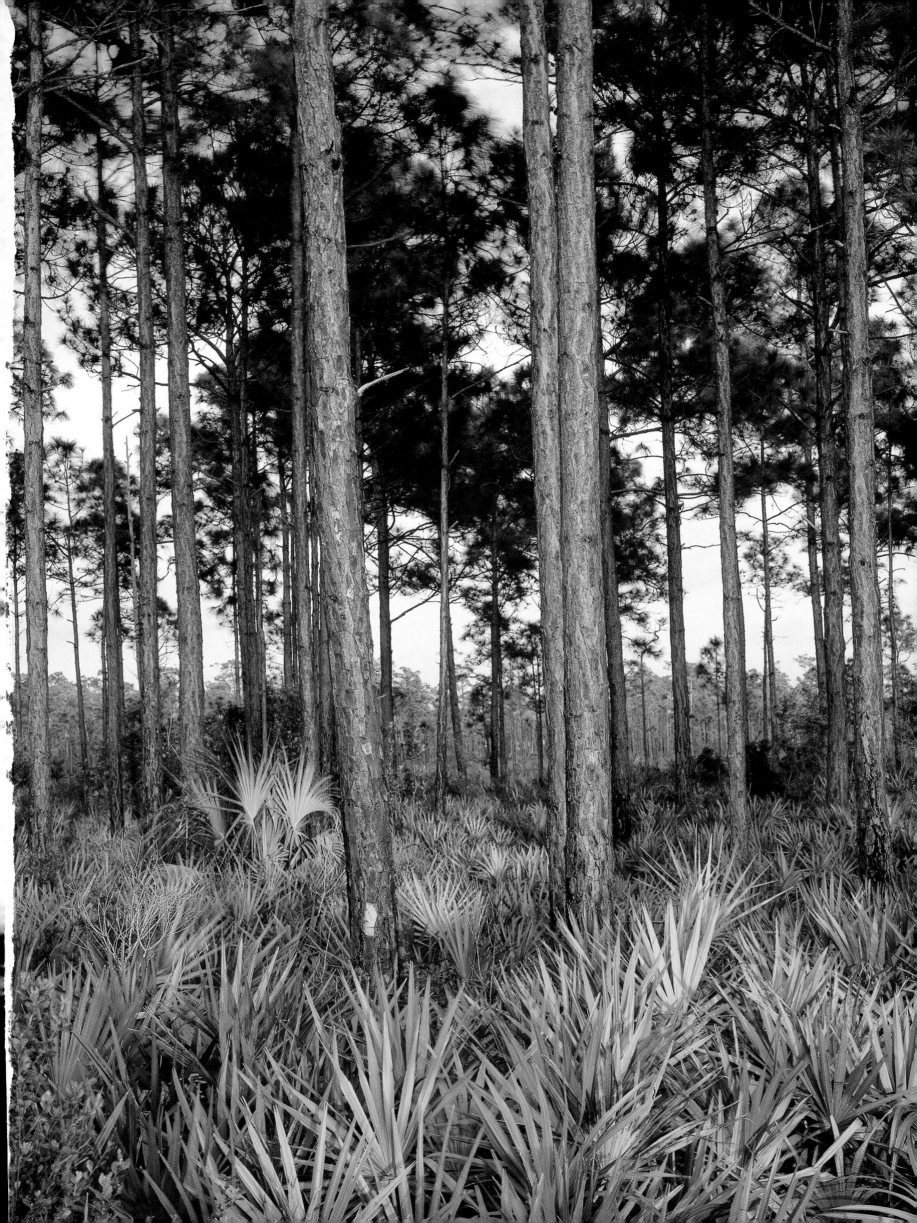

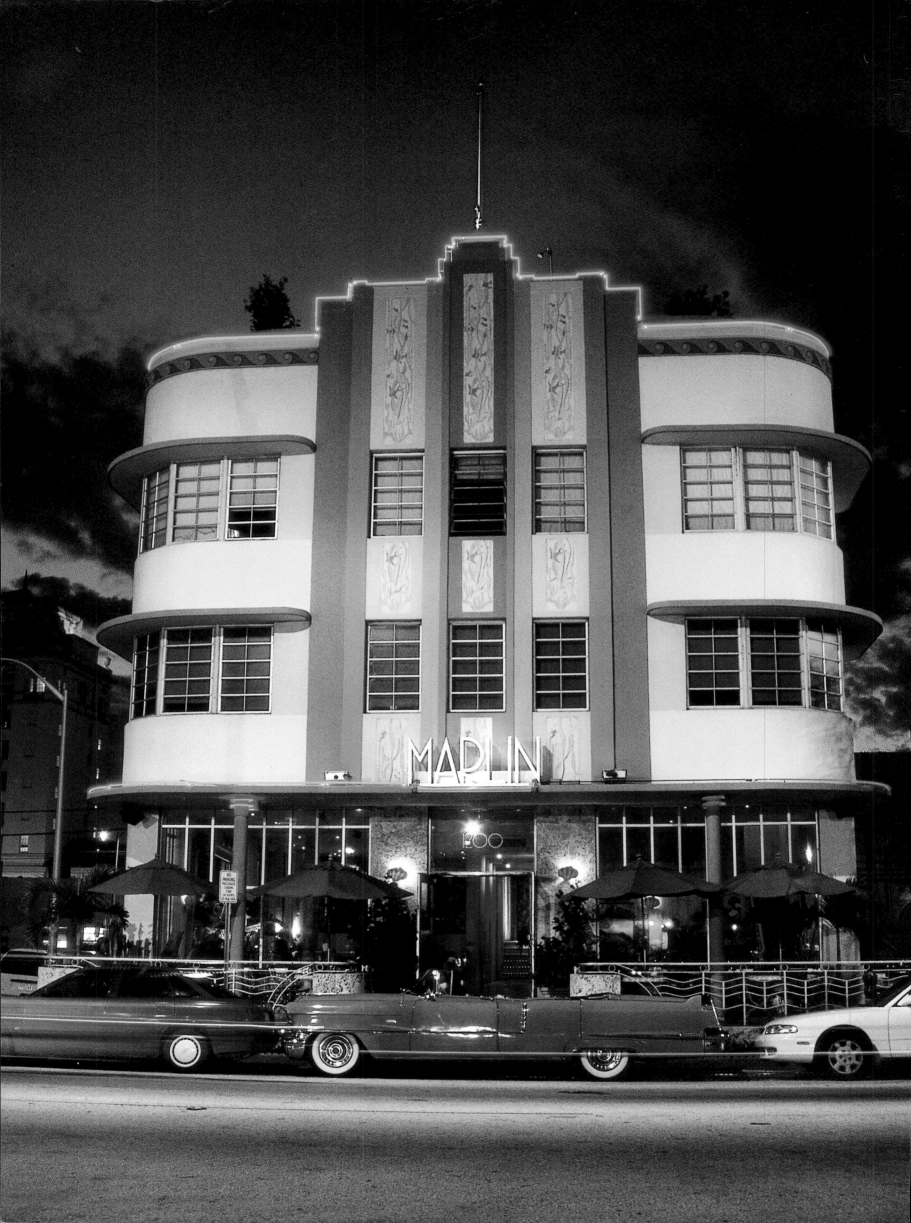

FLORIDA

ESSAY BY JOY WILLIAMS

GRAPHIC ARTS CENTER PUBLISHING®

Text and captions © MCMXCIX by Joy Williams

Book compilation © MCMXCIX by Graphic Arts Center Publishing®

An imprint of Graphic Arts Center Publishing Company

P.O. Box 10306, Portland, Oregon 97296-0306

503-226-2402

Library of Congress Cataloging-in-Publication Data:

Williams, Joy.

Florida / essay by Joy Williams ; photography by various photographers.

p. cm.

ISBN 1-55868-465-4

1. Florida—Pictorial works. 2. Florida—Description and travel.

I. Title

F312.W55 1999

917.5904'63—dc21 98-50004

CIP

President/Publisher • Charles M. Hopkins

Editorial Staff • Douglas A. Pfeiffer, Ellen Harkins Wheat, Timothy W. Frew,

Diana S. Eilers, Jean Andrews, Alicia I. Paulson, Deborah J. Loop, Joanna M. Goebel

Production Staff • Richard L. Owsiany, Heather Hopkins

Designer • Robert Reynolds

Cartographer • Ortelius Design

Book Manufacturing • Lincoln & Allen Company

Printed in Hong Kong

Bound in the United States of America

Half title page: The slash pine's most common companion is the saw palmetto.
Flatwoods flourish throughout the state, although, except in parks, most natural
stands have been replaced by tree farms that differ from the original habitat.
Frontispiece: The Art Deco district of Miami's South Beach is a square mile of over
eight hundred buildings constructed in Art Deco, Streamline Moderne, and Spanish
Mediterranean Revival styles. Built in the 1930s, the buildings were white with trim
only in bright colors. In the 1980s, they were touched up, unhistorically, to dazzle.

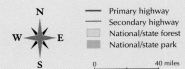

N
W E
S

—— Primary highway
—— Secondary highway
National/state forest
National/state park

0 40 miles

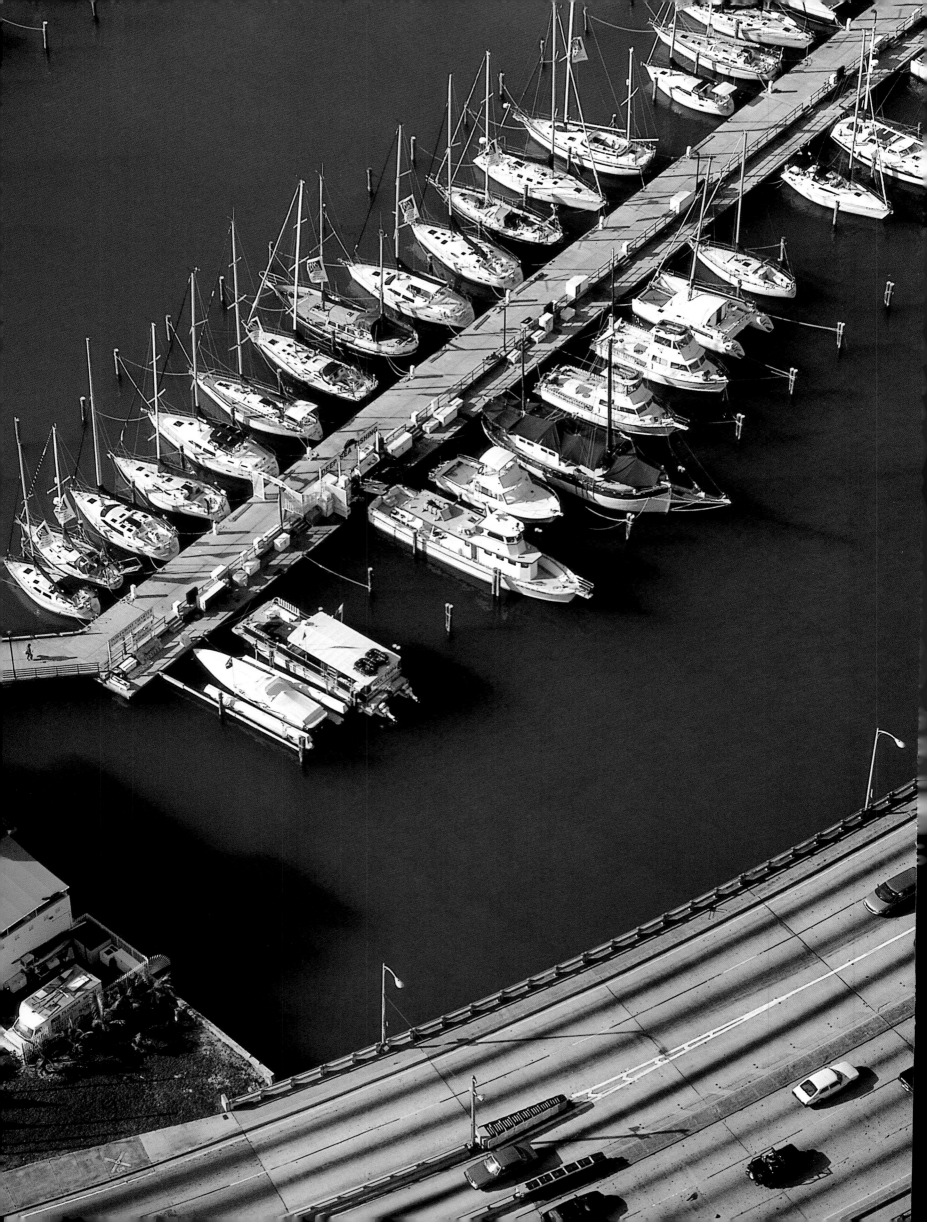

◄ Florida has over 8,000 miles of tidal coastline and 4,500 square miles of inland waters, making boating extremely popular. ▲ Sombrero Light is one of six spidery, graceful lighthouses that mark the reef off the Keys. The lighthouses were erected on as few pilings as possible to allow the free flow of water. ►► A royal tern can be recognized by its sleek black head feathers and pumpkin-colored bill.

▲ A wild golden aster blooms on a dune on Pensacola Beach. Part of the long barrier island off Pensacola Seashore, the beach is distinctive for its snowy dunes, which are held together by the fragile root network of plants such as these.
► Smathers is Key West's most active and popular beach.

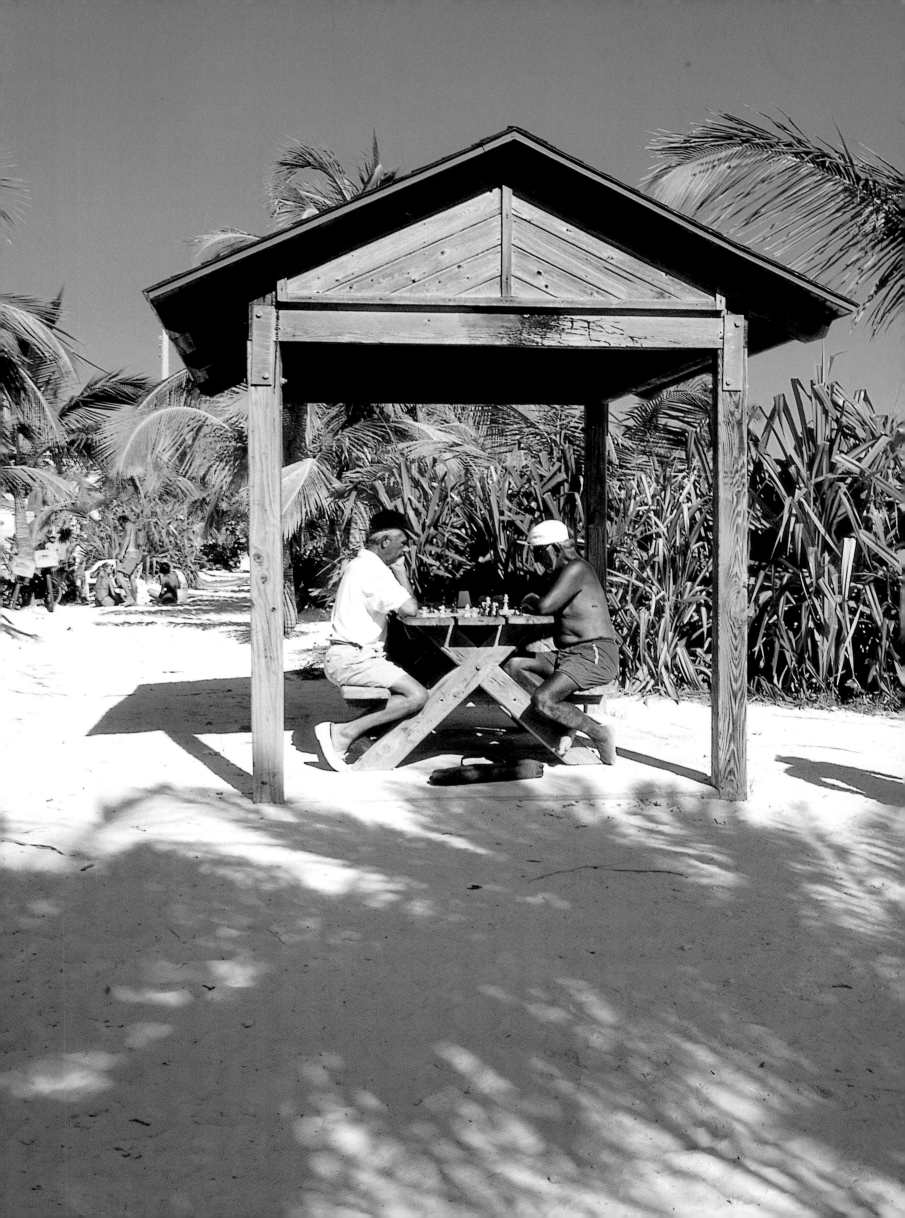

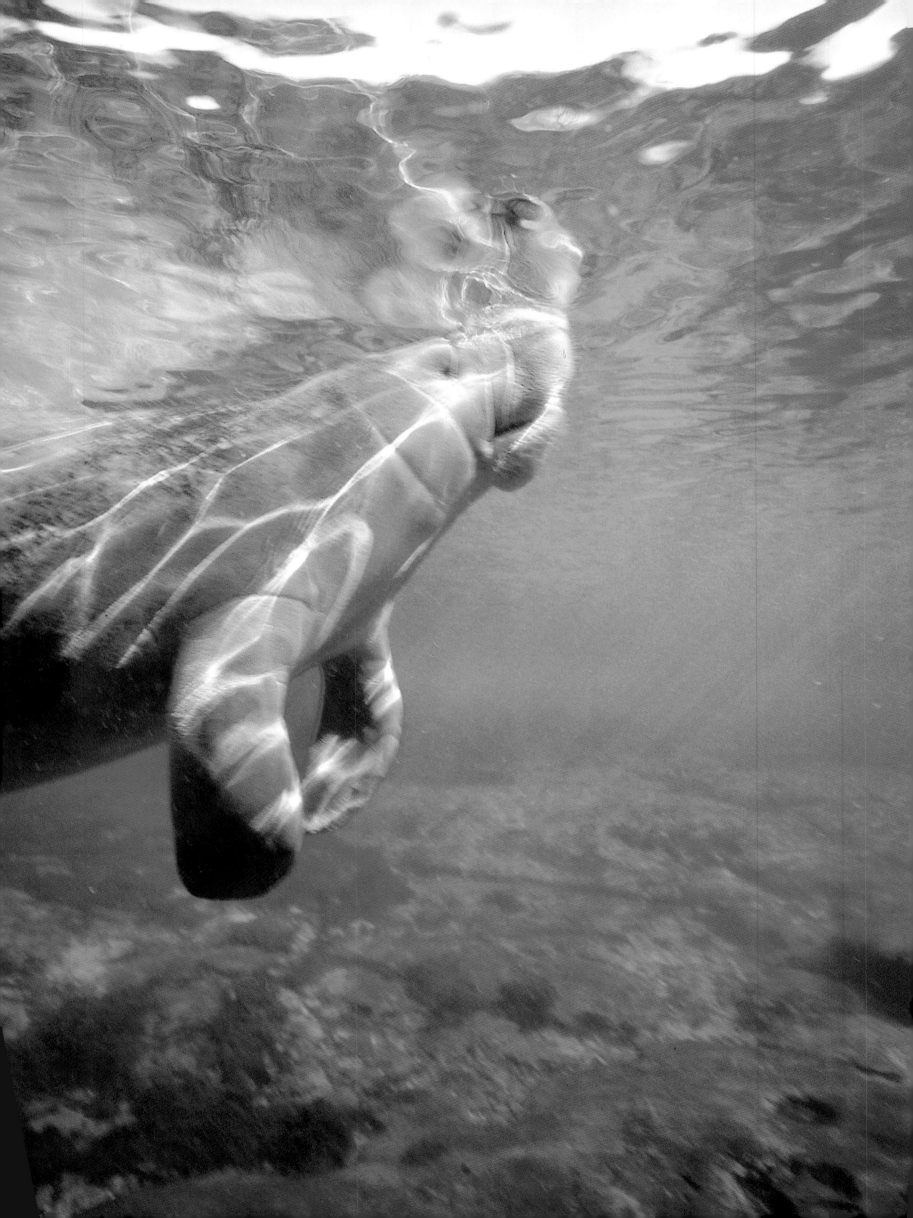

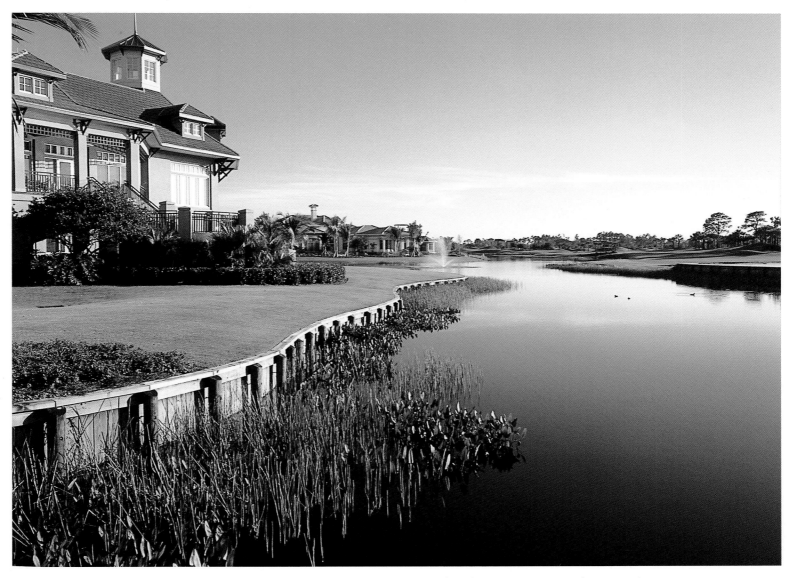

◄ Less than two thousand manatees remain in Florida. An immense, slow, gentle aquatic mammal remotely related to the elephant and aardvark, they must rise to the surface for air every fifteen minutes, making them vulnerable to motorboats.
▲ The residential Bay Colony Club and Golf Course is one of fifty-five golf courses in Naples, which has more greens per capita than anywhere else in the state.

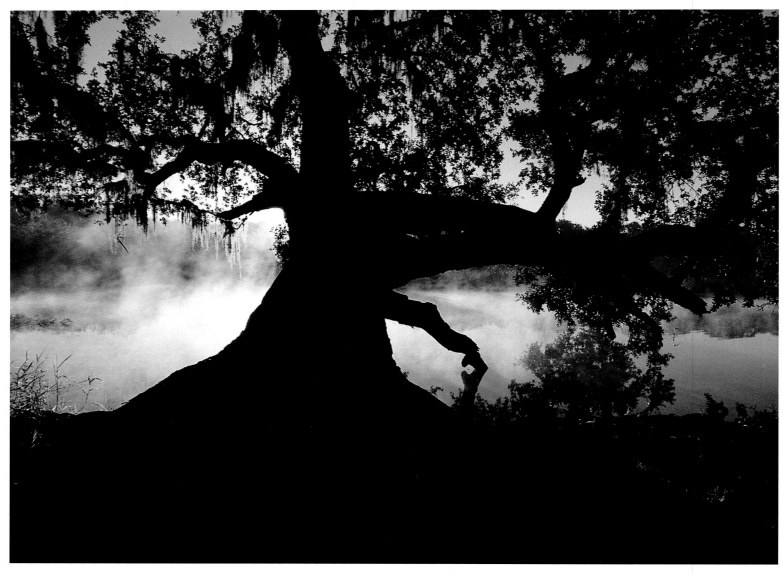

▲ A live oak, one of the South's most splendid trees, grows along the Myakka River in Myakka River State Park southeast of Sarasota. The 29,000-acre preserve is one of Florida's largest and most natural parks. ▶ The 1860 Jupiter Lighthouse still projects a beam visible from eighteen miles at sea. Visitors can climb 105 feet for a view of the Gulf Stream, the startlingly blue oceanic river that runs through the Atlantic.

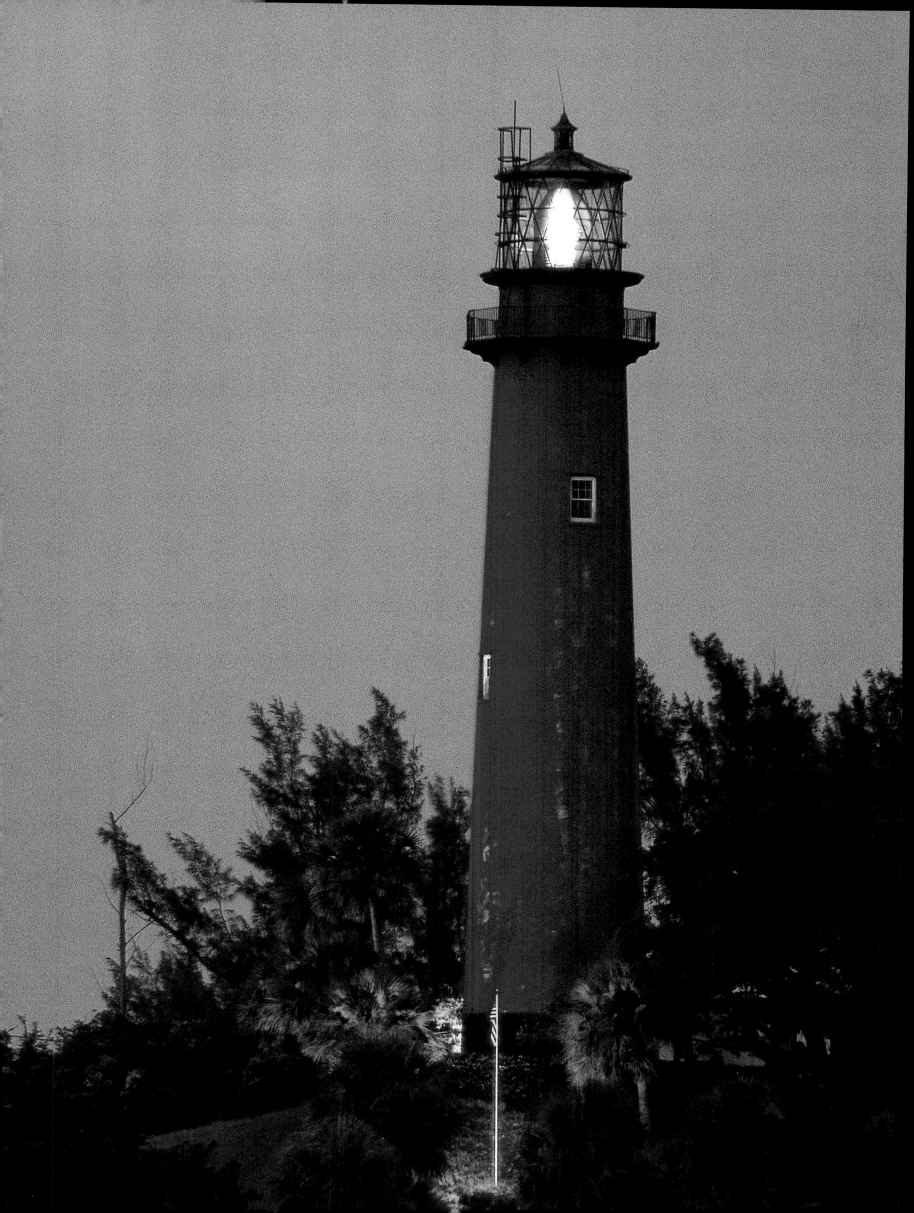

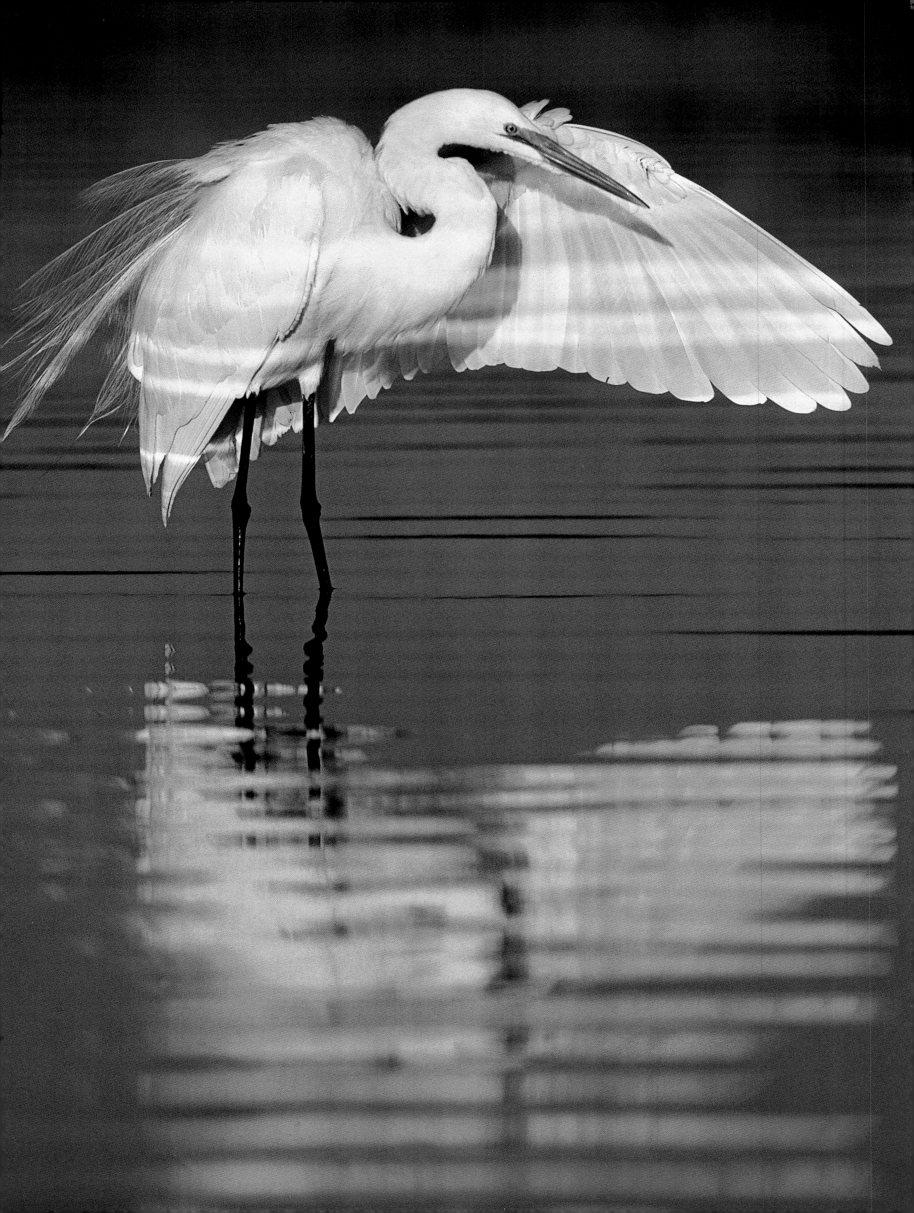

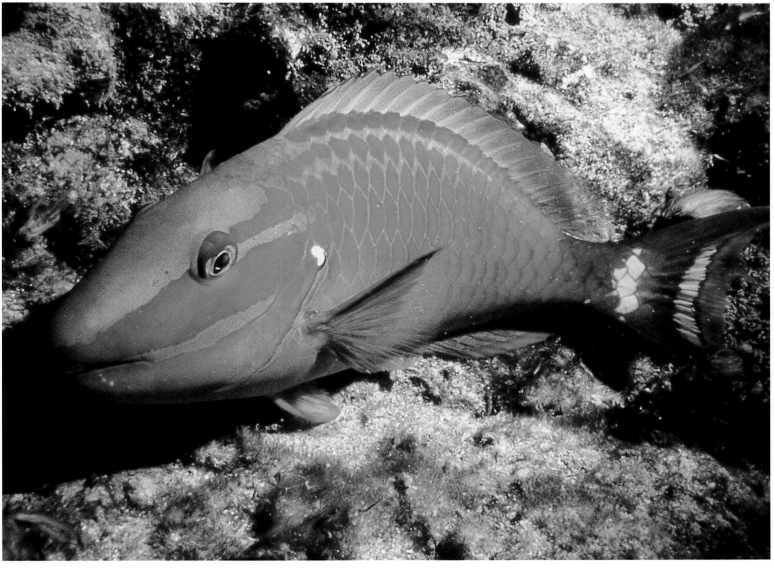

◄ During the nesting season, the great egret grows long feathers called "aigrettes." The great egret can be distinguished from the great white heron by its black legs.
▲ A vivid, stoplight parrot fish swims at John Pennekamp Coral Reef State Park. Parrot fish use their beaks to nip pieces of algae and other encrusting organisms off the rocky bottom of the reef. Their crunching is easily heard by divers.

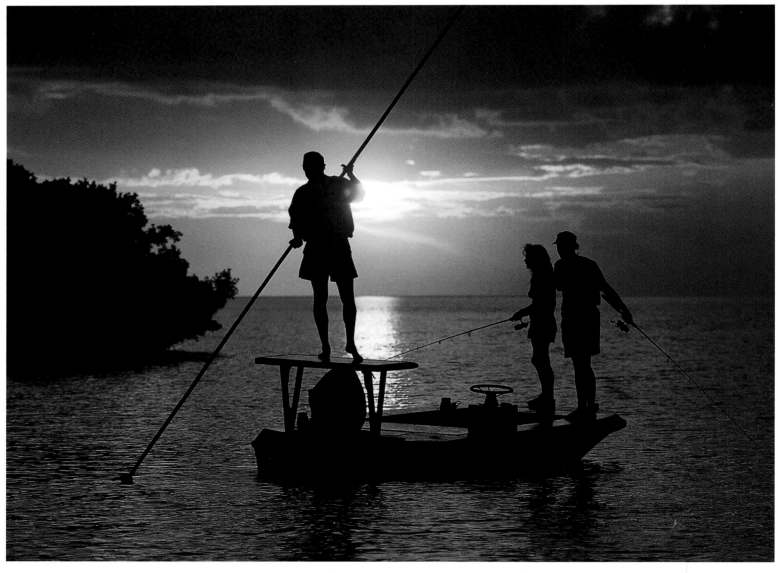

▲ Flats fishing for bonefish—shown here off Big Pine in the Keys—is a silent sport requiring considerable skill and even delicacy. ▶ The beautiful queen conch (pronounced "konk") is rigorously protected in Florida waters. This rosy, giant sea snail is the namesake of the "Conch Republic"—the fabulous Florida Keys. ▶▶ A sleek and curious bottle-nosed dolphin enjoys the waters of Florida Bay.

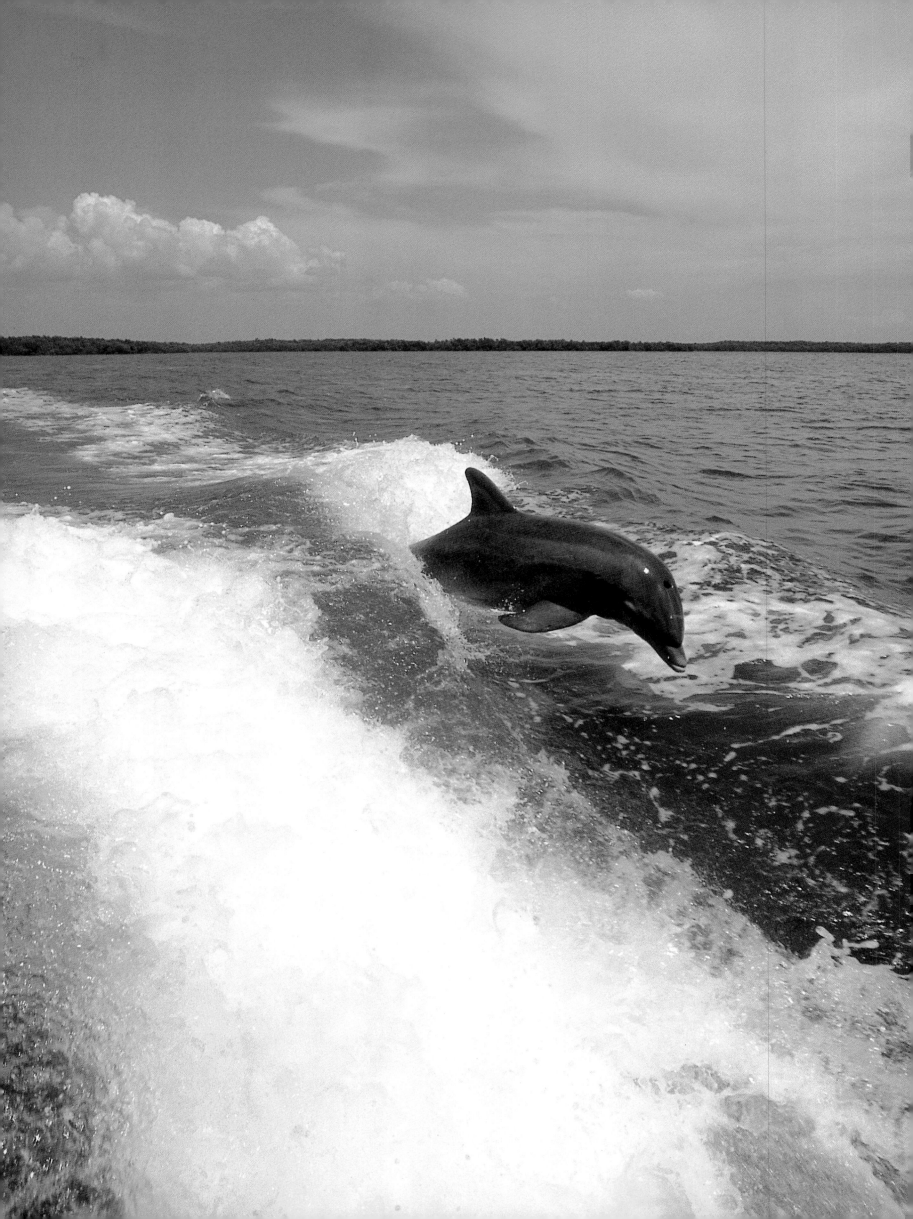

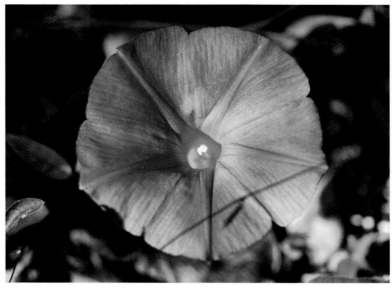
The morning glory is native to the American tropics.

When Archie Carr, Florida's fine naturalist, decided to write a book about the state in the late 1960s he knew the difficulties that awaited him. "I was almost bound to fall into the trap of nostalgia and indignation, of turning this book into a diatribe against the passing of original Florida." Carr's interest had been in the state's wild landscapes and wild creatures, but he decided against the nostalgic lament of things lost as well as railing against destructions just beginning. He decided instead on celebrating what remained of Florida's natural world and wrote his genial, charming book, *A Naturalist in Florida: A Celebration of Eden.* The "Eden" played off two classic titles of the past, John Small's *Eden to Sahara* and Thomas Barbour's *That Vanishing Eden,* two poignant (and elegiac and indignant) books about a natural Florida that was disappearing.

Three more decades have passed since Carr's celebrations of gators and turtles, of saw grass prairies and wild springs (no one writes more dramatically about these crystalline waters—"the jewels of the original Florida landscape"—than he), but despite his determinedly optimistic belief to the contrary, Florida's growth has continued unabated. Forty million tourists visit the state annually. One thousand people a day arrive to make Florida their new home. Florida has over fourteen and a half million people now, making it the fourth most populous state in the nation, and by 2020 that figure is expected to have doubled.

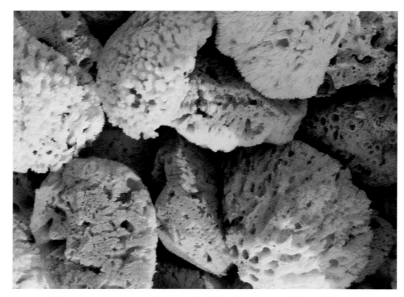

Sponges are marine animals that grow like plants.

Still, for one who cherishes Florida and would write about the state today, there is a longing to celebrate her beauties. For Florida has long been considered a playground. A location set. A sunny eccentricity. A beach. She was by no means America's last frontier, but still, in the 1880s, the major part of the state was unexplored wilderness, wetlands and swamps, immense piney flatwoods, live oak and cypress forests, twisting rivers and impenetrable mangrove mazes, with everywhere strange creatures, lizards and reptiles and great flocks of resplendent and remarkable birds. Key West, the tiny coral island more than one hundred miles off the tip of peninsular Florida, was then improbably the largest, wealthiest, and most sophisticated city of this vast and improbable state. Miami and Palm Beach did not exist. Florida's natural wonders—her fishes and reefs and palmy beaches—seemed extraordinarily exotic. She was simply unlike anywhere else.

Florida could be anywhere and serve the fantasies of anyone. She could become the repository for any number of crafted and imaginary histories, a wealth of simulated habitats and instant tropical gardens. She could be the African veld, the Mediterranean, Venice, and—despite hurricanes, frosts, and mosquitoes so plentiful it was said that a person could come up with a quart of them in a pint jar—Florida was fashioned into all these contrivances and more.

Florida was developed by monied visionaries, railroad barons, millionaires, and hustlers. Financiers such as Henry Plant and Henry Flagler spanned the state's great distances with railroads, planned elaborate communities with their millionaire friends, and built lavish hotels. In the 1920s, thousands of people abandoned their professions in the north to become real estate salesmen. Extravagant promotional schemes and promises abounded while dredge-and-fill operations transformed the landscape. Promoters of Hollywood, a soon-to-be instant city north of Miami, drove prospective purchasers of lots around on trails blazed through palmetto jungle. It was reported that some stretches were so desolate and forlorn that many women became hysterical, and a few fainted. But Florida was wild and peculiar and new, and investors were deeply susceptible to the feverish fantasies of aggressive developers. Florida had handsome palms, extraordinary sunsets, and seemingly endless miles of snow-white beaches. Speculation in scrub and swamp land had reached giddy levels before the boom went bust in 1926, some years in advance of the nation's great Depression, but Florida's profile, her image, had been established. It was not strange that the great showman, John Ringling, decided to make Sarasota the winter headquarters for his circus, or that the cartoonist and collector of all things odd, Robert Ripley, would find the southernmost state's emotional climate perfect for a number of his Ripley's Believe It or Not! museums. Nor, most dramatically, that the greatest fantasist and principal architect

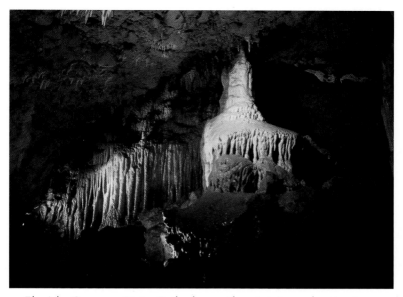

Florida Caverns State Park shows the state's underpinnings.

of the mass culture of our time, Walt Disney, would select forty-three square miles of lakes, groves, and farms outside the sleepy citrus city of Orlando for the site of Project X—which would become the megalithic Walt Disney World.

The wealthy continued to winter in their grand enclaves, but ordinary citizens flocked to Florida because they were sure that they would be entertained, amused. The invention of Florida resulted in the invention of modern tourism. Florida became both outlandish and quaint. There were reptile ranches and lion farms. There was alligator wrestling. There were mermaid shows. There were monkey jungles and parrot jungles. Everything from coconuts to cypress knees to coral became a souvenir. Even the sunshine was turned into a huckster, as was that most fragrant of scents, the orange blossom. The flamingo, an extravagantly vivid bird that scarcely looks real (perhaps because it became so prevalent in plastic) is the very image of a colorfully extravagant state (even though it is a native of the Caribbean and not a Florida bird). Practically anything that happened to be under the Florida sun was turned into a tourist attraction. Key West, the richest city per capita in America in the 1880s and the poorest by the 1930s, its citizens living on fish and coconuts, was turned over to the New Deal's Federal Relief Administration, which determined that it could only be salvaged by the tourist. Its graveyard became an attraction; its old Civil

War forts, some tame fish in a pond behind a nightclub. A 1940s guidebook described the entire city as "something of a public curiosity," with its writers and artists and green turtle steaks.

Everything in Florida was curious. Grapefruit was very curious—no one even knew what it *was* except a native Floridian. The shells and the egrets and the banyan trees were curious. There were fossilized sharks' teeth on the beach. There were pelicans. Everything seemed prehistoric and slightly preposterous. There was an inconspicuous part of Florida, of course. The economic workings of the state— the humble work of raising cattle and celery and beans, the realities of lumbered-out tracts and phosphate mines— were concealed from the visitor traveling down the west coast and up the east. In the same way, the underground city beneath Disney World would be hidden in future years—the complex of levels and warrens that houses the costumes and computers and delivery systems that enable the "Magic" and "Wild" Kingdoms to function.

Florida was a show, an entire state seemingly dedicated to the vacation principle. With twelve hundred miles of coastline, she was America's beach. It was not a rugged coastline, it was a flat accessible one, a beach so fine and packed so hard you could drive your car on it. It didn't possess just the Atlantic; it had the Gulf too—azure waters, blue-black waters, teal and emerald waters. Florida succumbed easily to romance and fantasy. She was mild

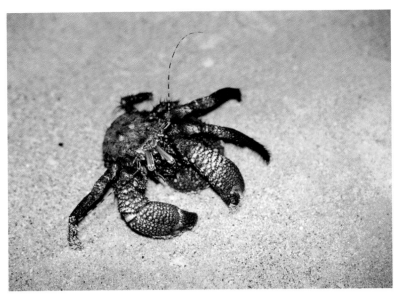

As they grow, hermit crabs relocate to bigger snail shells.

and malleable, and her mysteries were almost all exposed, even her biggest mystery of all—the Everglades.

* * *

More than half of Florida is, it is startling to consider, Everglades, which ecologically begin around Orlando. Linked to the lakes and streams that begin halfway up the interior of the peninsula, the Everglades is a vast sheet river system flowing shallowly down and across the state, its waters eventually spilling into the Gulf of Mexico and Florida Bay. The 1.4-million-acre Everglades National Park comprises only one-fifth of the historic Everglades. Orlando is, or has been since 1971, the site of Walt Disney World, the entertainment mecca of the planet. At 30,500 acres, it's one-fifth the size of the remaining Everglades. Only one-quarter of the many "worlds" here have been developed, leaving lots of room inside the berm for the "Imagineers" and "Audio Animatronic" experts (who can bring to apparent life any three-dimensional figure that can be built) to create additional worlds without apparent end. Foreign visitors have a tendency to refer to the entire state as "Orlando" and frequently don't go anywhere else, except ironically, Everglades National Park, whose watery complexities can never be imitated or invented.

The Kissimmee River, which begins near Orlando and is the master stream for a vast complex of landscapes linked to the Everglades system, has been straightened and channelized for much of its length. Locks, canals, channels, floodgates, and vast impoundment areas kept water off the land so that sugarcane could be grown. By the time the park was established in 1947, the land's natural systems had been considerably altered. Neither the release nor the retention of water was synchronized with the natural cycles that had governed the Everglades for aeons. Most of the clear, clean life-giving water was simply flushed out to sea.

"Save the Everglades" has been a battle cry for fifty years, ever since Marjory Stoneman Douglas wrote *Everglades: River of Grass,* which transformed the public's perception of the Glades as a useless swamp to an awareness and appreciation of its uniqueness and splendid beauties. Nothing is prettier than a Glades hammock rising out of golden saw grass, unless it is the sight of herons flashing impossibly white through a darkening, impossibly epic South Florida sky, or the vision of a royal palm grove in Fahkahatchee Strand, or the black water shining among cypress trees bristling with flowering air plants. The Everglades, whose loveliness is subtle, strange, and shy, is probably the most delicate of all wildernesses, and it is ironic (as so much in Florida is) that it should be increasingly subjected to the cold, starved language of agricultural lobbyists, engineers, suburban growth consultants, and water managers. For now, just before the turn of the century, efforts are intensifying to salvage the Everglades that have no counterpart

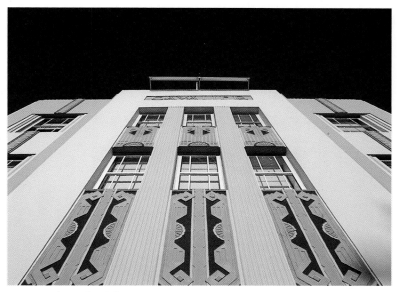

An Art Deco building in Miami's South Beach shows bright trim.

anywhere on earth. The Army Corps of Engineers, whose original mandate was to drain the River of Grass, is now poised to "replumb it" (in their language). Rainwater will be pumped into natural underground aquifers instead of out to sea. Some farmland will be restored to marsh, and the sugar industry will be gradually limiting the destructive discharges and fertilizer runoff connected with the growing of cane. The Kissimmee River will be reinvented in part, mostly by putting some curves back into its life, curves meant to mimic its once-natural course.

<p style="text-align:center">* * *</p>

Florida has been fashioned into worlds and kingdoms and coasts—the Treasure Coast, the Space Coast, the Gold Coast, the Nature Coast. She has been compartmentalized— Old Florida, Historic Florida, Forgotten Florida. (Areas that resist compartmentalization like the Florida Keys become "states of the mind.") But always, everywhere, she has been adapted to offer something for everyone. St. Augustine is old and dignified but not so dignified that it can't support a wonderfully weird museum or two—you can see the car wherein Jayne Mansfield unhappily lost her head; you can see the ambulance that took Lee Harvey Oswald on his last ride. Miami's South Beach is movie stylish, its deco hotels drenched in cartoon-bright colors, its nightlife all sparkling chic, but its convenience to the visitor is doubled by its improbable proximity to the Everglades.

Florida is an overlay, a festival, a performance, a resembler. At Sea World, a simulated helicopter ride transports customers through blizzards and avalanches to a purportedly realistic arctic environment, complete with polar bears. The arena where orcas and dolphins perform, however, does not purport to be a natural environment at all; it is a gigantic stadium, a watery stage supplemented with a giant video screen running footage of other orcas and dolphins, wild ones, doubles of those being seen. In the Panhandle, the recently created Neo–Victorian community of Seaside easily doubled as the eerily perfect, highly controlled stage set for the movie *The Truman Show,* in which the hero was literally an actor in his own life and his hometown nothing but a façade. Hundreds of men who have groomed themselves to look like Ernest Hemingway flock to Key West in the scorching heat of July to compete in a look-alike contest. Tampa's Busch Gardens has over three thousand African animals on three hundred acres, as well as a new little area called "Egypt," which has a replica of Tutankhamen's tomb. Off Key Largo, placed to delight divers, is the *Christ of the Deep* statue, a duplicate of the *Christ of the Abysses* statue in the Mediterranean off Genoa, Italy. It seems entirely reasonable that the largest collection of the works of Salvador Dali, the great surrealist and outrageous self-impersonator, would be assembled in St. Petersburg. The artist had no association with Florida, but his great collectors and admirers, a couple from

University of Florida Gators are rivals of Florida State Seminoles.

Ohio, chose the museum's waterfront site because of its perceived resemblance to Dali's birthplace in Caldaques, Spain. The little town of Grayton Beach decided that a re-creation of Claude Monet's home and garden in Giverny, France, would give them some distinction, while Davie, a town inland from Fort Lauderdale, recast itself into a western town with cacti, corrals, and a weekly rodeo. On the coast at the Kennedy Space Center on Merritt Island, actors, suited up in the costumes of astronauts, mingle with the crowds, as friendly and accessible as any Goofy or Minnie. The past, even the so-recent futuristic one, becomes entertainment.

High on the western coast, south of Cedar Key, this part of Florida, with its many springs in which both salt- and freshwater fish gather, is referred to in tourist development literature as "Mother Nature's Theme Park." Florida's animals have always been a source of interest and on display. For years, a zoo near the little town of Everglades City advertised "Mother Nature's Creatures on Parade." Today, most of the roadside zoos are gone, and wildlife rehabilitation centers— pelican hospitals, turtle hospitals—are increasingly, if somewhat disconcertingly, becoming tourist attractions. Down in the Keys, at Grassy Key and at Theater of the Sea, visitors pay to swim with dolphins. In Florida, the dolphin has been packaged as the supreme educational showman of the natural world. The manatee, a dear and improbable creature (and next to the panther, the most endangered mammal in the state) has too modest and retiring a personality to be enticed into show business, although one enterprising marina along the Crystal River offers opportunities to swim or snorkel, that is, "interact," with them too.

* * *

As Florida continues to mimic foreign or nostalgic environments and styles, she is also beginning to display, on a reduced scale, copies of an idealized and unthreatened natural self. On the east coast an attraction called Flamingo Gardens is a one-stop eco-experience with all five habitats natural to South Florida on display—coastal prairie, mangrove swamp, cypress forest, saw grass marsh, and subtropical hardwood hammock—and all on sixty acres. On the west coast, in Tampa, the new eighty-four-million-dollar Florida Aquarium's most ambitious room is the Florida Coral Reefs Gallery. The scene dwarfs the visitor who looks into it. It is impressive, it is educational, it is well designed, yet for all its size, it is a miniature. It is reef life enclosed, on exhibition, alive yet artificial. It is Accessible Florida. The Florida Coral Reefs Gallery is a considerable distance from Florida's actual reef, the only living coral reef in North America, which sits four to seven miles offshore and runs along the Keys from Miami to the Dry Tortugas, a distance of some two hundred miles. To see this real reef, to dive within it, to float and gaze within this life, this different life, stately and colorful and strange, is an unforgettable experience. The lovely sea fans and

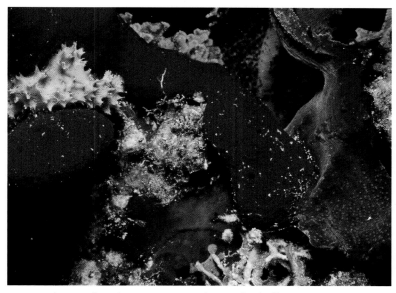

The reef is the most complicated of all ecosystems.

whips, the massive brain and pillar corals, the winding corridors streaming with bright fish—it's a different world, a different real world, and exceptionally beautiful. But it's difficult to see sometimes. The waters can be bumpy or cloudy, and more and more dive boats attend the more vivid pockets, and somebody else's flippers or bubbles can obscure your own private viewing of manta rays and parrot fish and barracuda. Like the Everglades it is an unexpectedly fragile environment that has been stressed by urban growth and deteriorating water quality as well as other vagaries of Florida life, such as boat groundings and cold snaps.

As Florida becomes more and more a state attuned to growth, the pace quickens to promote Florida places that have avoided being turned into what Florida is perceived to be. Key West, the onetime "public curiosity" has name recognition unparalleled among the small cities of this country. Key West connotes a palmy recklessness, a tropical hedonistic laid-back style. Her architecture—simple wooden clapboard, pitched tin roofs, porches, and a dash of gingerbread scrollwork—is insular, eccentric, and mostly determined by the elements, and is now cookie-cutter copied in new housing developments throughout the state. Key West is alone in being Mile 0, the end of the road, the road being the Overseas Highway, which follows the old roadbed of Henry Flagler's railroad. Flagler linked the Keys with forty-two bridges including the Great One, the Seven Mile Bridge, his graceful masterpiece and an engineering marvel. (John Dos Passos, in a letter to Hemingway, described the long slow train trip across the glittering waters as a "dreamlike journey.") A new Seven Mile Bridge now runs along the abandoned original, which had been built so well engineers deemed it too expensive to demolish and remove. The gulf side of the Keys is actually Florida Bay, the upper reaches of which belong to the Everglades. The bay side is called the backcountry or outback. The Atlantic side is actually the Straits of Florida, where wide Hawk Channel runs parallel to the reef. Beyond the reef is the Gulf Stream—"out front"—that great oceanic river whose demarcation can clearly be seen, the waters being a profound and fabulous blue. Beyond the Gulf Stream lies the ocean. The Keys are special, and her waters, recently designated a National Marine Sanctuary, are her treasure. The journey down the Keys is no longer quite so "dreamlike," but Key West is still Mile 0 and the lively end of the road, though this has not kept her from becoming a new and major cruise ship destination. In the 1970s, hippies, who felt they had to have *something* to do, invented "Sunset" at a run-down dock on Mallory Square. Nowhere, even now, three decades later, has the unexceptional behavior of the sun sliding into the horizon at the close of day been so giddily and communally celebrated. The sunset has become a specialty act attended by carnival acts. The towering cruise ships, which would quite preclude the event if they remained

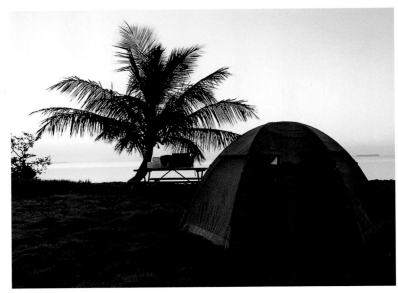

Florida campsites frequently come with graceful flora.

at dock, are required to cast off before the famous moments of the sun's descent. Sunset is special here; it is different from other sunsets—for the Keys and Key West are considered unique. They are not supposed to be like the rest of Florida. The Keys and Key West are "not Florida" and therefore have become a quintessentially Florida destination.

* * *

Florida's great size and ragged, unusual shape contain enough paradoxes and surprises for any traveler. Indeed, she is the most paradoxical of places, for she is most herself when she is not the crowded amalgam she has become. The "Other" Florida is northern Florida, west of the metropolis of Jacksonville, west of the capital, Tallahassee. This is the rural Florida of peanuts and cotton and cattle, great mossy live oaks, towns without stoplights, the Florida of the adage, "The farther north you go, the farther south you get." Florida here is a state of the deep South, sharing a border with Alabama, its beaches along the Gulf affectionately dubbed the "Redneck Riviera" by its residents. Whatever Florida is (and Florida is almost everything), she was once a Confederate state, the third state to secede from the Union at the time of the Civil War. Whatever Florida is becoming (and she can become almost anything), she is essentially her most wondrous and exceptional self when she is not the Florida that is the result of a century of fabrication. Florida has always been unusual but has always been translated into something

else for a supposedly optimum effect. Her true uniqueness was never judged to be enough.

Now Florida's natural areas are being showcased as her newest and nicest aspect. "Hidden" Florida is the "Real" Florida—state parks and forests, marine sanctuaries, canoe trails, and undeveloped keys and islands. The Real Florida is the experience of an empty beach. A kayak trip among mangrove islands. A canoe paddling down the Suwanee River, or down the challenging Wilderness Waterway of the Everglades. To see Hidden Florida is to have the experience of seeing a wild, unfettered thing. A tarpon gliding across the flats of the backcountry, the magnificent frigate bird gliding high in the perfect blue of a Far Tortugas sky. The "Real" Florida is "Undiscovered" Florida, and though perhaps as rare and reclusive as the Florida panther, is being promoted as that aspect of Florida really worth discovering.

The Undiscovered, however, is not so easily marketable, being mostly the essence of a thing, its quiet heart. It is not so much that Florida is both more and less than she appears—"the state with the prettiest name...the poorest postcard of itself..." in the words of the poet Elizabeth Bishop—but that she is frequently so different from the presentations made on her behalf. Somewhere, Florida's soul exists, solemnly beautiful, and there is no need to exaggerate there, no need to invent or elaborate upon her ephemeral beauties, beauties that fall like blessings on those who care for her and love her.

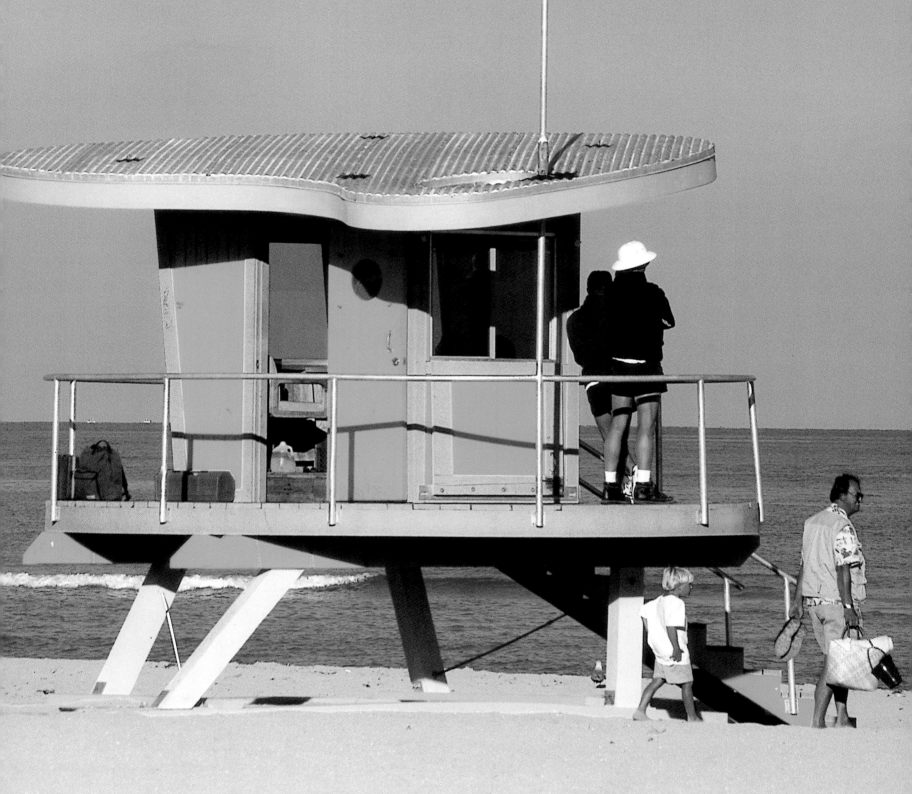

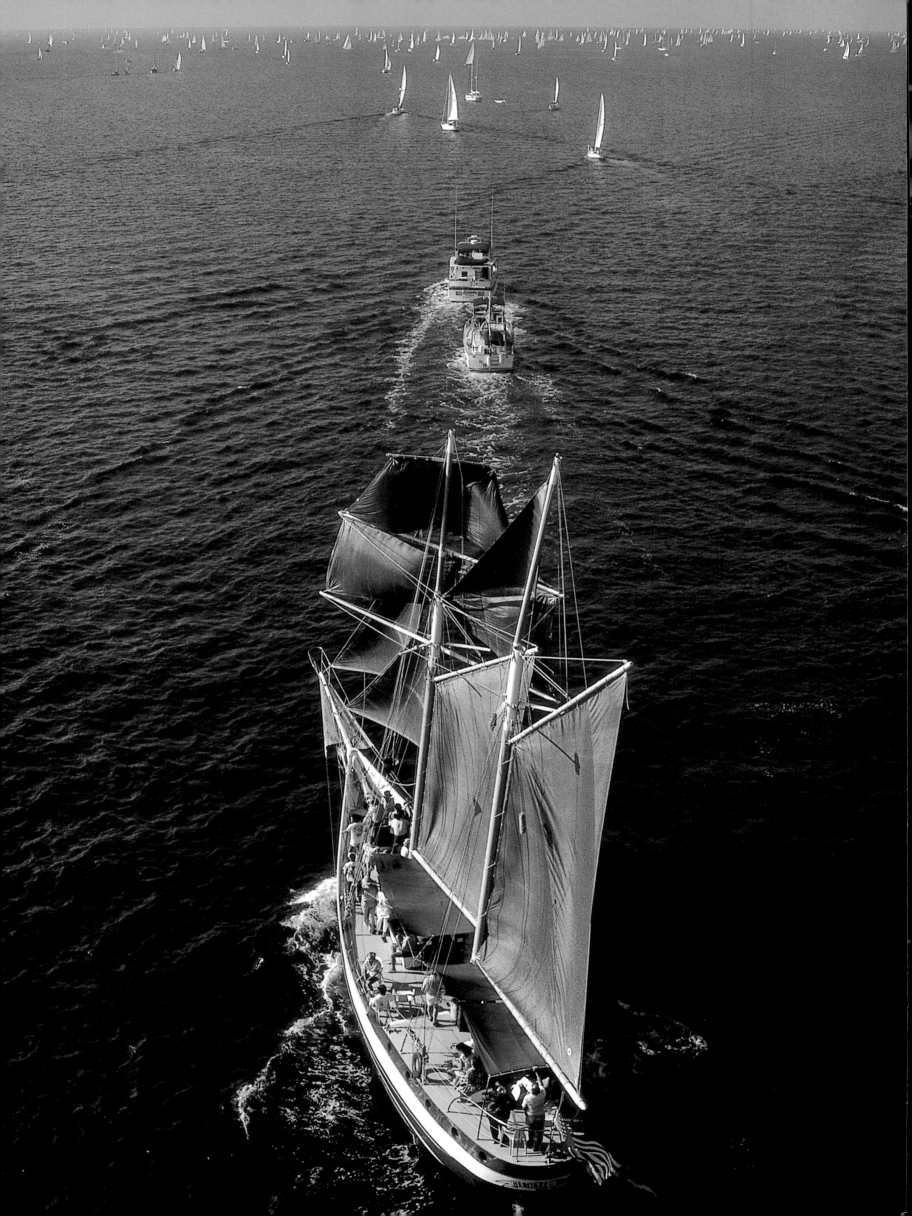

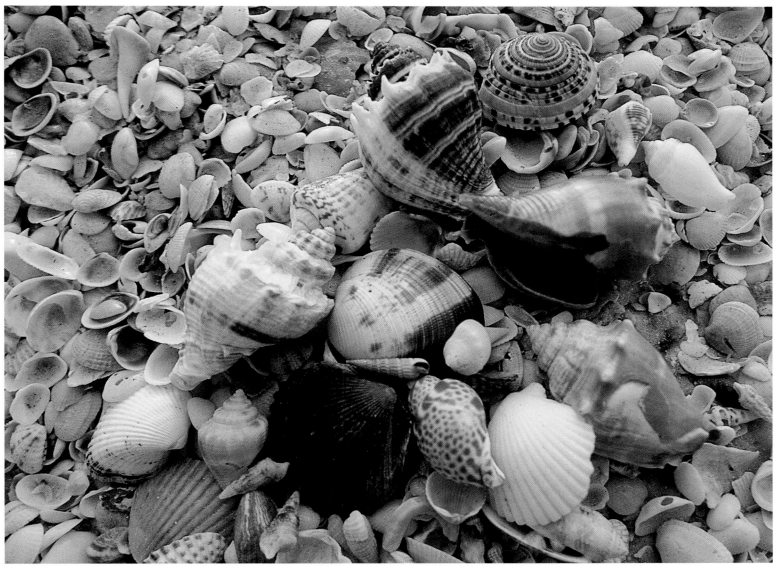

◄ ◄ A jazzy lifeguard hut punctuates the view on Miami's South Beach. The impressive beach sands have all been imported and are replenished frequently to counter erosion. ◄ A gaff rigged schooner takes to the breezes nicely on Biscayne Bay. ▲ Sanibel Island on Florida's Gulf Coast is a sheller's paradise. On this pretty island no one is allowed to construct any building taller than the tallest palm.

31

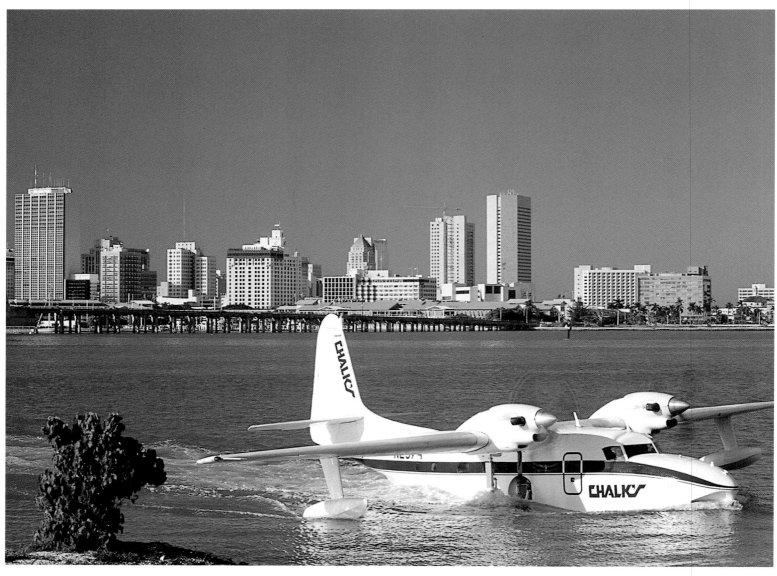

▲ Chalk's Airline offers an alternative to the ever-popular cruises to the Caribbean: unique amphibious airline services to Caribbean destinations from their base on the Miami waterfront. Both locals and tourists use Chalk's to commute.

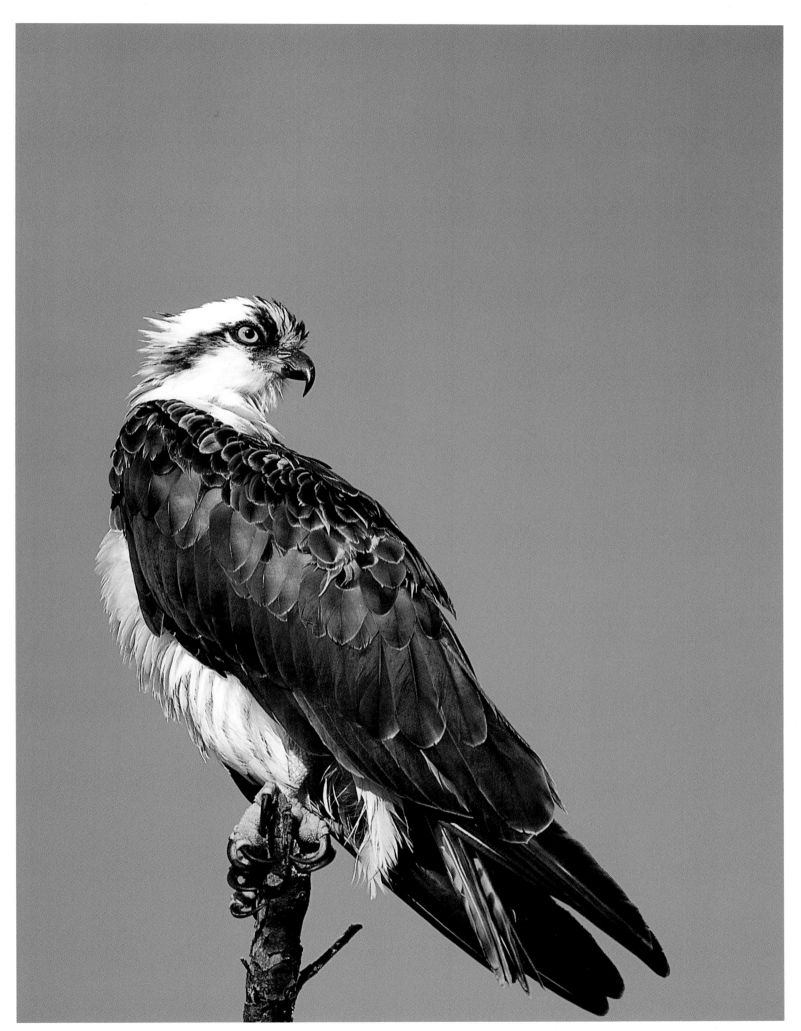

▲ The osprey, a large water-loving, eagle-like hawk, hovers on beating wings and plunges feet first to catch fish. Ospreys build large, visible nests, which they expand and improve upon each year.

▲ The San Carlos—the old Cuban Club and school on Duval Street, Key West—
was built in 1889 and restored in the 1990s. This historic building hosts the Key
West Literary Festival each January, as well as a number of *veladas* (evening events).
It is named for Carlos Manuel de Céspedes, the father of Cuban independence.

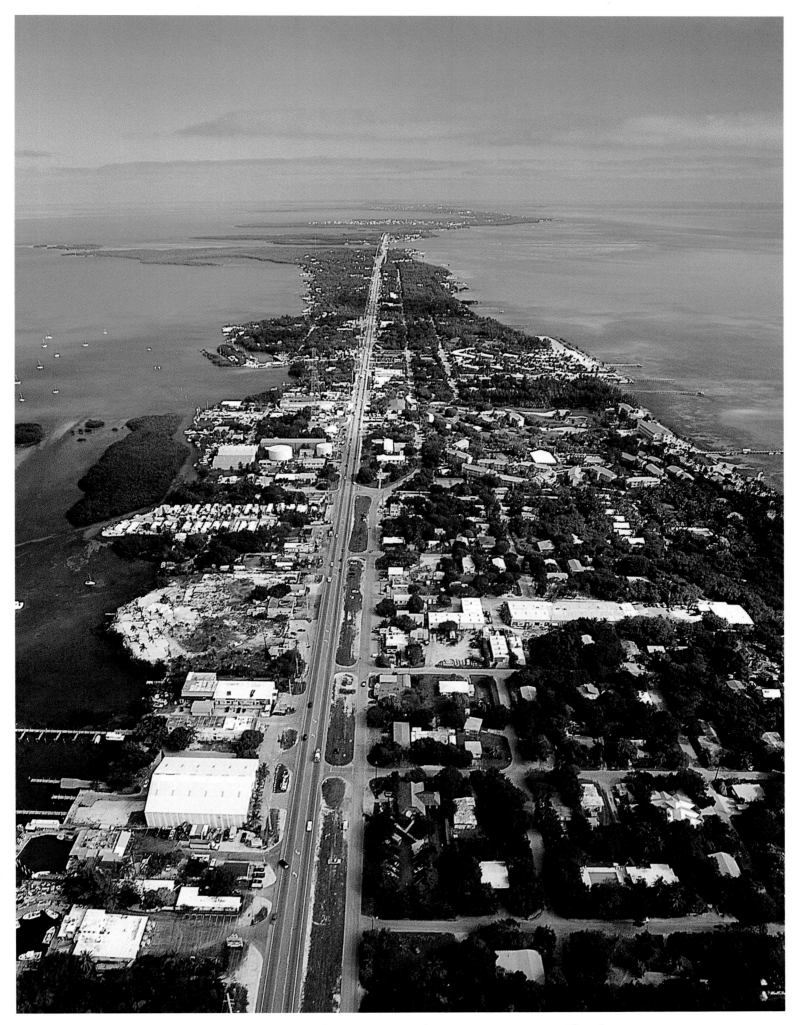

▲ Midway down the Florida Keys is vanishing point Key West. The Overseas Highway replaced Flagler's railway route, which was destroyed in the hurricane of 1935. Flagler's Railroad, completed in 1912 and reaching 137 miles out into the ocean, was considered an engineering marvel.

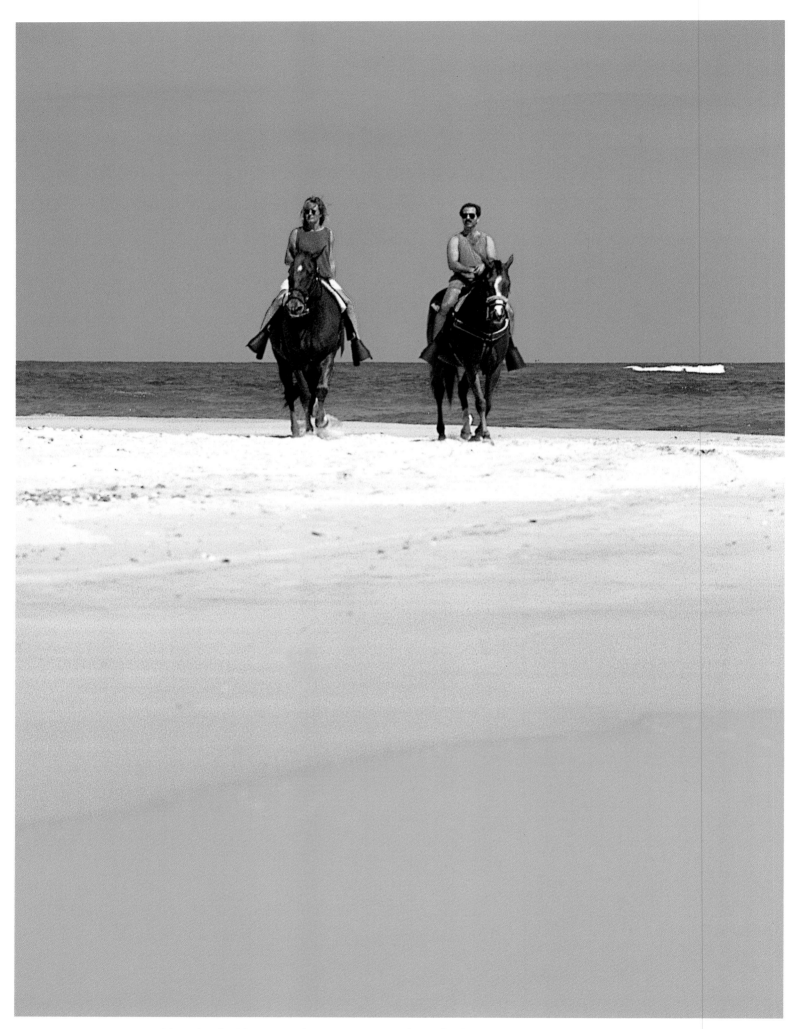

▲ Horseback riding is a pleasant pastime along the beach on Amelia Island, across the St. Mary's River from Georgia. Horses are available for rent on the island. The island's only town, Fernandina Beach, was Florida's first resort in the mid-nineteenth century and has lovely Victorian buildings.

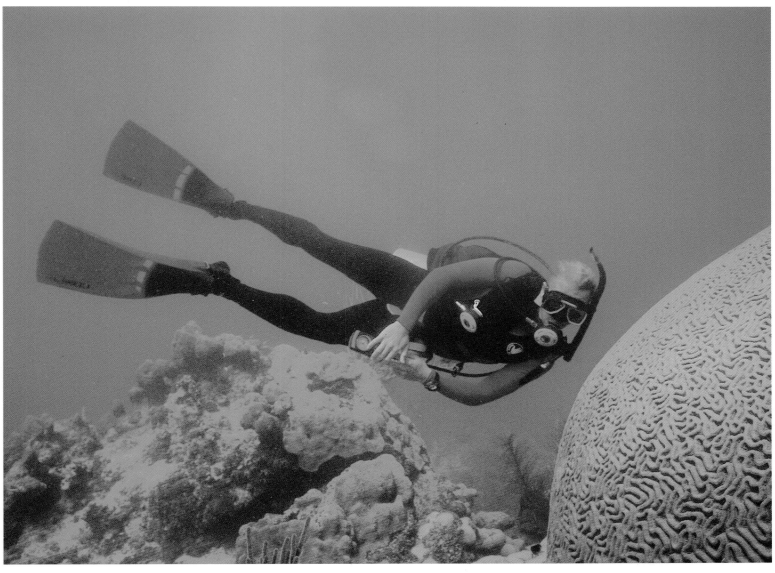

▲ A diver inspects a massive brain coral in the waters of Looe Key, seven miles offshore in the lower Florida Keys. Named for a frigate that ran aground here in 1774, Looe—with exceptionally clear water, deep winding coral corridors, and a great diversity of life—is perhaps the most beautiful reef in the Keys.

▲ Sands Key is situated in Biscayne National Park. Just 4,000 of the Park's 180,000 acres are land. Accessible only by boat, the islands north of Key Largo have remained pristine treasures protected from the worst ravages of man.

▲ The striking underground limestone caverns of Devil's Den near Ocala in central Florida are part of the vast Floridan aquifer, which holds most of the waters of the state. ►► Six miles long and three miles wide, Marco Island is the largest and northernmost of the Ten Thousand Islands. An ancient Calusa Indian site, it is now heavily developed, boasting dozens of miles of streets and urban canals.

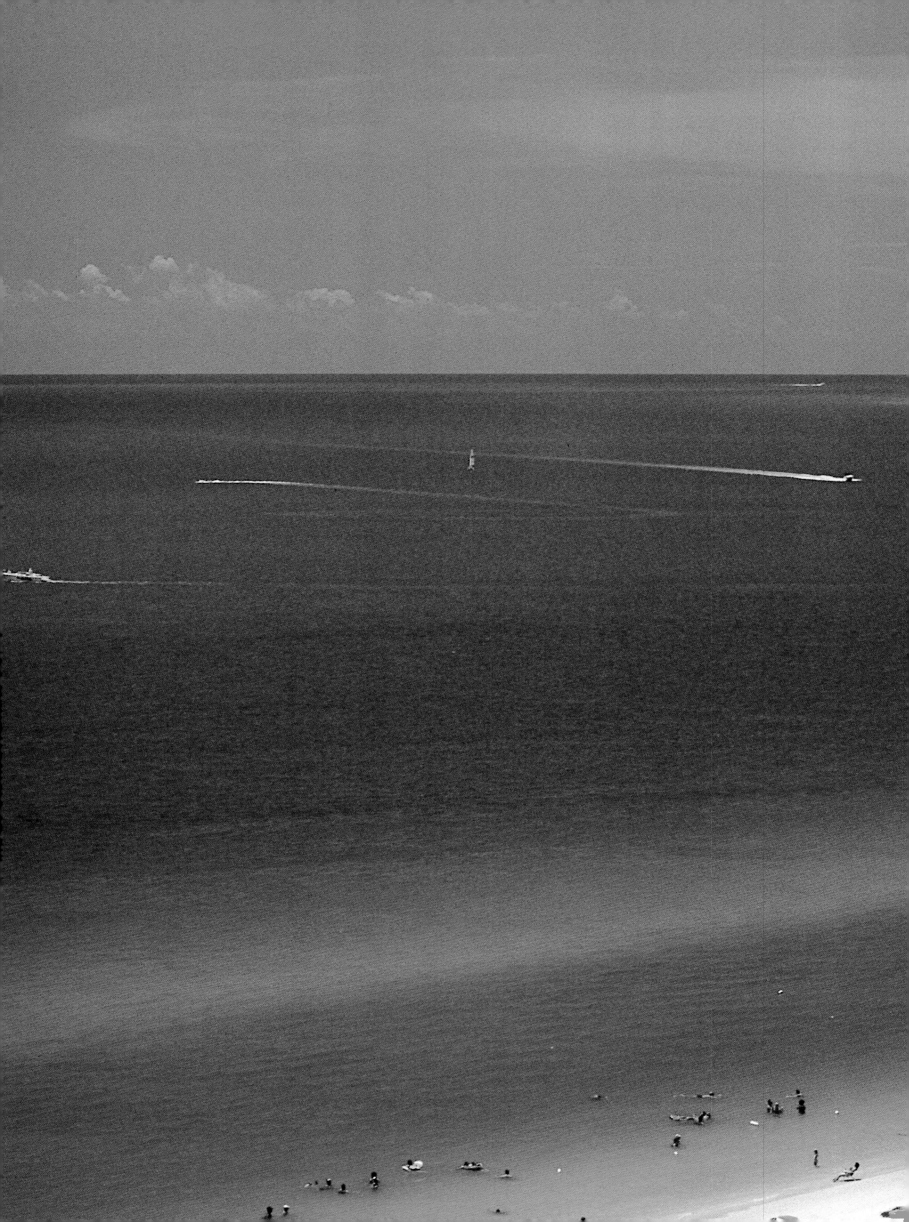

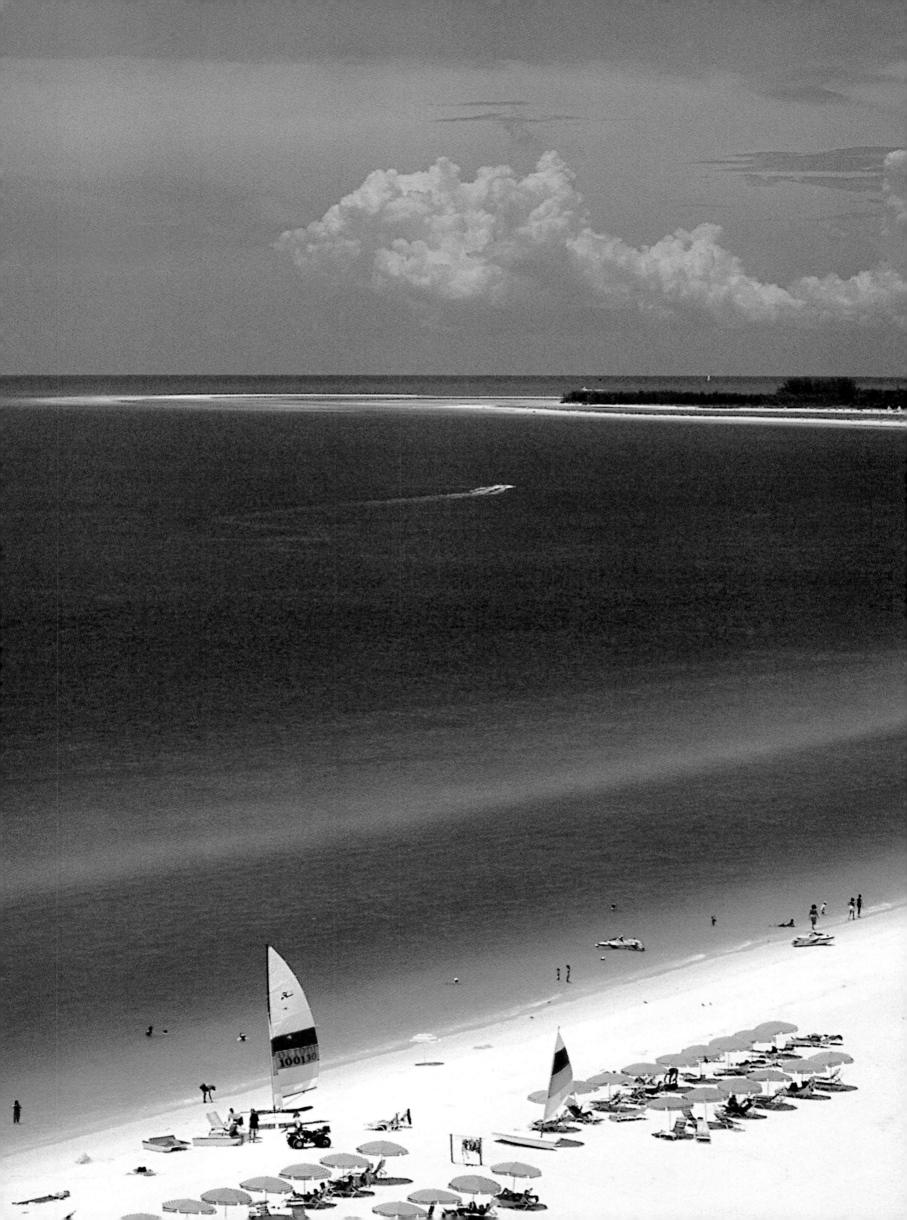

▲ Despite the ubiquity of the Florida orange, a sample plucked fresh from the tree is a delight worth savoring. ▶ Marjorie Kinnan Rawlings lived in this "cracker" house in Cross Creek in the 1930s. The Pulitzer Prize–winning novelist, best known for *The Yearling,* also assembled vignettes of country living in the book, *Cross Creek.*

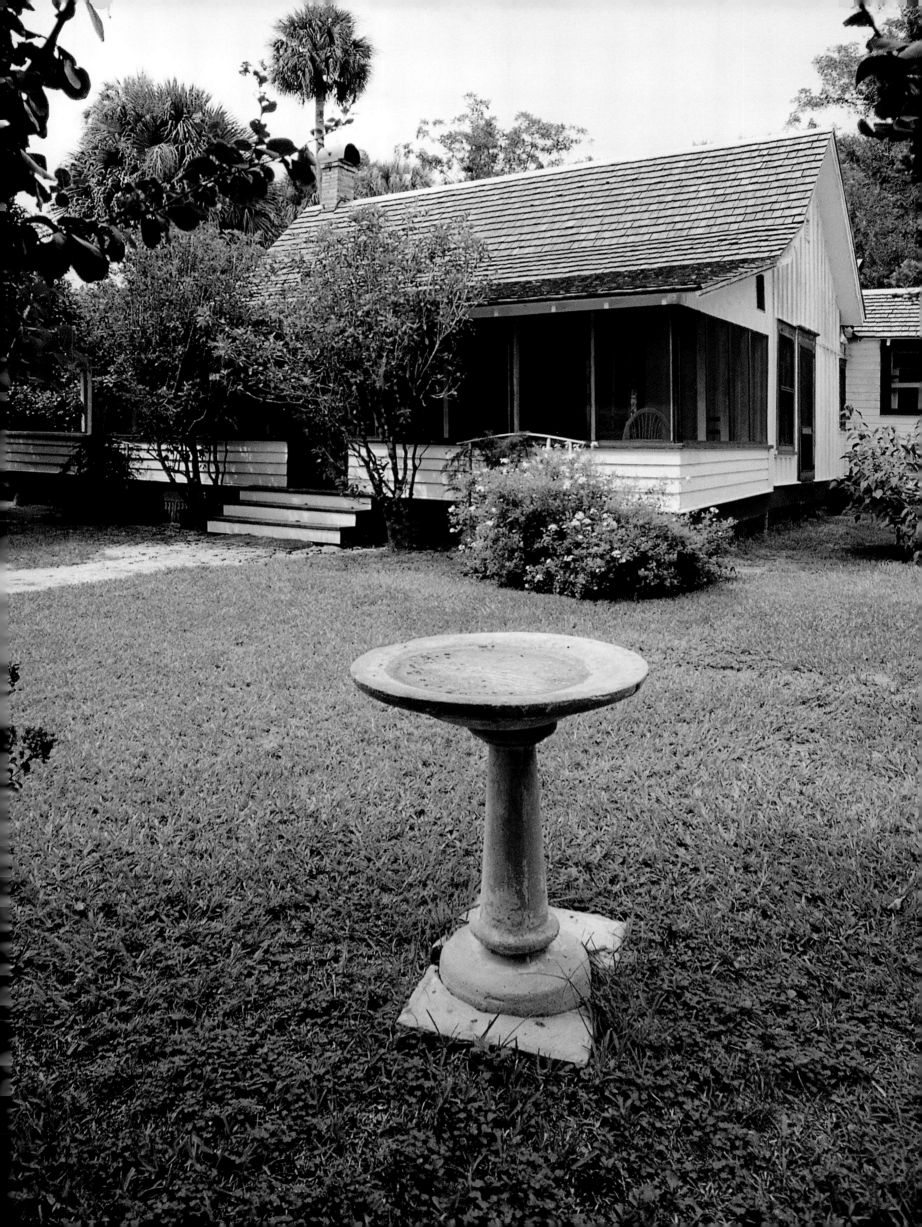

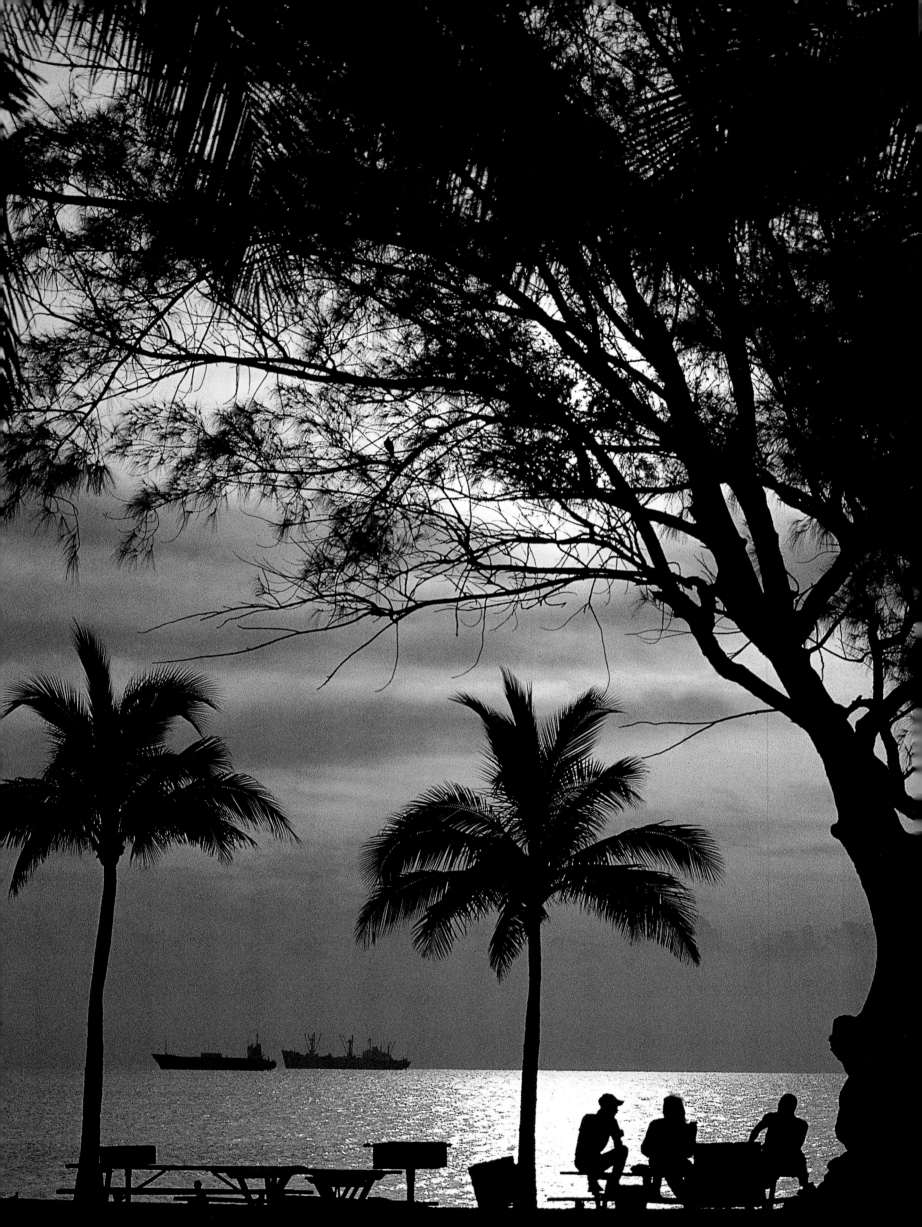

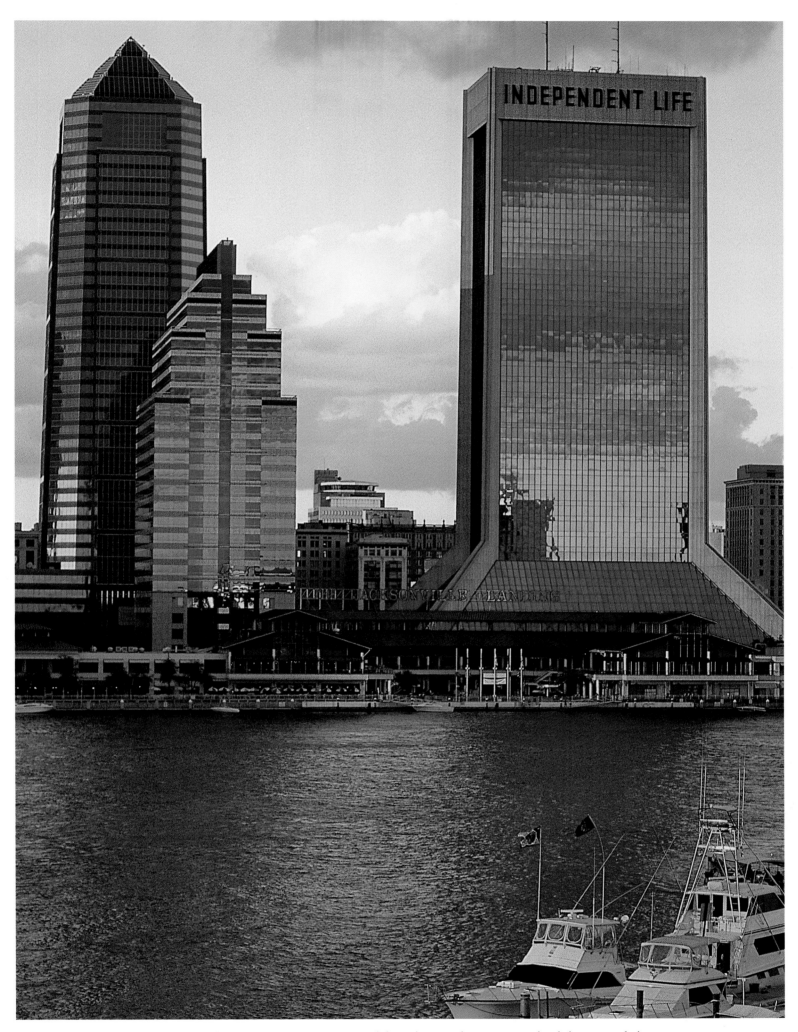

◄ Miles of lagoons, waterways, and beaches make Fort Lauderdale one of the most popular areas on the Gold Coast. A shady promenade runs along part of its attractive beachfront. ▲ Jacksonville, on the St. Johns River, has over a million residents—and is proud of it. Florida's largest commercial, financial, and industrial center, Jax has a mile-long pedestrian walkway along the river in the heart of town.

45

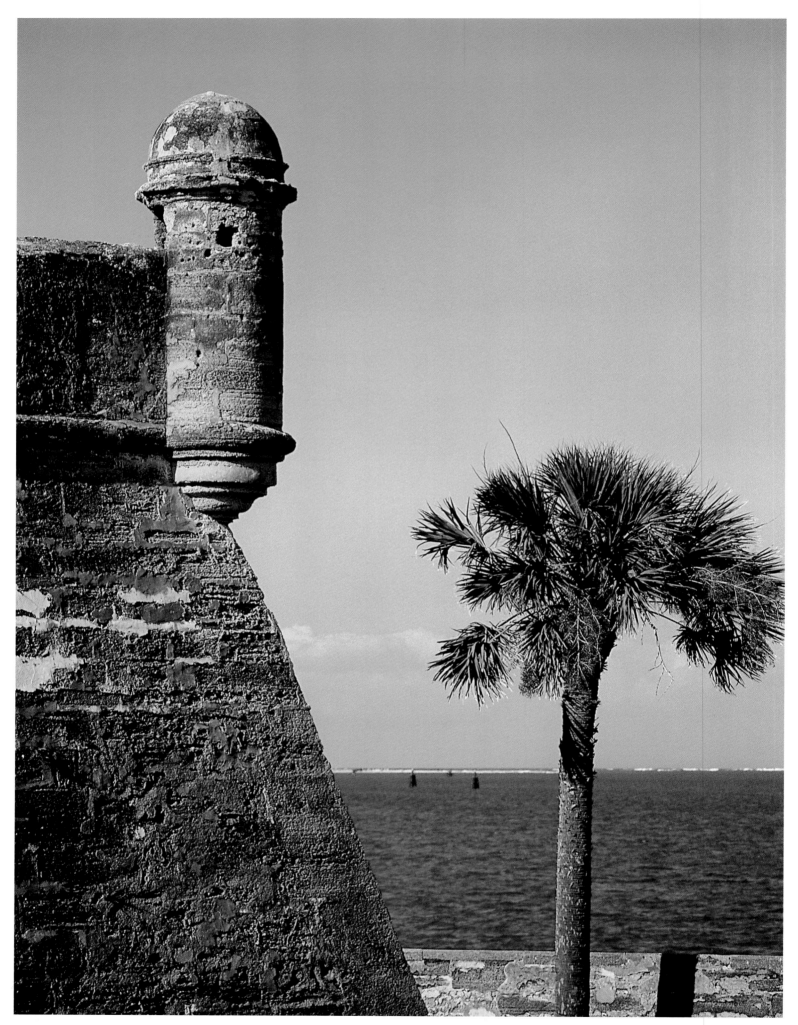

▲ The Castillo de San Marcos National Monument rises above Matanzas Bay in St. Augustine, the nation's oldest city. Completed in 1695, the Castillo was built over a twenty-three-year period by the Spanish, using coquina stone and oyster shell mortar. Seminole Indians—including their legendary leader, Osceola—were imprisoned here during the Seminole Wars of the 1800s.

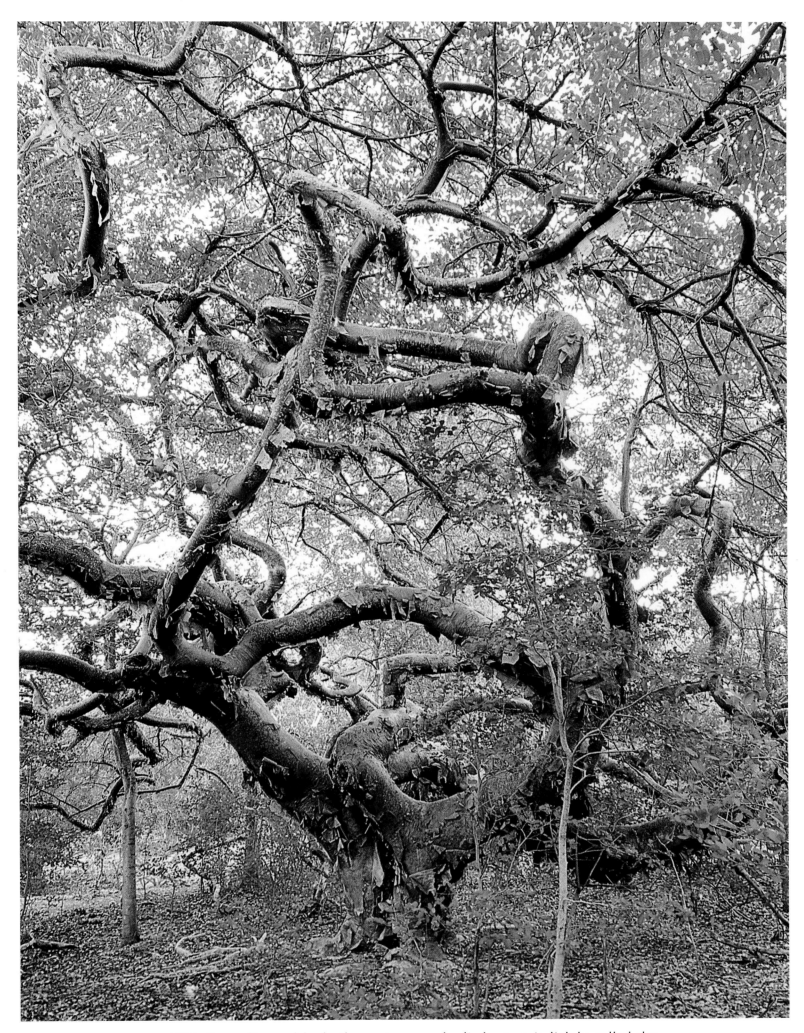

▲ With its peeling red bark, the curious gumbo-limbo tree is lightly called the "tourist tree" because the limbs look tortured with flaking, peeling sunburn. Posts made from the stout limbs sprout branches and become living fences.

▲ Florida's oldest pleasure park, Cypress Gardens in Winter Haven flaunts eight thousand varieties of plants and flowers on 208 acres. Exhibits include birds of prey educational shows, an enchanting butterfly conservatory, and canal boat rides.

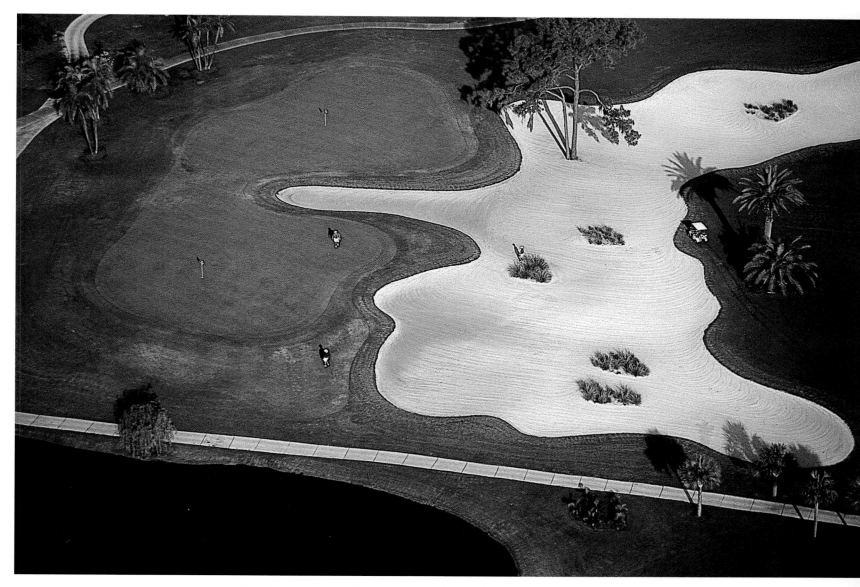

▲ C. Perry Snell built a replica of a Venice bridge to his island on Tampa Bay in 1925. Snell Island has now evolved into a typically Florida dream of luxury houses and a beautifully manicured golf course.

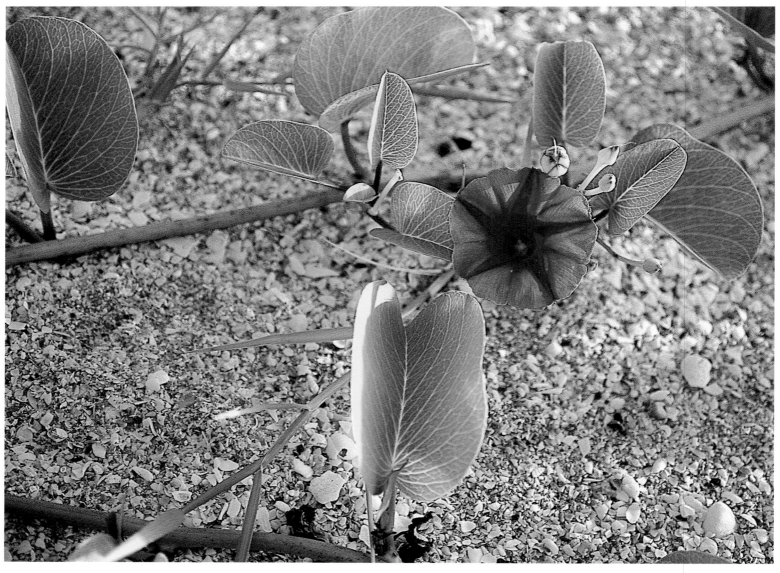

▲ The rambling, rugged, dune-loving beach morning glory finds root in Cayo Costa State Park on a barrier island north of Captiva on Florida's Gulf Coast. ▶ This flamboyant old house on the Atlantic at the end of Duval Street in Key West is called the "Southernmost House," though that honor actually belongs to the house between it and the Southernmost Point, marked by a large, concrete, ground-anchored buoy.

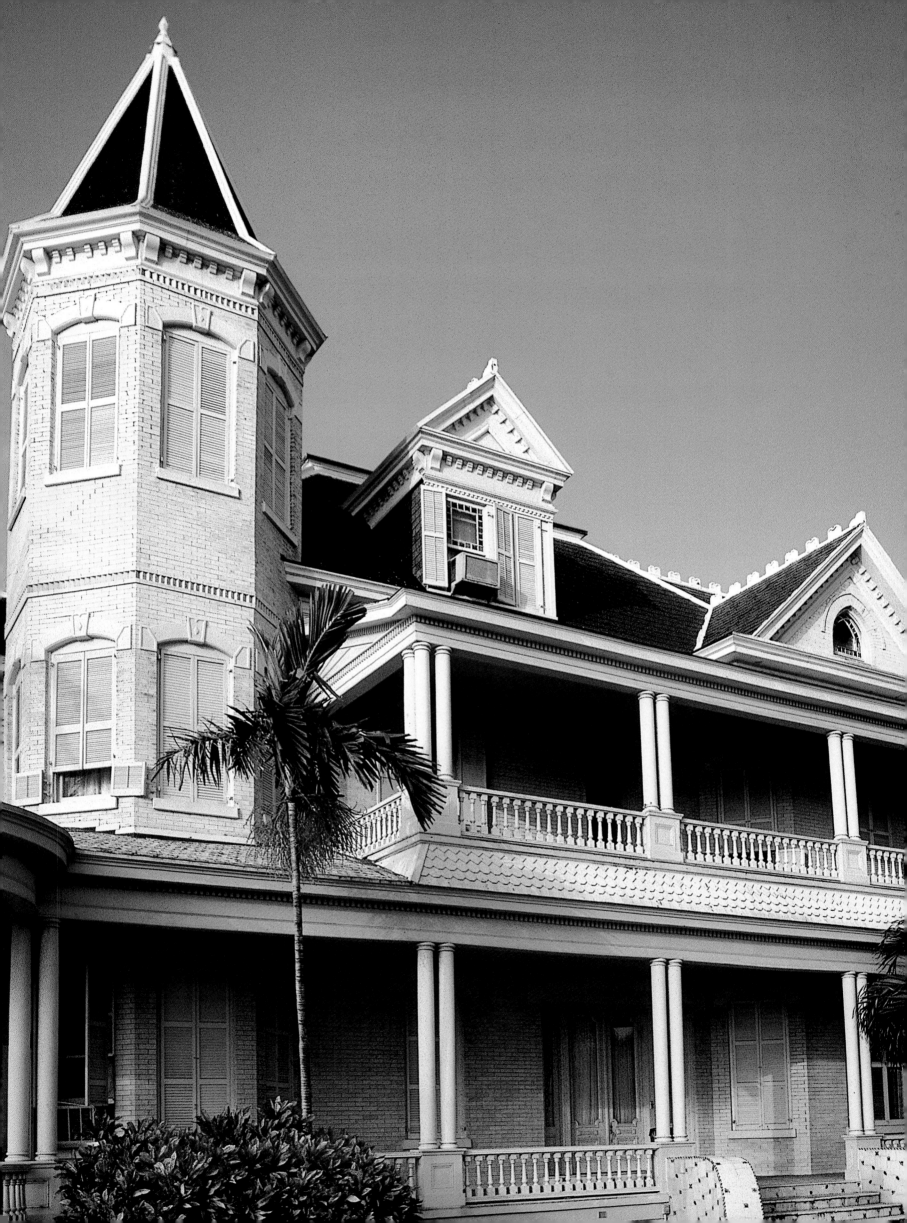

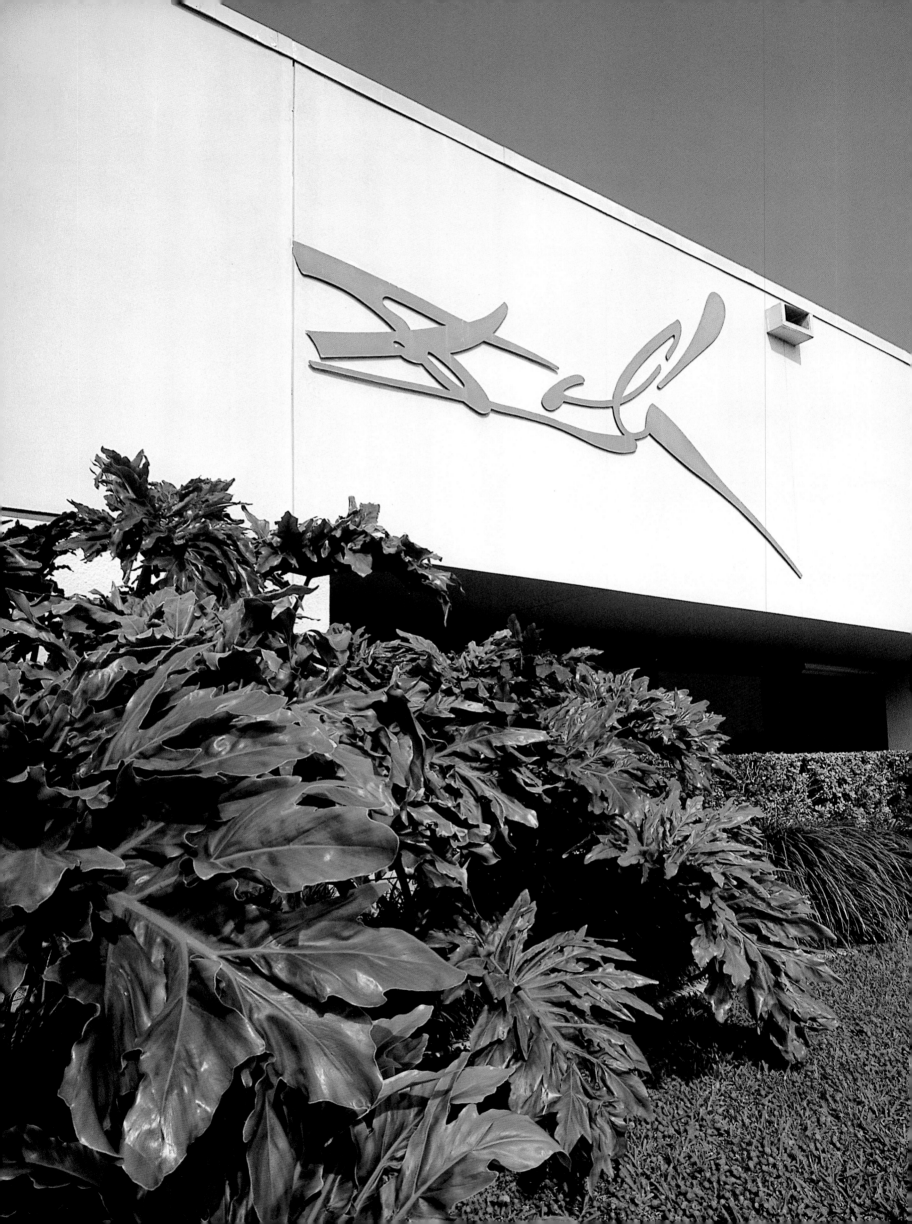

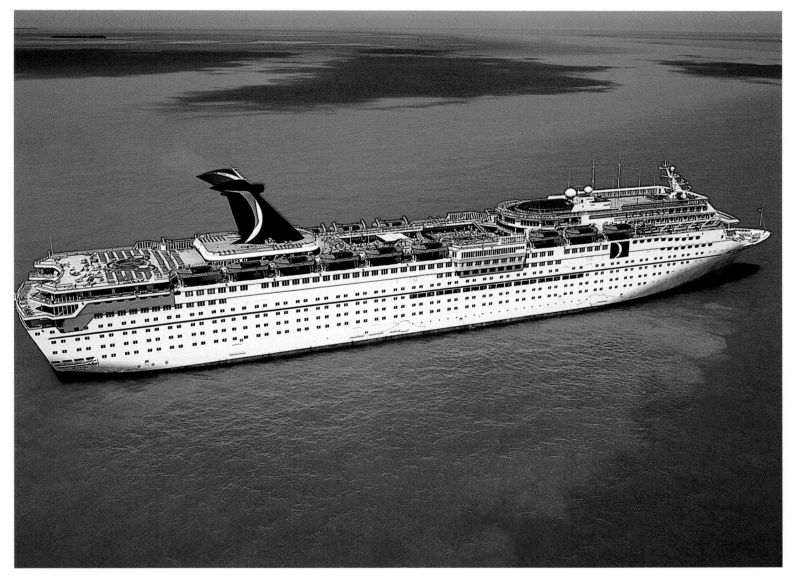

◄ The Salvador Dali Museum is located in St. Petersburg. Dali, who died in 1989, once said, "The only difference between a madman and me is that I'm not mad."
▲ Cruise ships have been making Key West a port of call since 1992. When docked, the huge ships, which can carry two thousand passengers, loom above the town, making everything else appear Lilliputian.

▲ Hollywood Beach is described as a five-mile mirage of golden sands and swaying palm trees. ▶ Erected in 1925, this neo-classical building on Miami's Biscayne Boulevard was made famous during the 1960s when it became the reception center for Cubans who fled Castro. Renamed the Freedom Tower, it now stands empty.
▶ ▶ A 120-mile road encircles Lake Okeechobee, a vast freshwater impoundment.

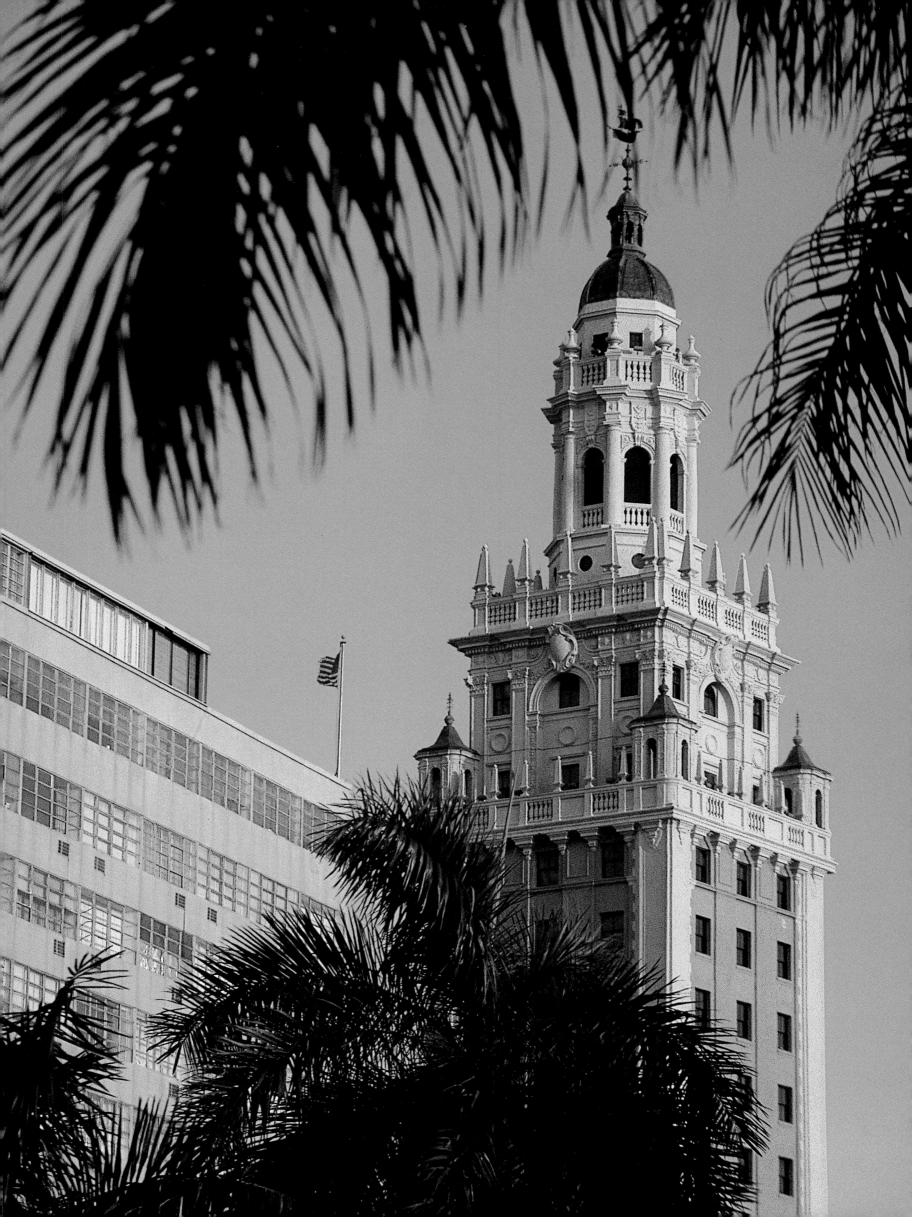

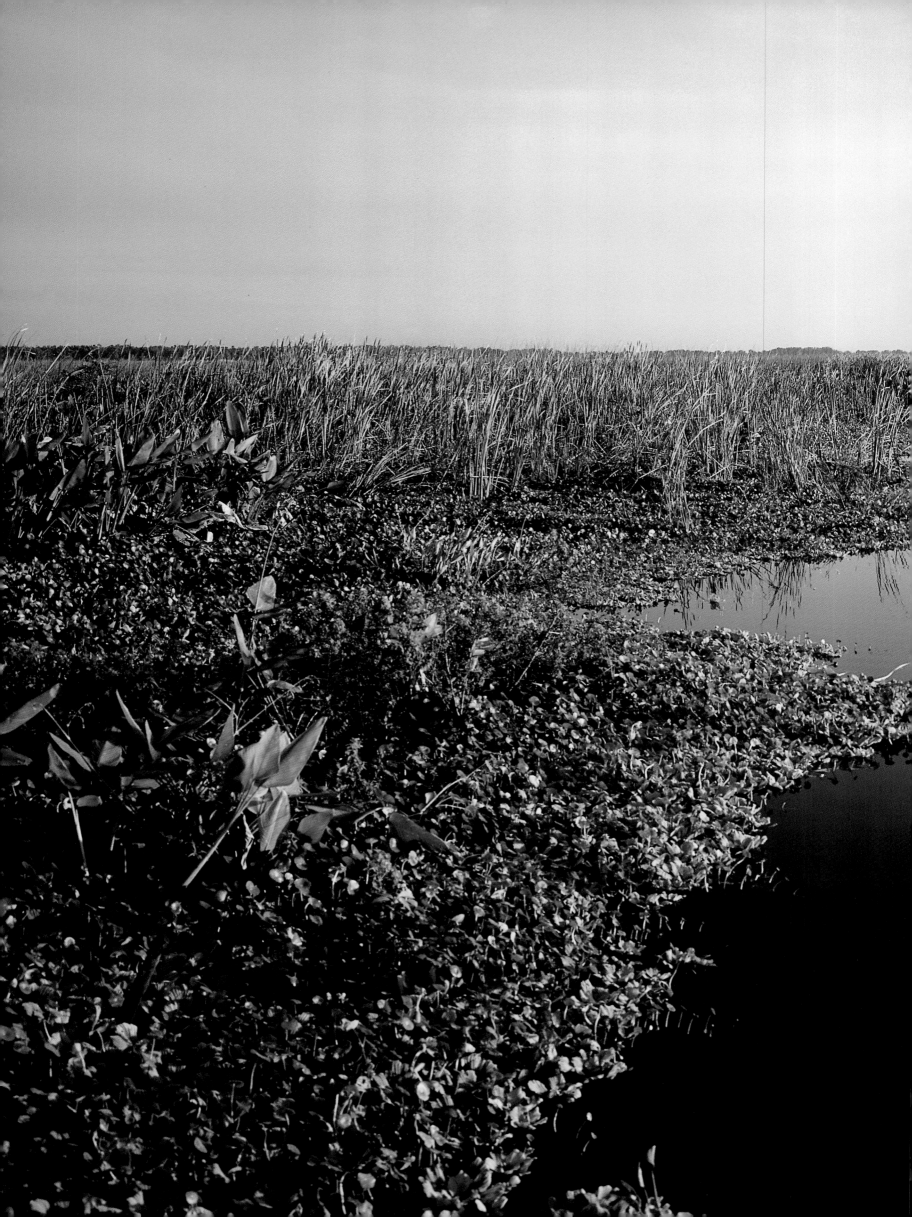

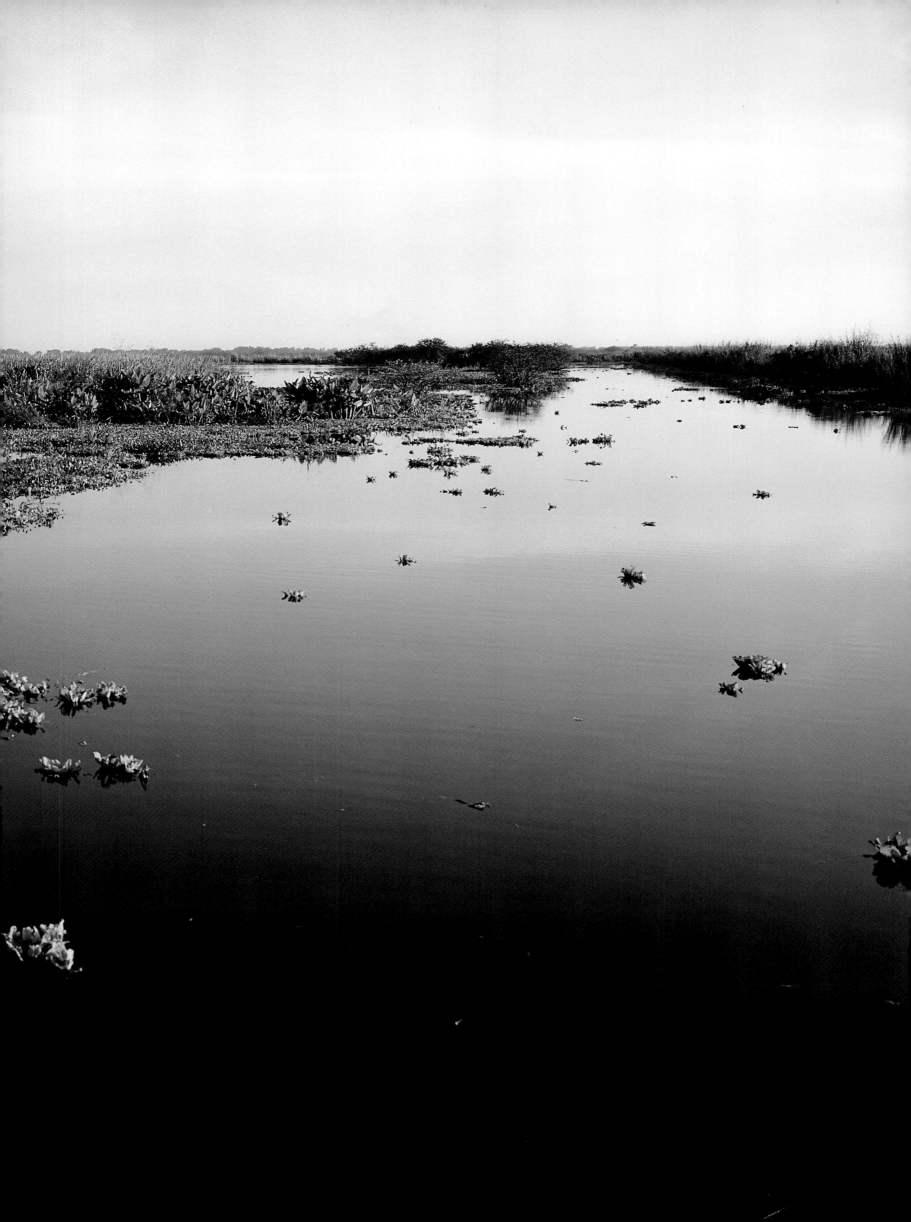

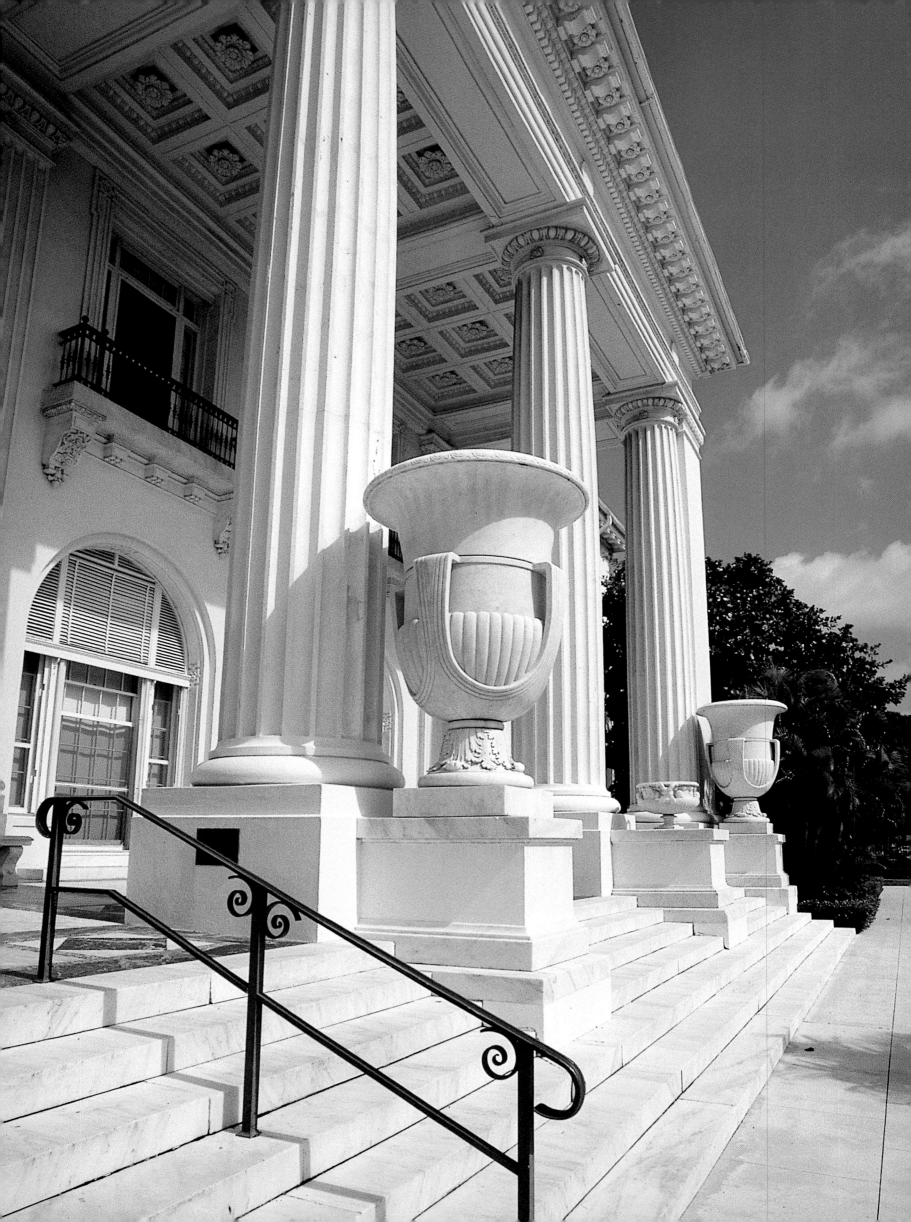

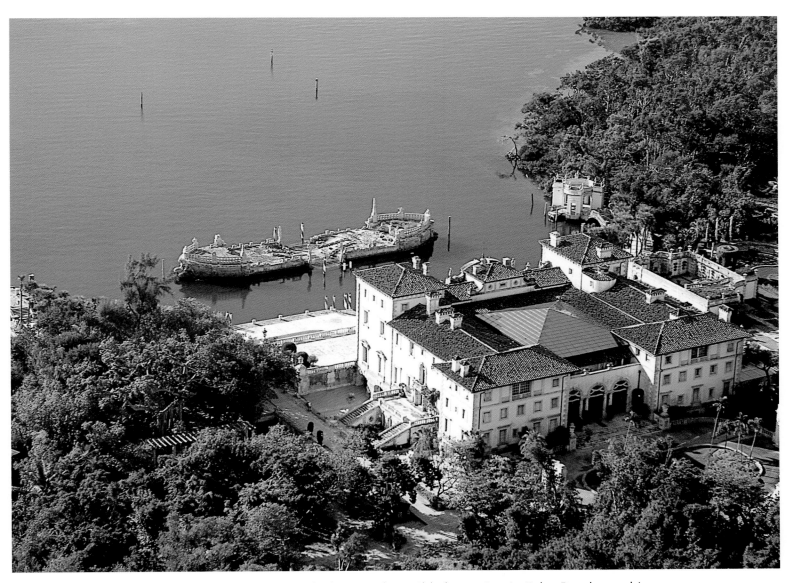

◄ Railroad tycoon Henry Flagler's opulent gilded mansion in Palm Beach was his winter residence. ▲ In 1915, farm machinery mogul James Deering spent fifteen million dollars recreating a sixteenth-century Italian villa on Biscayne Bay in Coconut Grove and filling it with a jarring mix of Baroque, Renaissance, Rococo, and neo-classical fixtures and furnishings.

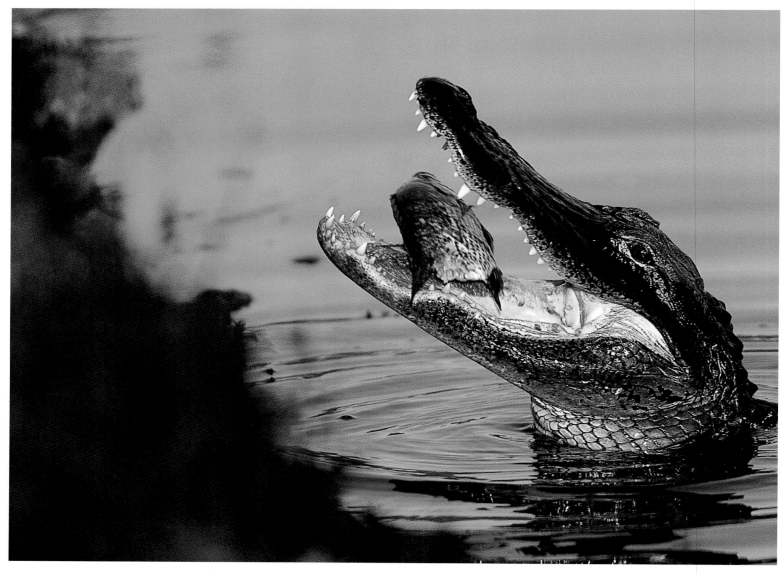

▲ A gator plays with his lunch. They eat turtles, snakes, bullfrogs, and anything that comes their way. ▶ A rare ghost orchid has found a home in the Fahkahatchee Strand in the heart of the Big Cypress Swamp. It is a leafless species with a big, waxy, white flower that resembles a snow-white frog suspended in midair. The flowers rise directly from roots that snake about on the trunks of hammock trees.

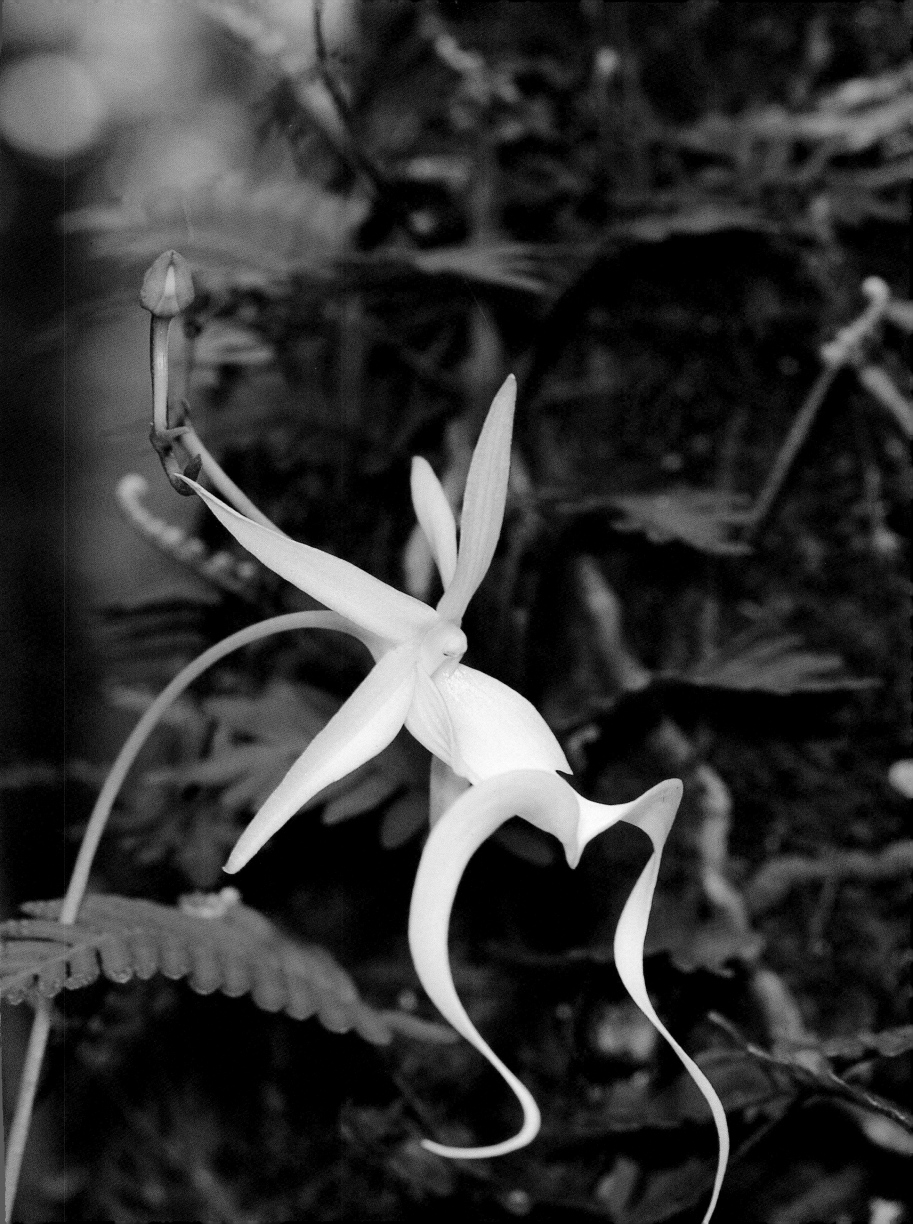

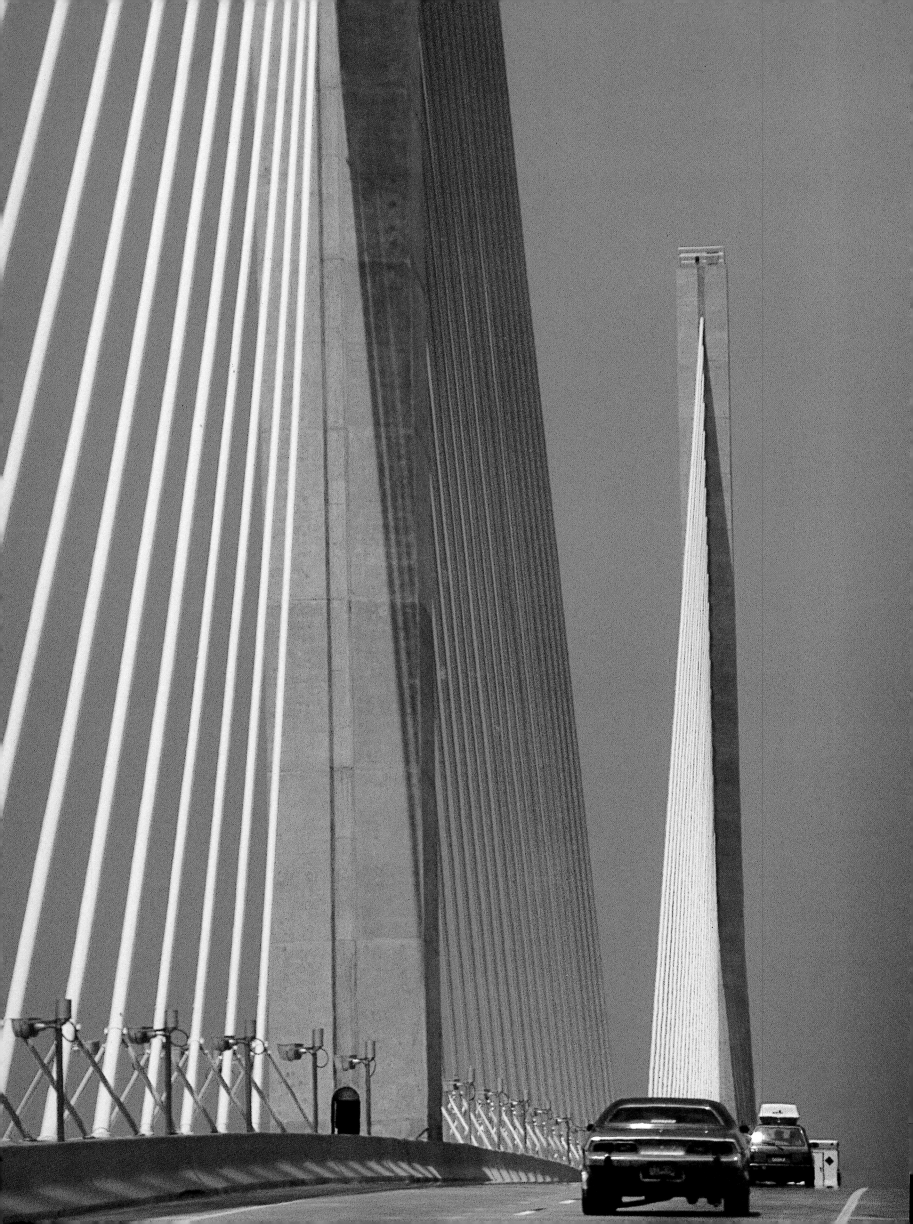

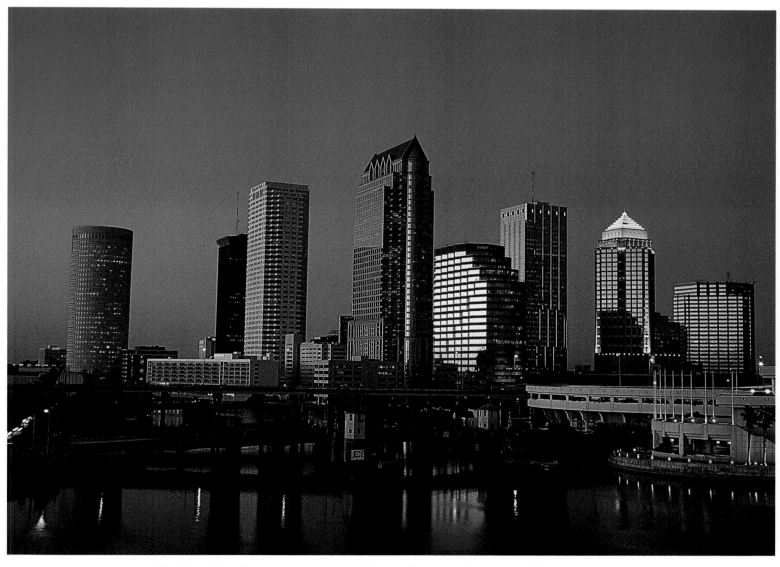

◄ The Sunshine Skyway soars across Tampa Bay. A tanker struck the central section of the southbound span in 1980, and several cars and a Greyhound bus plunged into the waters below. A portion of the truncated span now serves as a fishing pier.
▲ Tampa, very businesslike, rises above the Hillsborough River and Tampa Bay.

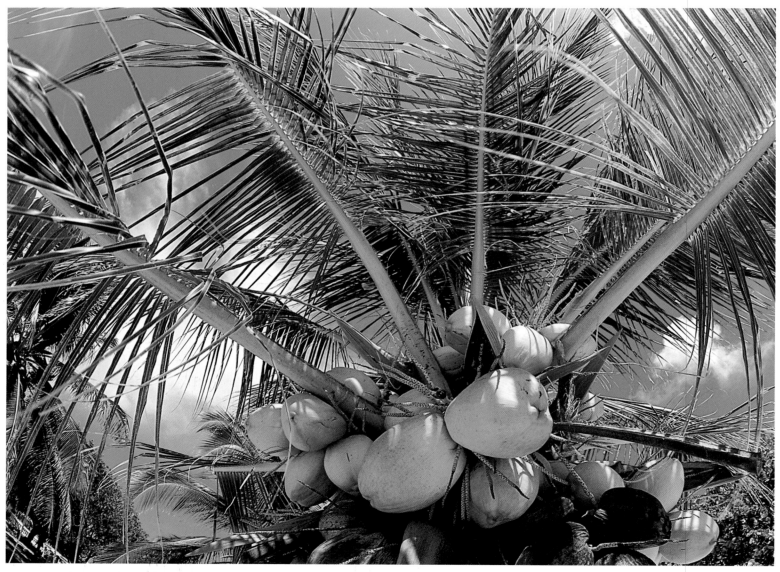

▲ The fruit of the coconut palm is the largest produced by any palm. The seed, or nut, is enclosed in a thick, waterproof husk that is impervious to water. The husks are carried by wind and current and, when washed ashore, quickly sprout to form new trees. They arrived in Florida from the West Indies all on their own.

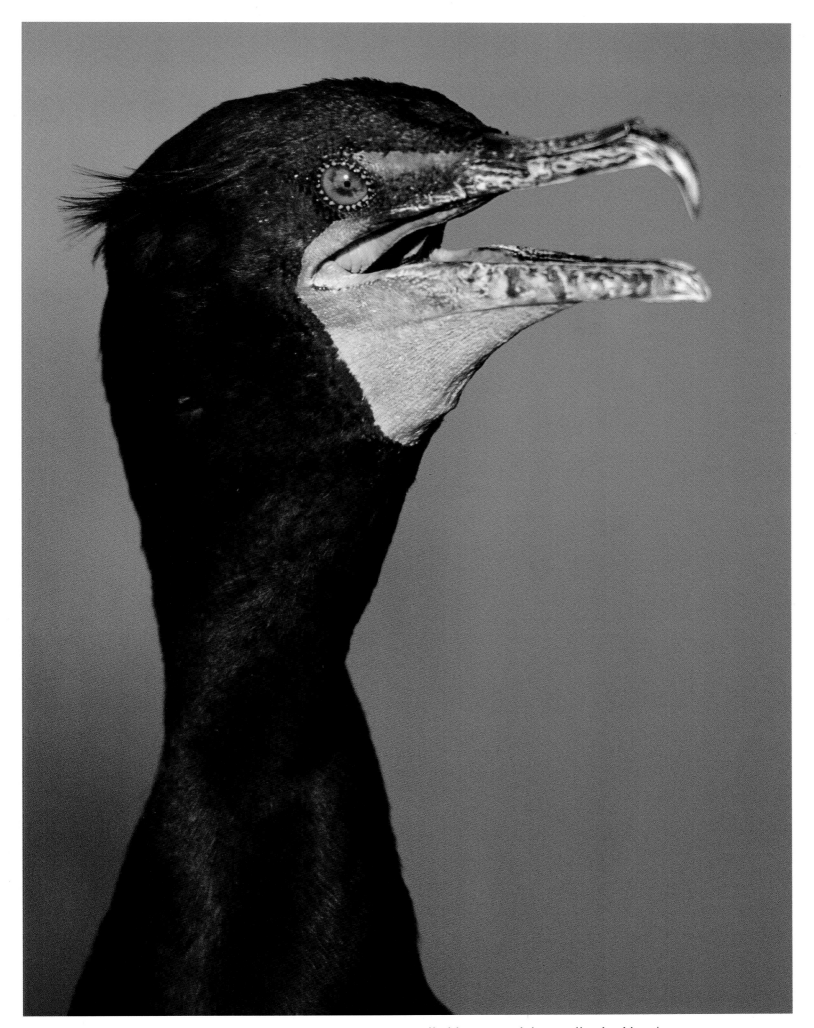

▲ Florida's double-crested cormorant (so called because of the small tuft of head feathers that appear during breeding season) can often be seen industriously drying its wings on pilings and channel markers. Unlike other water birds, the cormorant does not have oil glands for waterproofing its feathers.

▲ Florida Bay, the great marine nursery of south Florida, is utterly dependent for its health on a healthy Everglades. The grass beds of the Bay support large numbers of redfish, trout, snook, mangrove snapper, and tarpon.

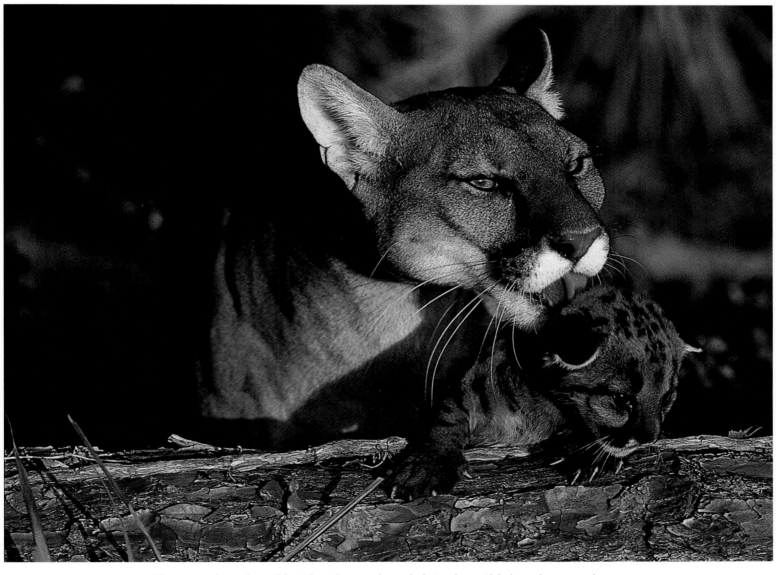

▲ There are less than fifty Florida panthers left in the wild, but they can be seen at many zoos and breeding ranches throughout the state. Here a mother grooms her cub at Three River Ranch outside Tampa.

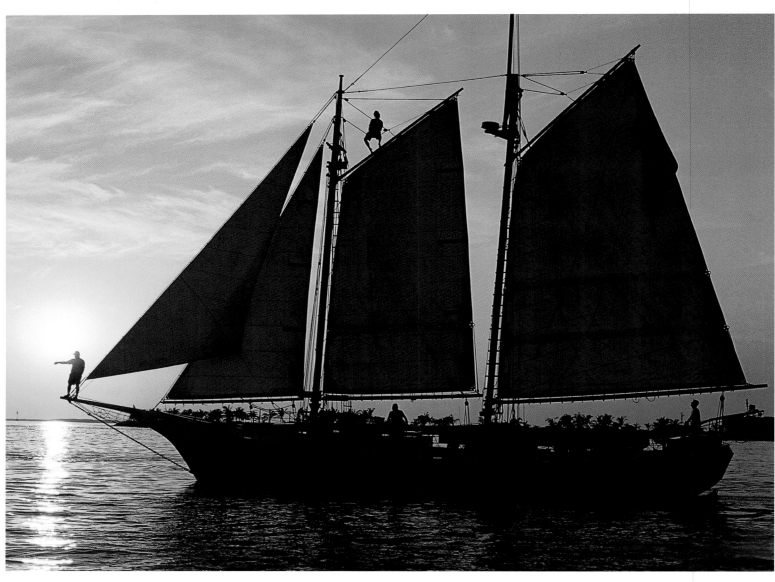

▲ Sunset is everyone's favorite occupation in Key West. Mallory Square is a popular place to watch the show, and short cruises are available on many beautiful boats in the harbor. Often, champagne is served, adding to the sparkle of sun on water.

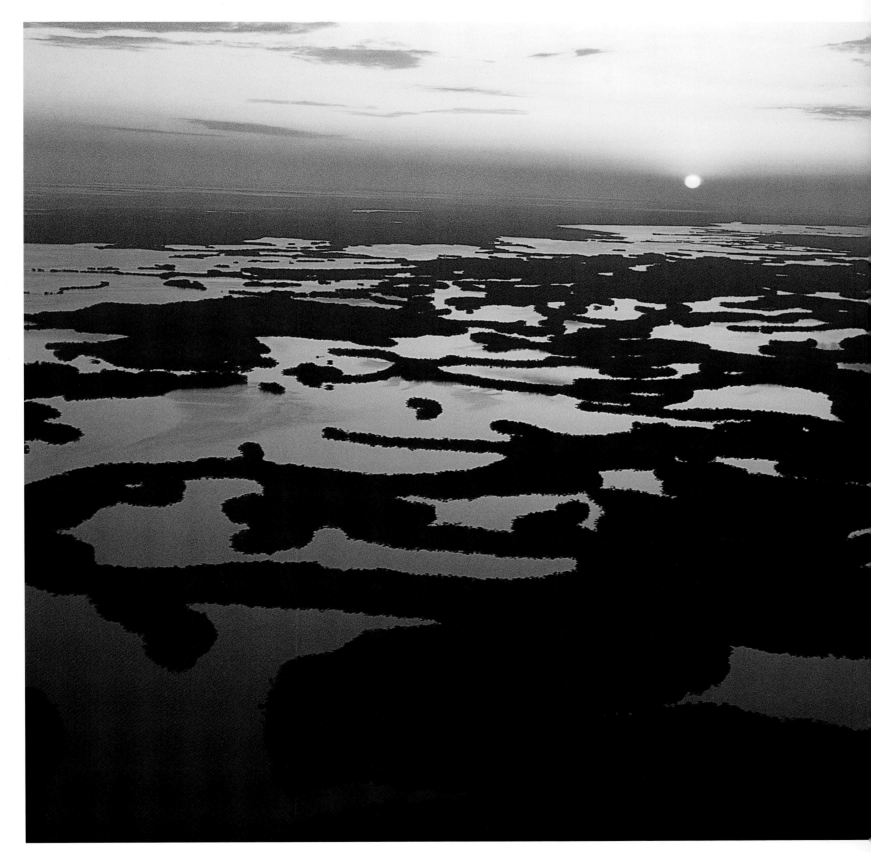

▲ From the air, the Ten Thousand Islands are the most striking landscape in Florida. A mosaic of mangrove islands, this bewilderingly patterned archipelago begins at Cape Romano below Naples and extends southward to Cape Sable.

▲ The Keys have few natural beaches. The reef absorbs the roll of waves that, if they came ashore, would wear away rock to sand. ▶ Two identical houses, prefabricated in Maine, were brought to Fort Meyers in 1886. Thomas Edison lived here until his death in 1931. ▶▶ The clear water in the Keys offers kayakers glimpses of fine and fleeting things—turtles and rays and, in this case, a little nurse shark.

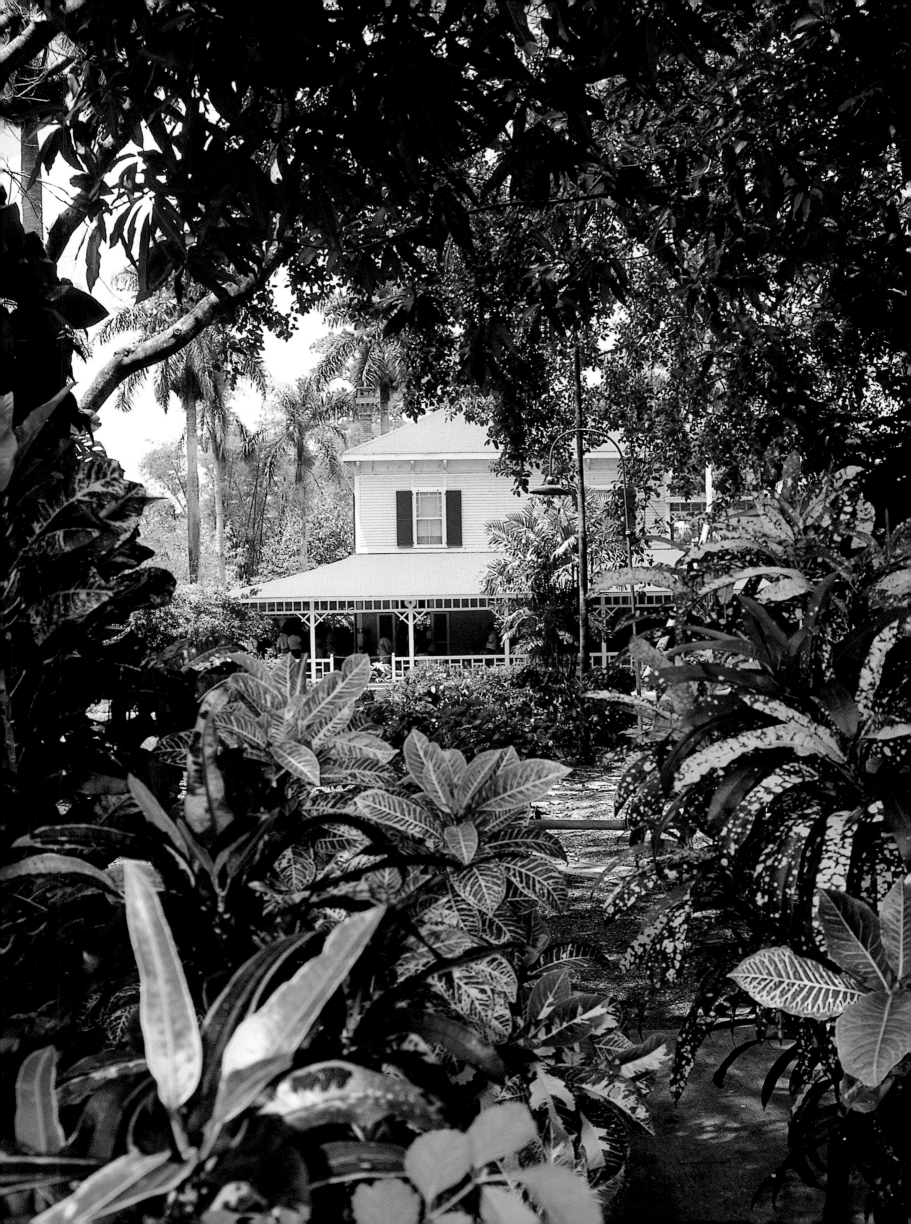

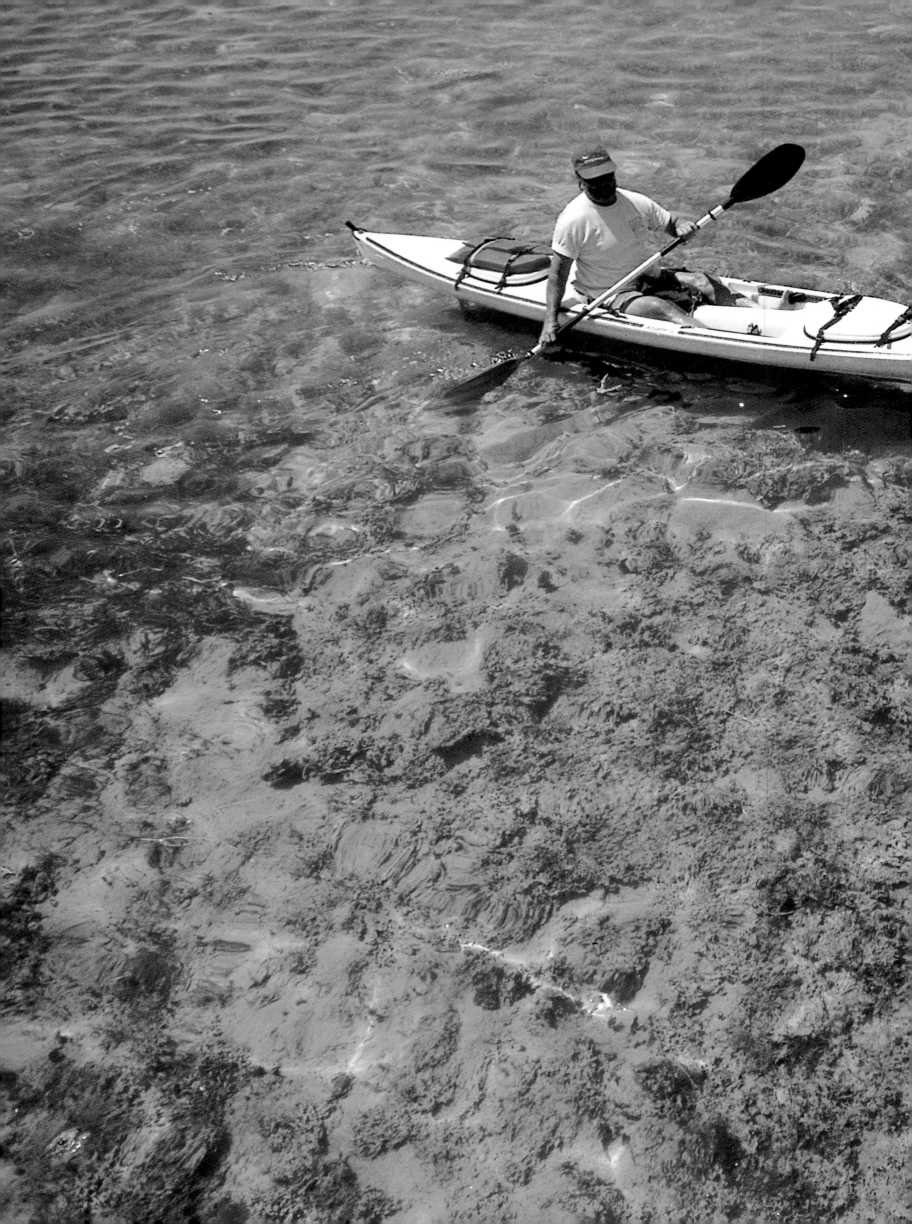

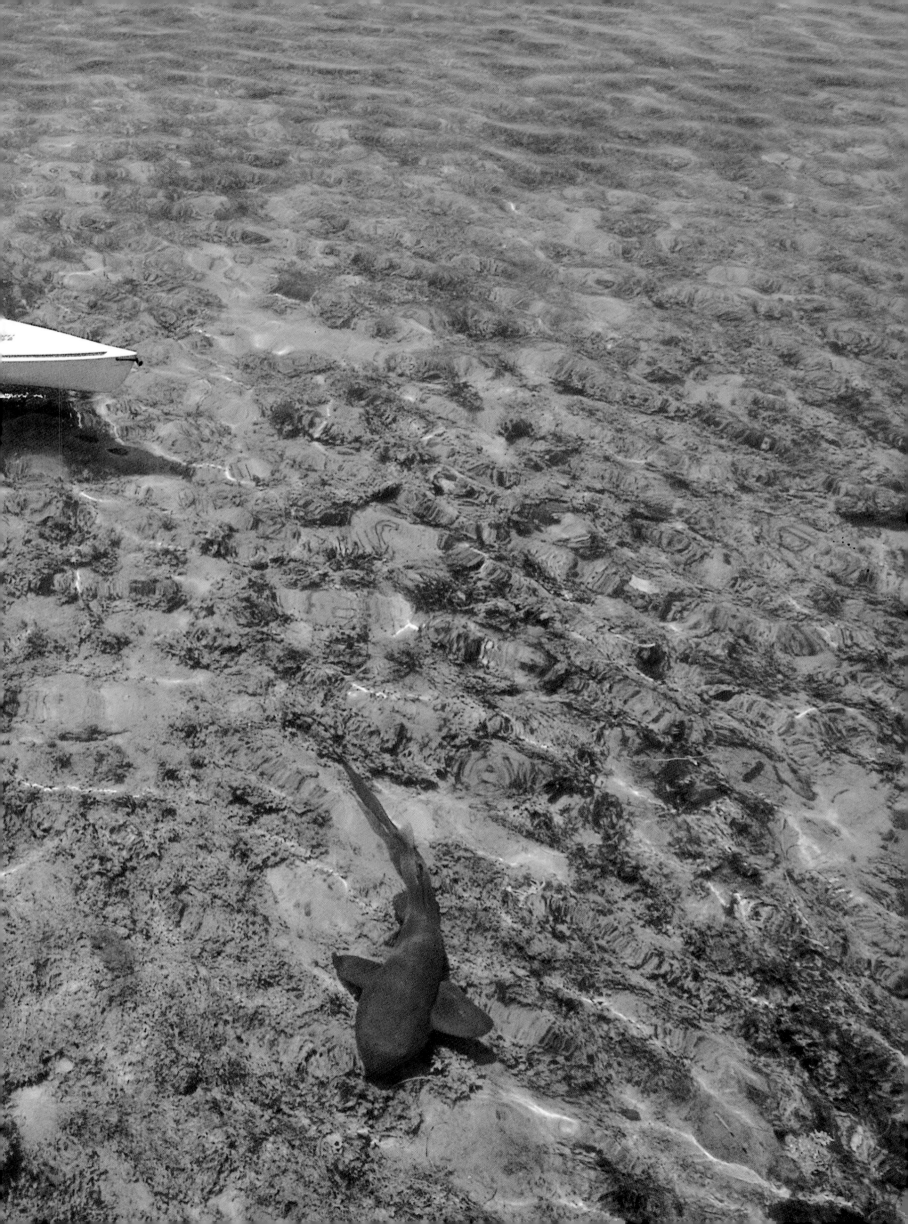

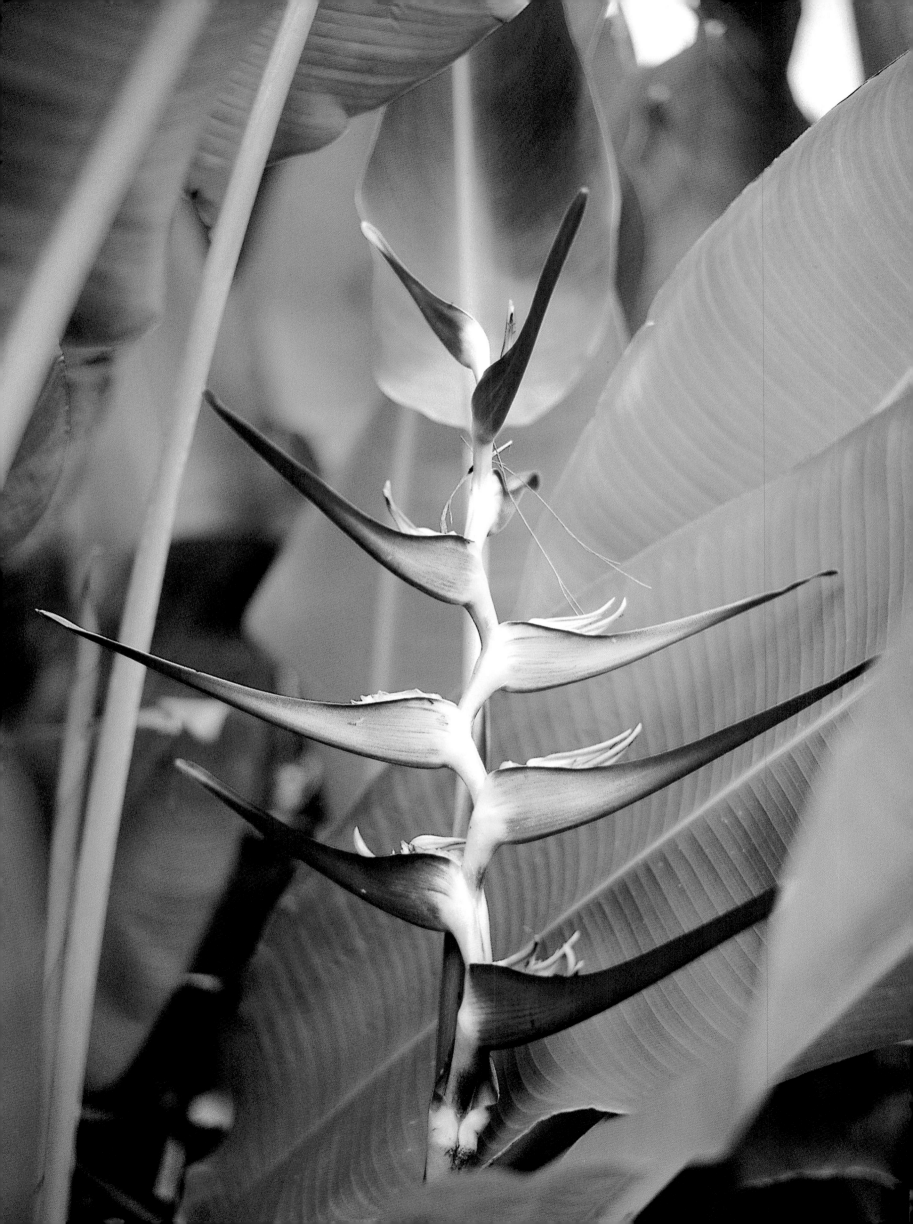

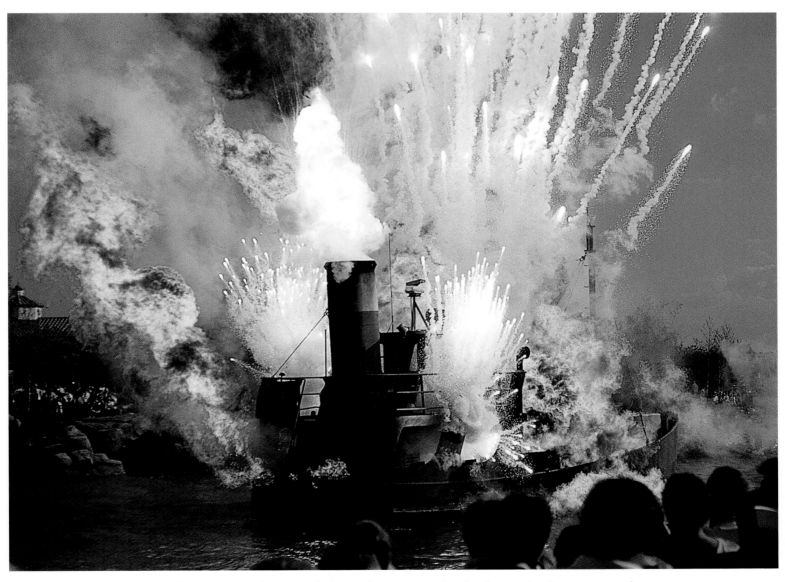

◄ *Heliconias,* a "designer banana," is grown for its fantastic flowers, not for its inedible fruit. ▲ Universal Studios in Orlando is a theme park that doubles as a film and TV production center. On a very *un*placid lagoon, extravagant pyrotechnic stunts are performed daily.

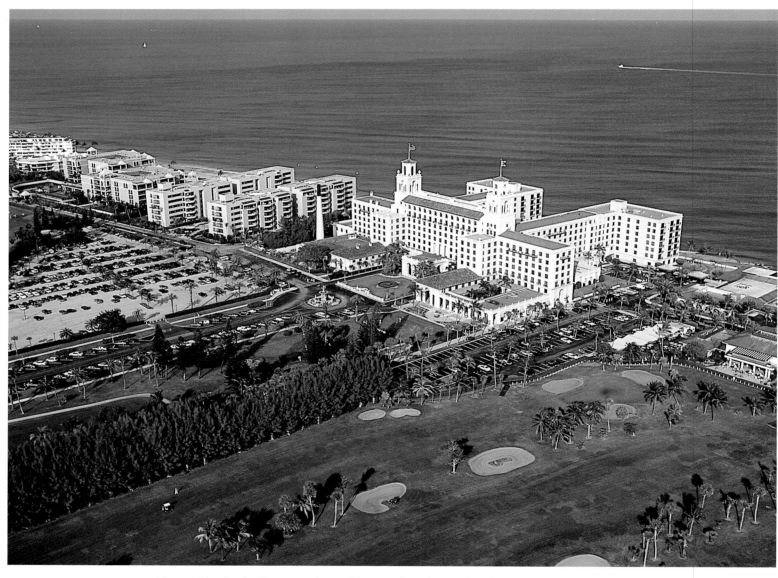

▲ Henry Flagler built a number of luxury hotels in Florida, including the original Breakers Hotel, which burned down in 1925. It was replaced with this even grander edifice. ▶ The outrageously hued purple gallinule is a moorhen that behaves very much like a duck. Its extremely large feet enable it to walk on lily pads and other water plants in search of insects.

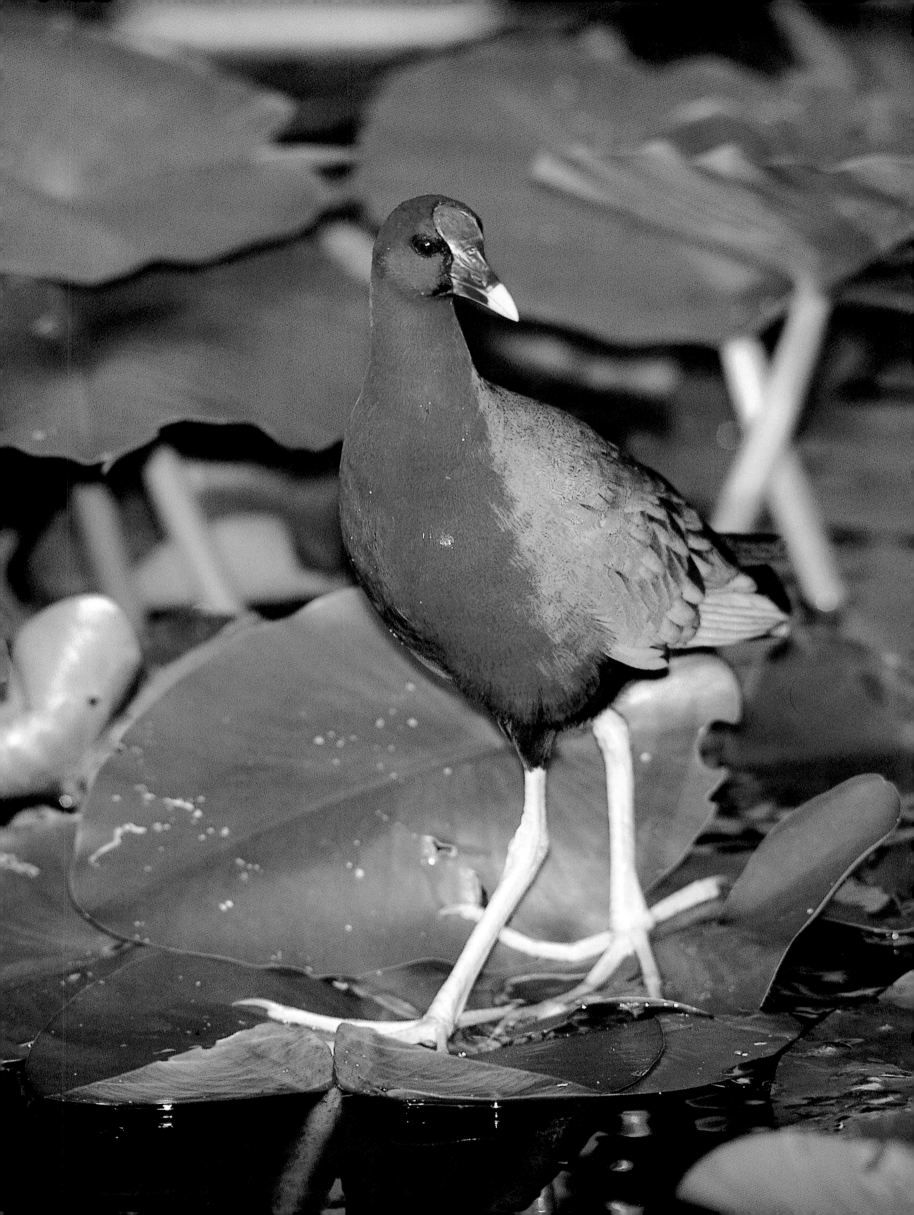

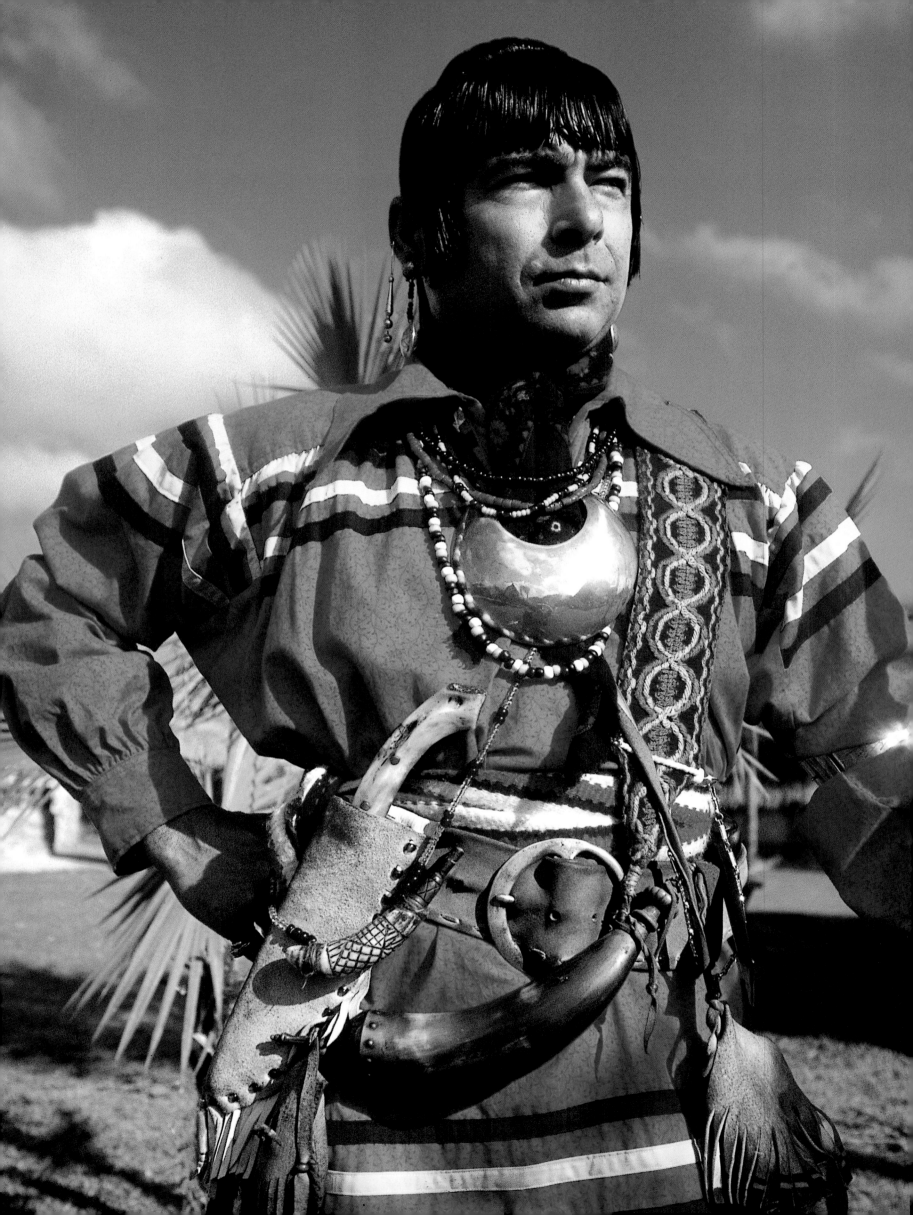

◄ Seminole was a term first used in the 1700s for members of several Indian Creek tribes who fled south to Florida. Visitors may learn about Seminole history and culture at the Ah-Tah-Thi-Ki Museum in the Big Cypress Seminole Reservation.
▲ The agribusiness of raising sugarcane has had a dramatic effect on the River of Grass by altering both the flow and the quality of water that enters the Glades.

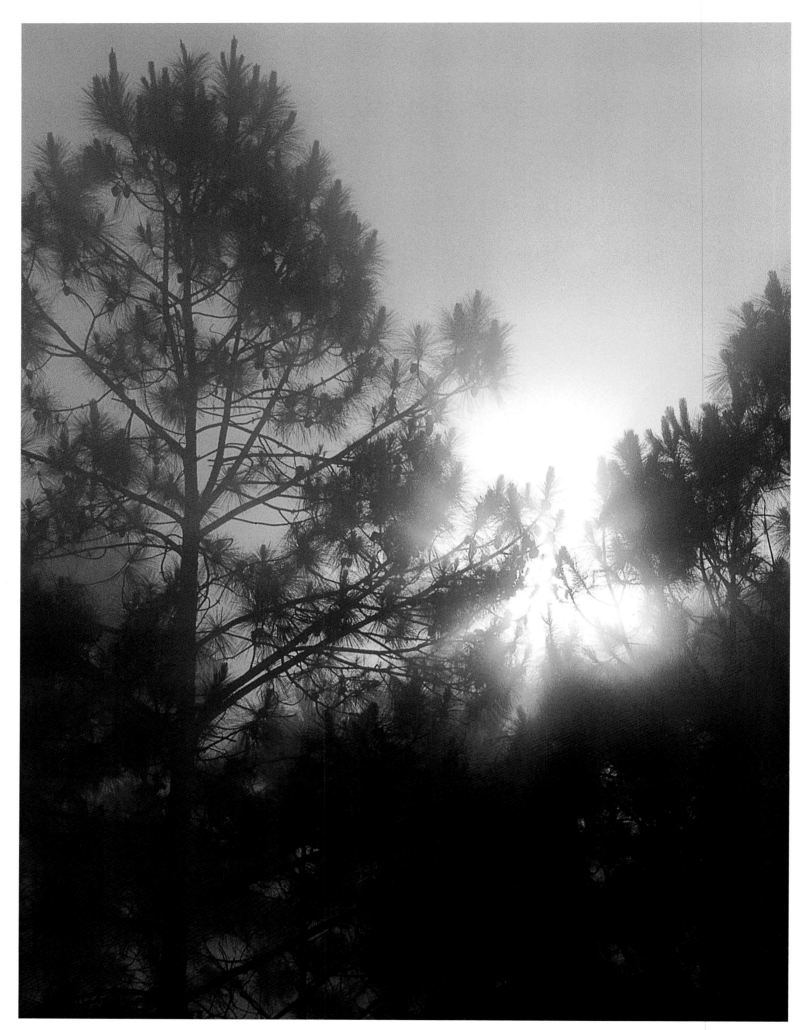

▲ The slash pine is common in the swamps and lowlands, here made beautiful by sunrise. A fast-growing tree, it is planted in lieu of the more desirable long-leaf pine. The slash pine's uses for railroad ties, general construction, and pulp are rather prosaic. Far nicer is its use as a nesting site for Florida's water birds, such as the yellow-crowned night heron.

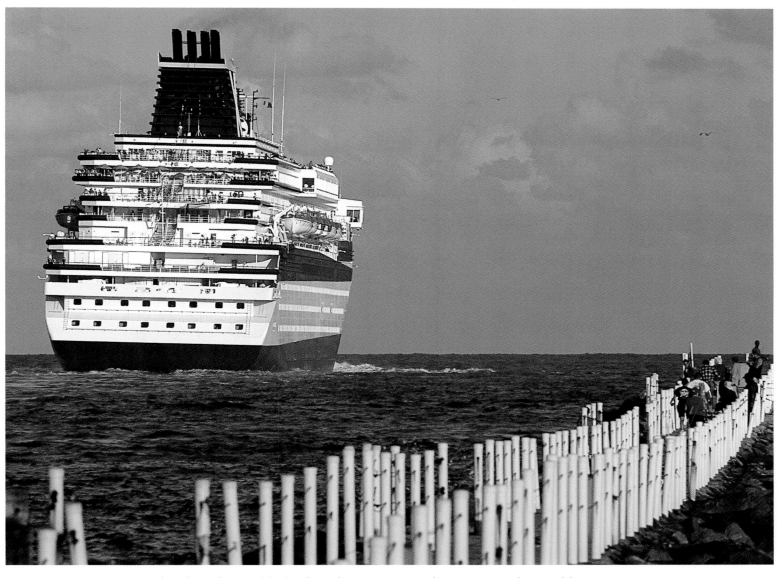

▲ Florida is the world's leading departure point for cruises to the Caribbean. Here, the *Zenith* leaves Fort Lauderdale's Port Everglades, which accommodates military vessels, container ships, and oil tankers, as well as holiday craft.

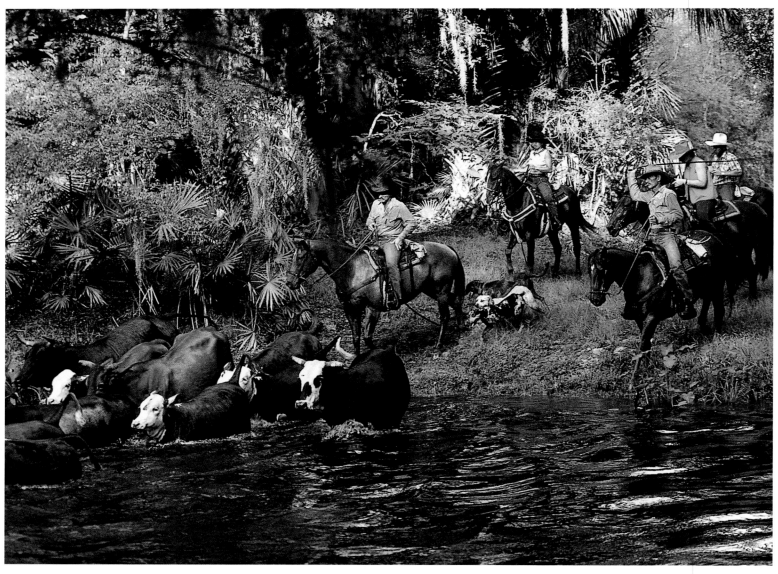

▲ Tropo cowboys drive their herd across a picturesque stretch of the Hillsborough River. The river, which winds for fifty-four miles beginning near Zephyrhills and ending in Tampa, is a favorite for local canoe enthusiasts.

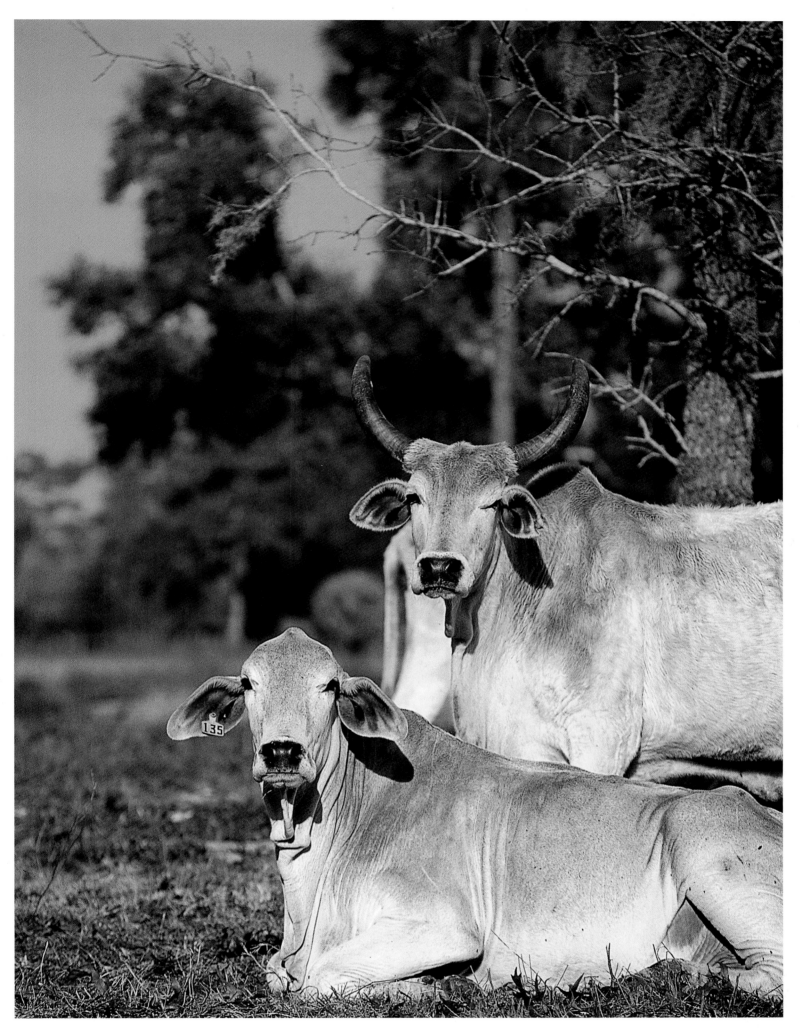

▲ Cattle were shipped from Florida to market in Cuba under the Spanish. Today, in the southeastern states, Florida is second only to Kentucky in the raising of beef cattle, its industry based largely on Brahmin cattle that originally came from India.

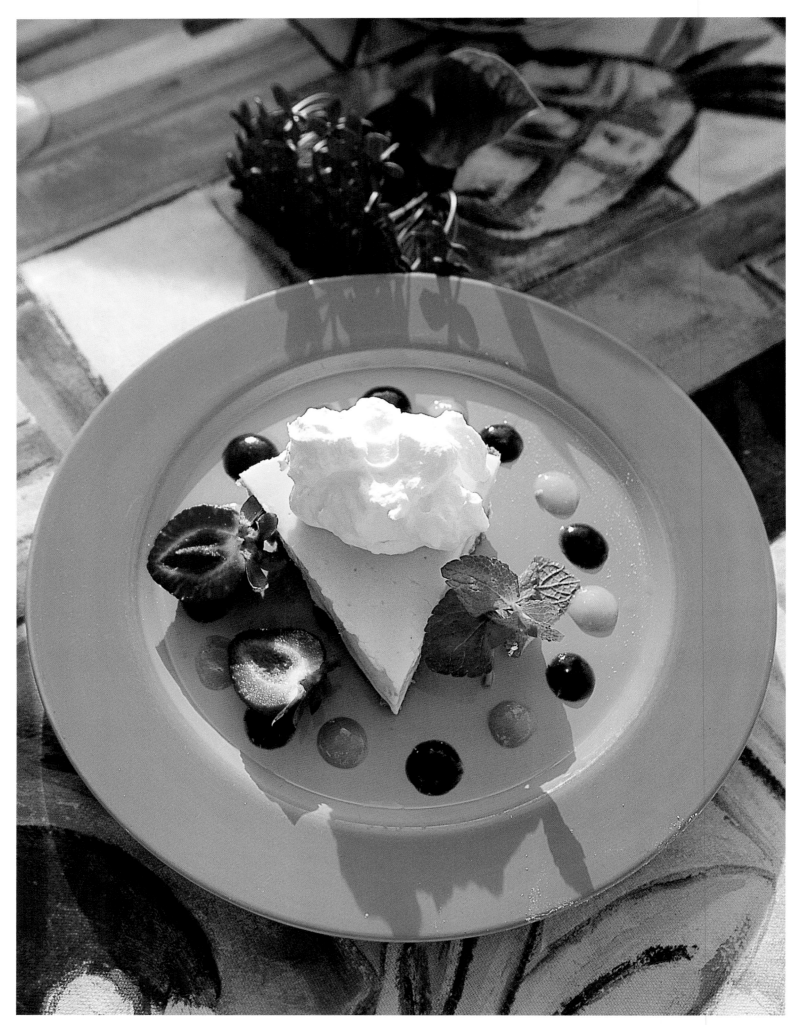

▲ A visit to Florida would never be complete without a slice of key lime pie. Key limes are tiny, yellow, wildly juicy, and tart. Never make a pie with those big green Tahiti limes. The secret to making the most popular dessert in the state—other than using the wild limes—is that it's made with a can of plain old condensed milk.

▲ Sailing is popular in Matlacha Pass near Sanibel on the Gulf Coast. The J. N. "Ding" Darling National Wildlife Refuge comprises most of Sanibel's north side, and there are many small, scattered, beautiful refuge islands accessible only by boat. If you're cruising and interested, inquire at the Refuge headquarters.

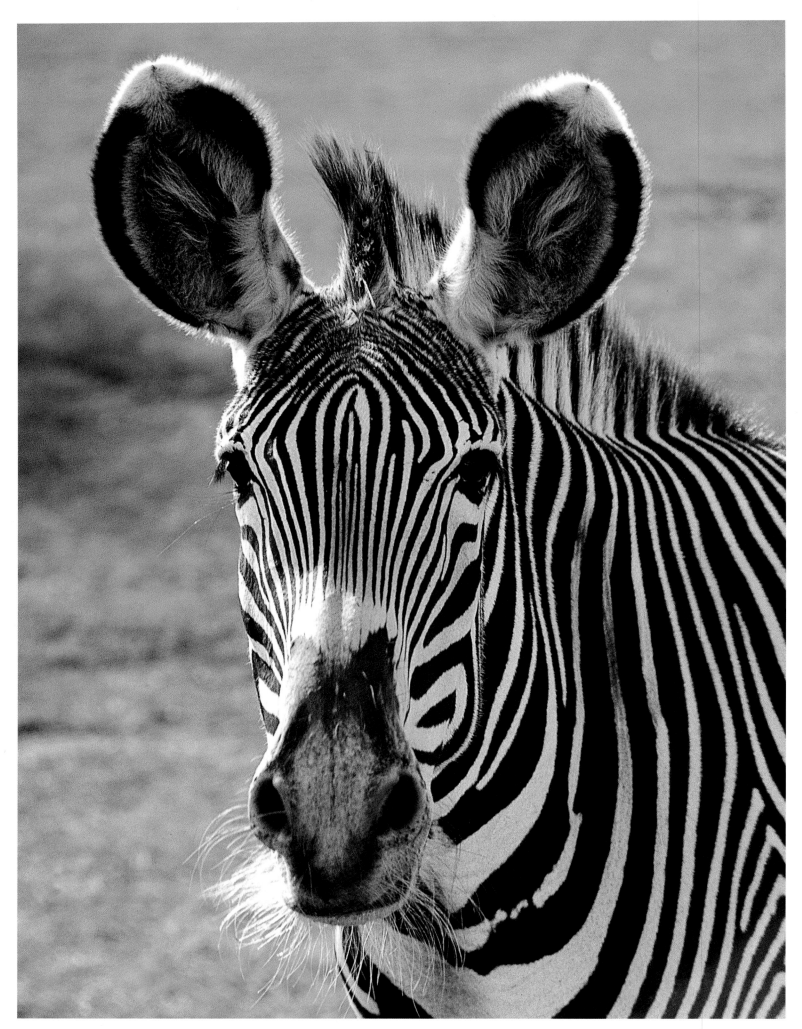

▲ Like many nonnatives, this zebra has accommodated itself to Florida living. Here in the eighty-acre Serengeti Plain area of Busch Gardens in Tampa, visitors can view a variety of African animals by monorail. There are even hyenas here, though they have their own "village" and do not mingle with their natural prey.

▲ The Hemingway House stands on Whitehead Street in Key West. The great author lived here off and on from 1931 to 1940 before changing his tropical base to Cuba.
► ► The red mangrove, Florida's one true mangrove, is recognized by its clumping root system and its long seedlings. Practically the only living organism that can stand during a 100-mile blow, the trees protect coastal Florida from hurricanes.

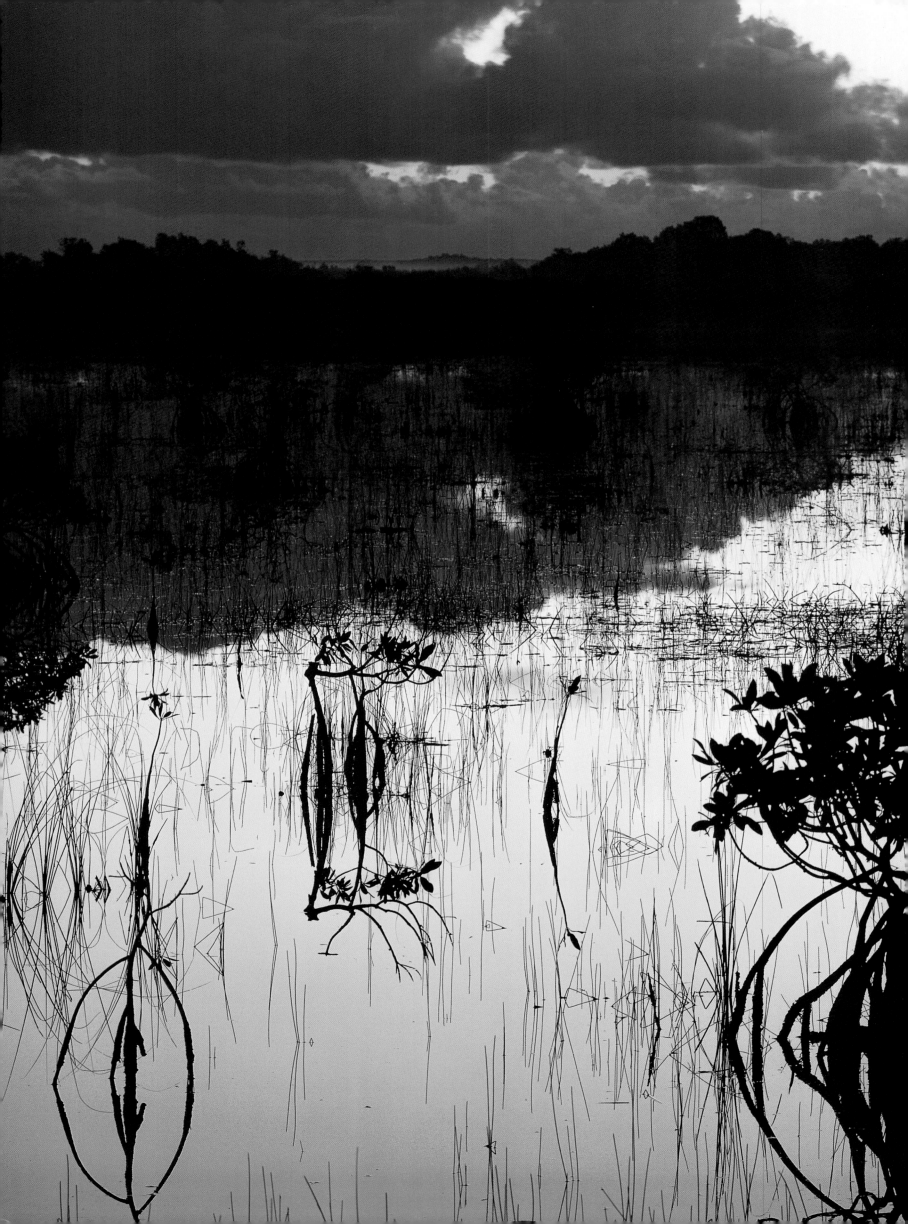

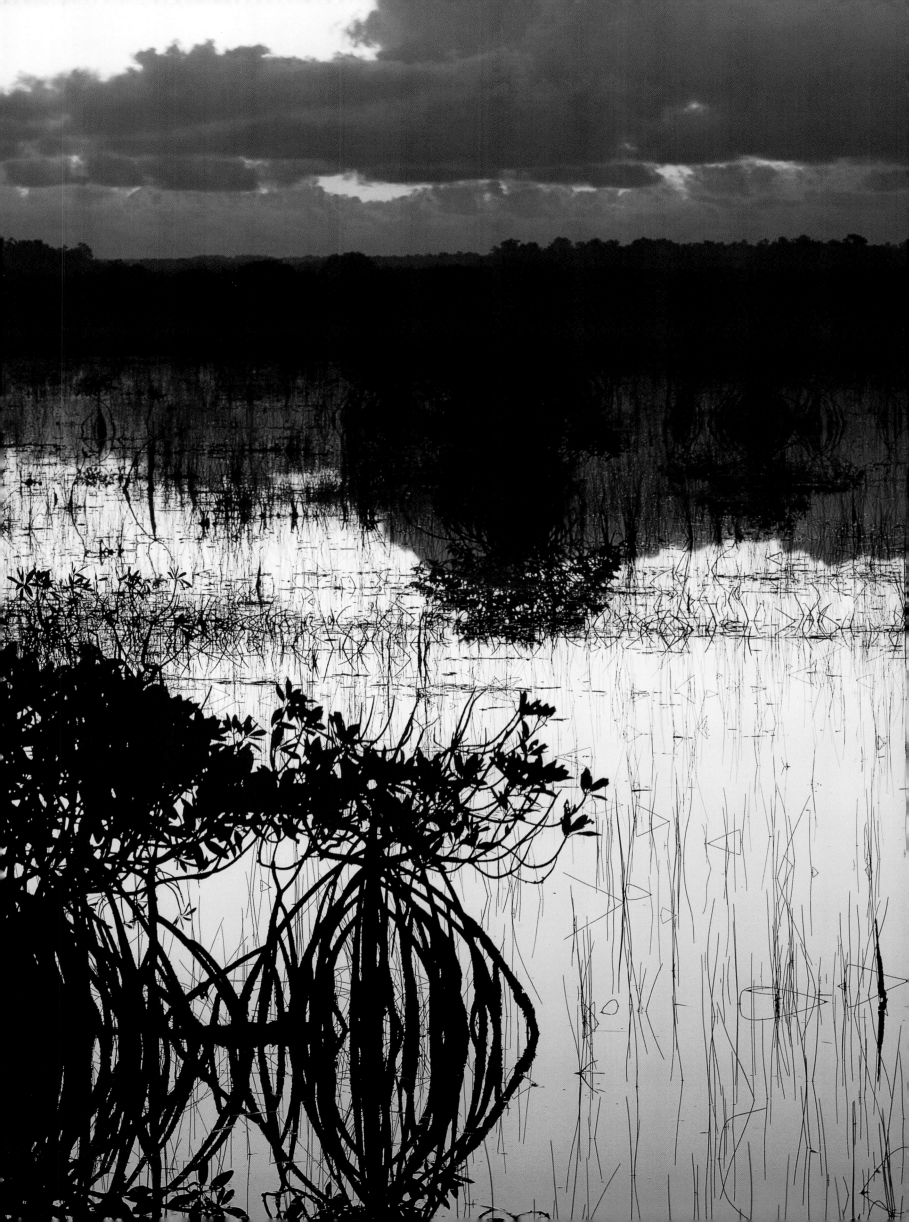

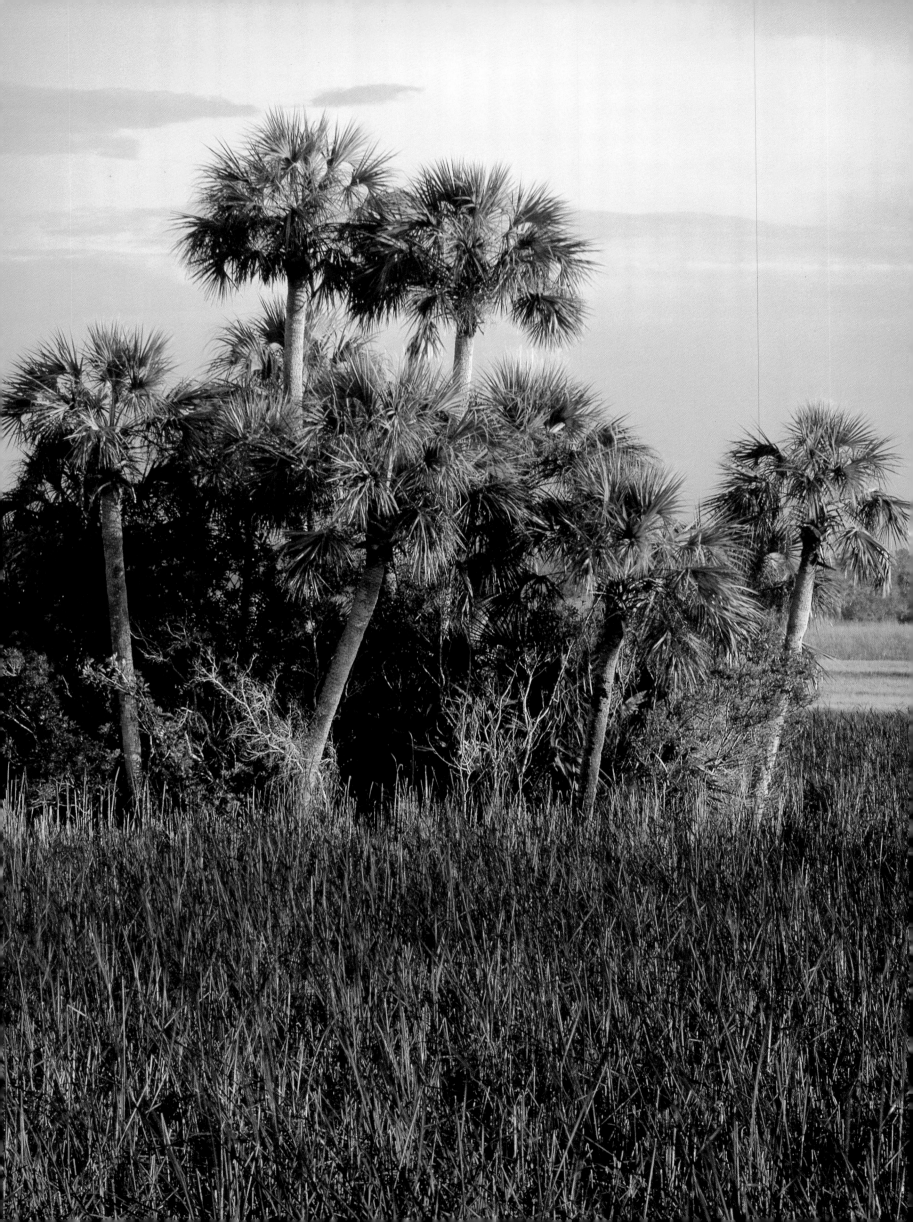

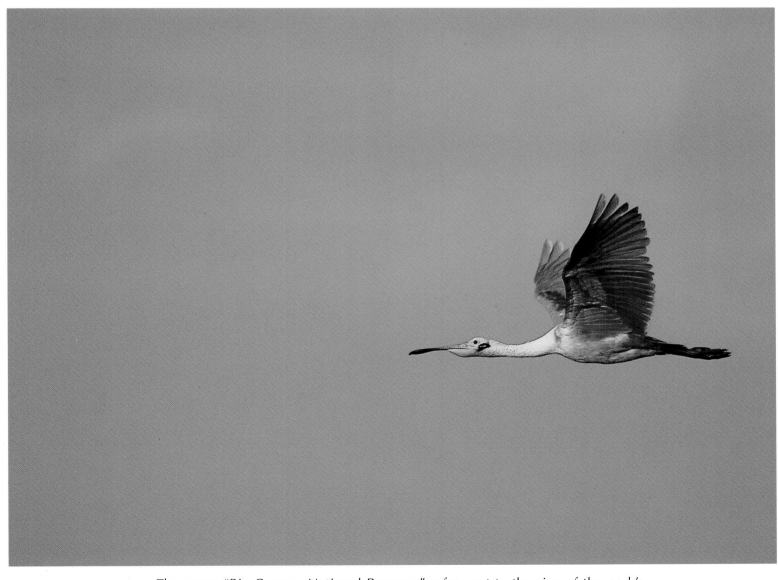

◄ The name "Big Cypress National Preserve" refers not to the size of the park's trees (its giants were logged out long ago) but to its expanse—2,400 square miles. ▲ A roseate spoonbill takes wing at the J. N. "Ding" Darling National Wildlife Refuge on Sanibel Island on Florida's Gulf Coast. "It is as though an orchid had spread its lovely wings and flown" is how one person described this beautiful bird.

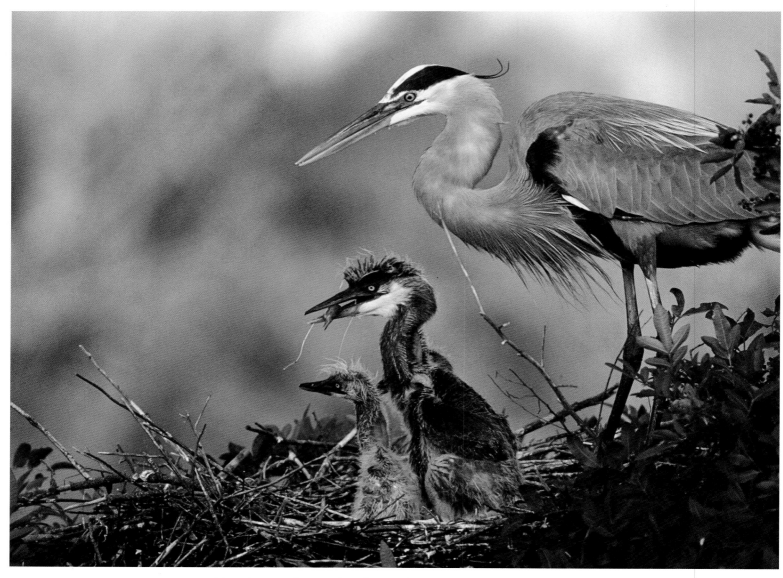

▲ A great blue heron shows the throat feathers and crown tassel of breeding plumage. When the parent who has been out fishing returns, a lovely ritual involving bowing, stretching, and wing spreading is performed by the mating pair.
▶ Highlands Hammock State Park has trees ranging in age from 400 to 1000 years. Here, bladderwart—an aquatic, insectivorous plant—is in the foreground.

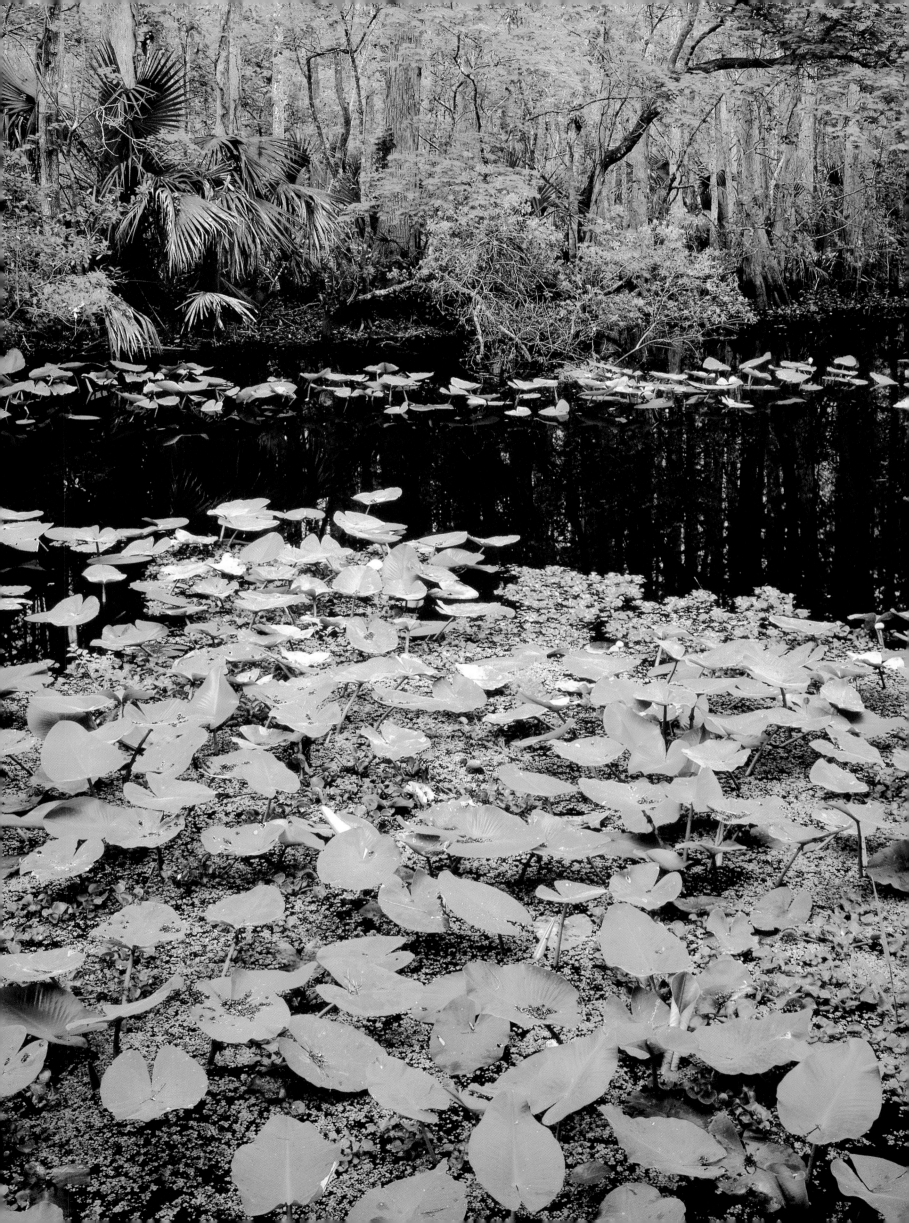

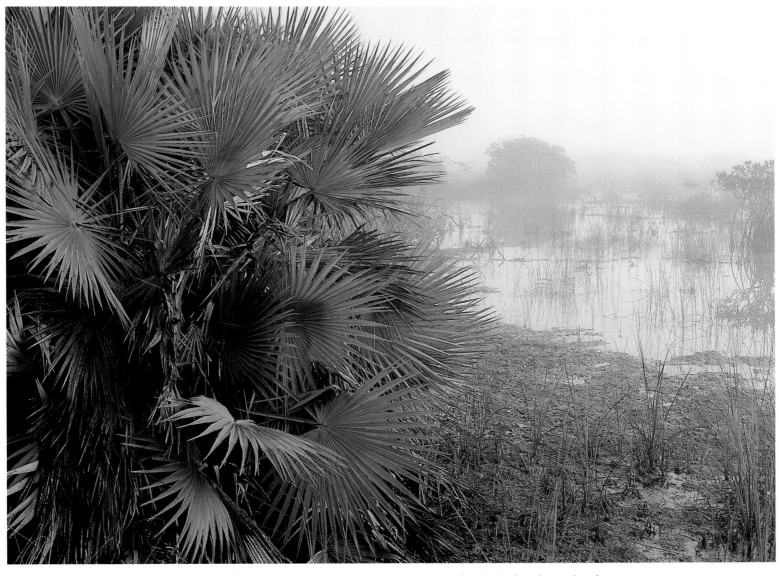

◄ Fisher Island is a new exclusive, luxurious, residential island south of Miami Beach. Not a natural island, it is a fill, or spoil, island made from the dredging development of Miami. ▲ A classically misty marsh in the Everglades creates a mysterious scene of saw palmetto marsh grass and red mangrove.

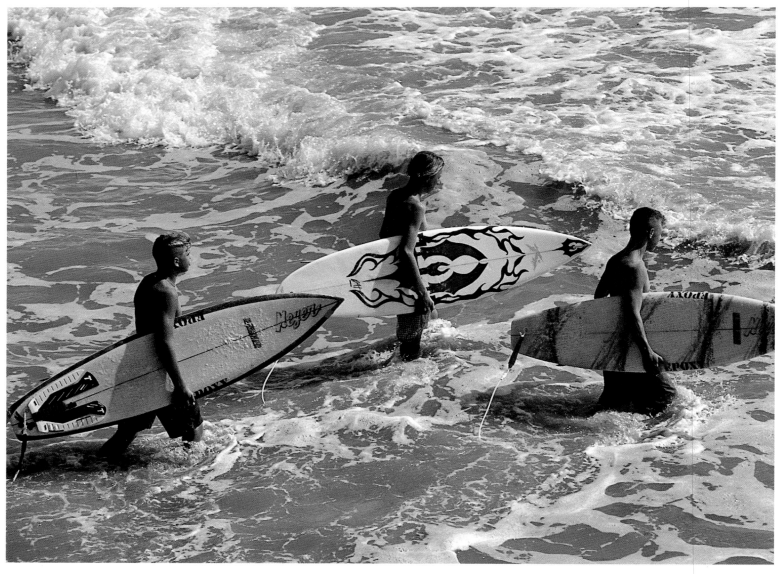

▲ Cocoa Beach is considered one of the top surfing spots on the East Coast. It is also home to the Ron Jon Surf Shop, a twenty-four-hour neon extravaganza devoted to the ultra-cool art of surfing. ► Evidence of a walk along Canaveral National Seashore quickly disappears beneath the waves.

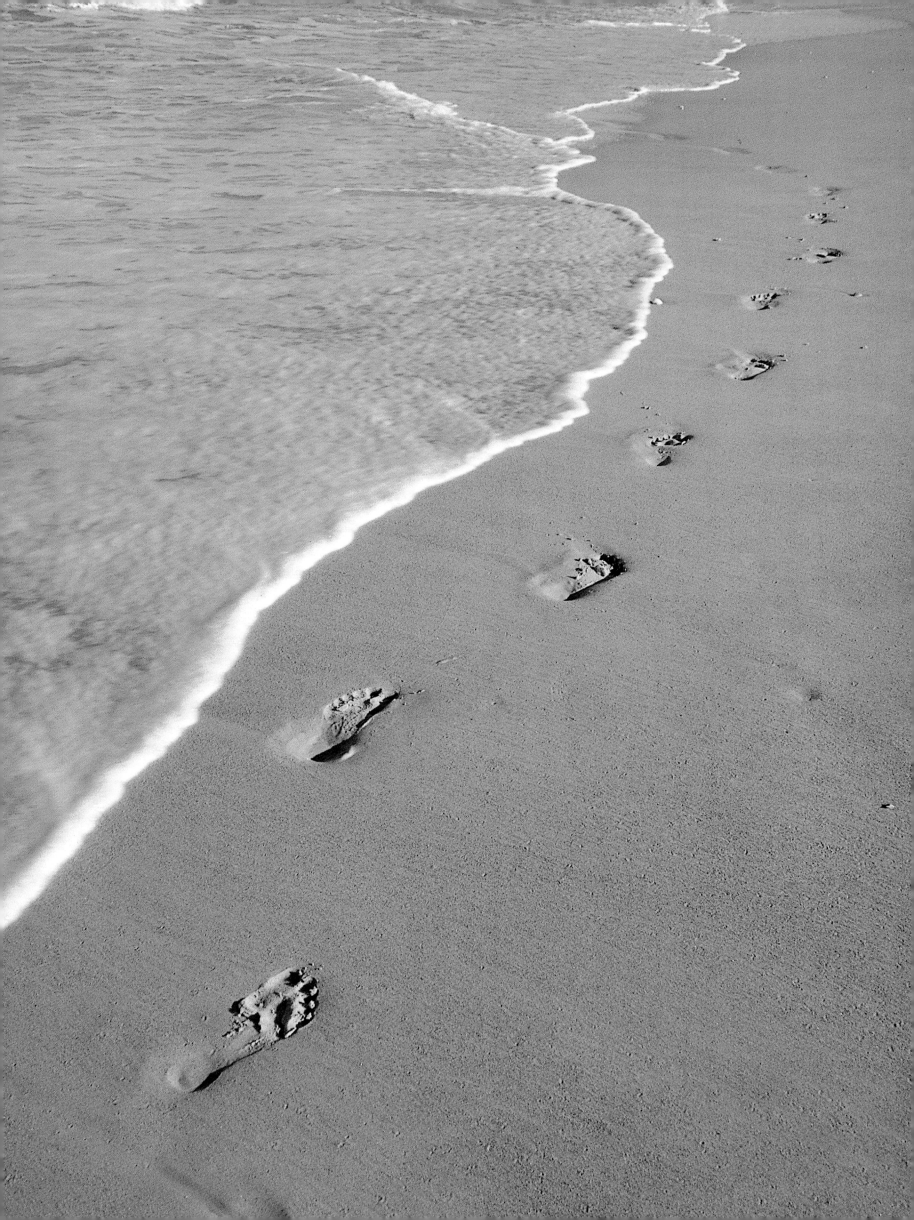

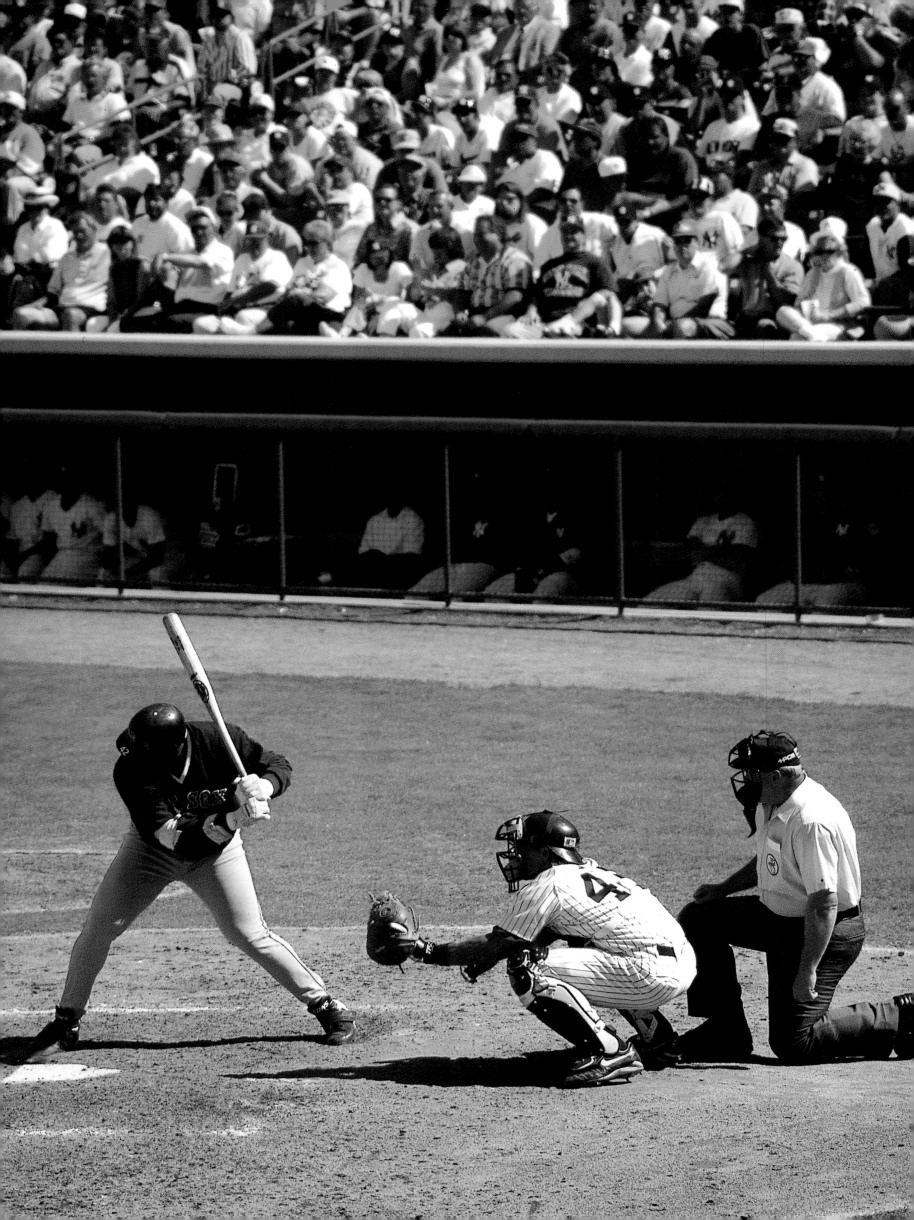

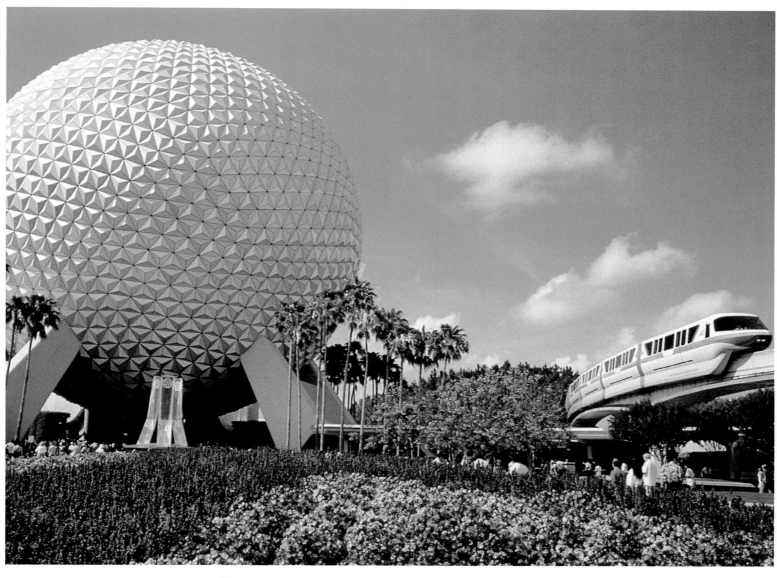

◄ Since World War I, Florida has been a favorite spring training site for major league baseball. Here, the New York Yankees, at home in Legends Field in Tampa, play the Boston Red Sox in the laid-back "Grapefruit League." ▲ Resembling a one-million-pound golf ball, the geosphere at Epcot in Walt Disney World is visible on a clear day from an airplane flying along either Florida coast.

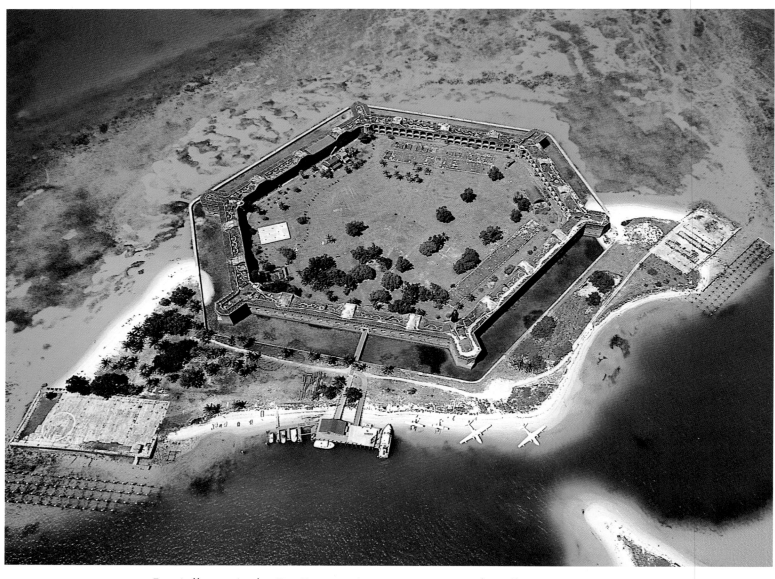

▲ Fort Jefferson in the Dry Tortugas is seventy watery miles off Key West. Begun in 1846 on Garden Key, it was the largest of America's coastal forts. Sixteen million bricks went into its construction, but it was obsolete before it was finished; no shots have ever been fired at an enemy from its cannons. Today, it is one of America's most fascinatingly contained and remote national parks.

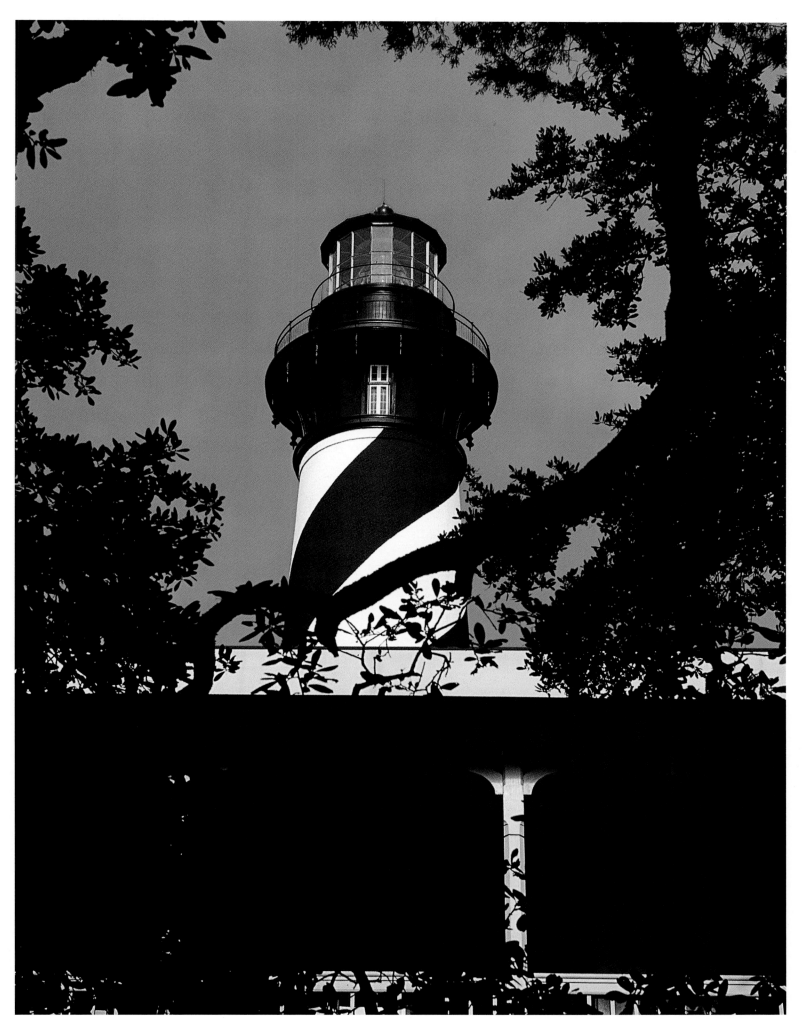

▲ The stately striped lighthouse on Anastasia Island at the entrance to St. Augustine's inlet in northeastern Florida is probably the most visually striking of Florida's lighthouses. It was built in 1871 after the sea took an earlier one built in 1824.

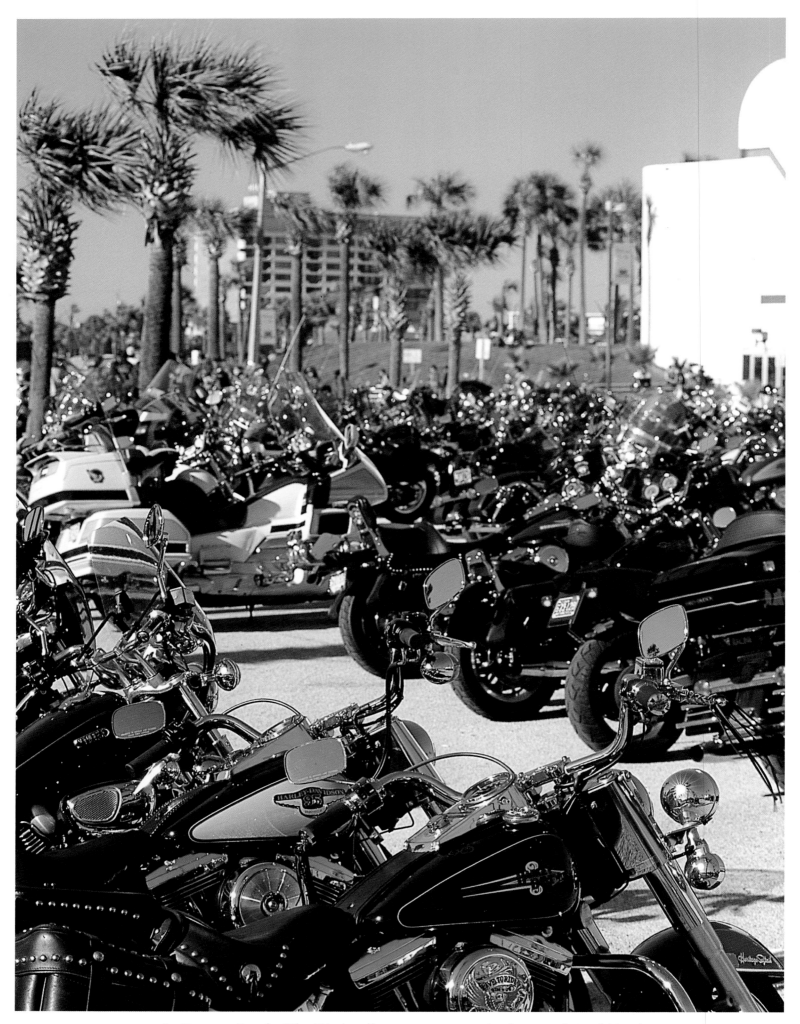

▲ In Daytona Beach, Bike Week rolls on to consume the first ten days of March. Daytona loves the glamour of engines. The Daytona International Speedway presents major race car, stock car, motorcycle, and go-cart races throughout the year.

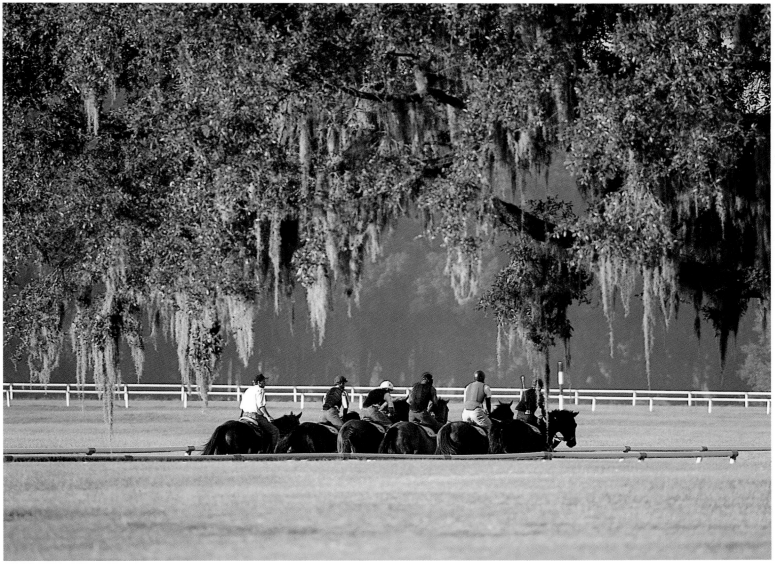

▲ Ocala is the heart of Florida's thoroughbred horse industry, with more than four hundred thoroughbred farms and specialized breeding centers. Many are open to the public. ▶ ▶ A venerable bald cypress stands on the Suwanee River, which arises in Georgia's Okefenoke Swamp and runs 265 miles to the Gulf of Mexico. The river is flowing quietly here, its banks densely forested with hickory, oak, and magnolia.

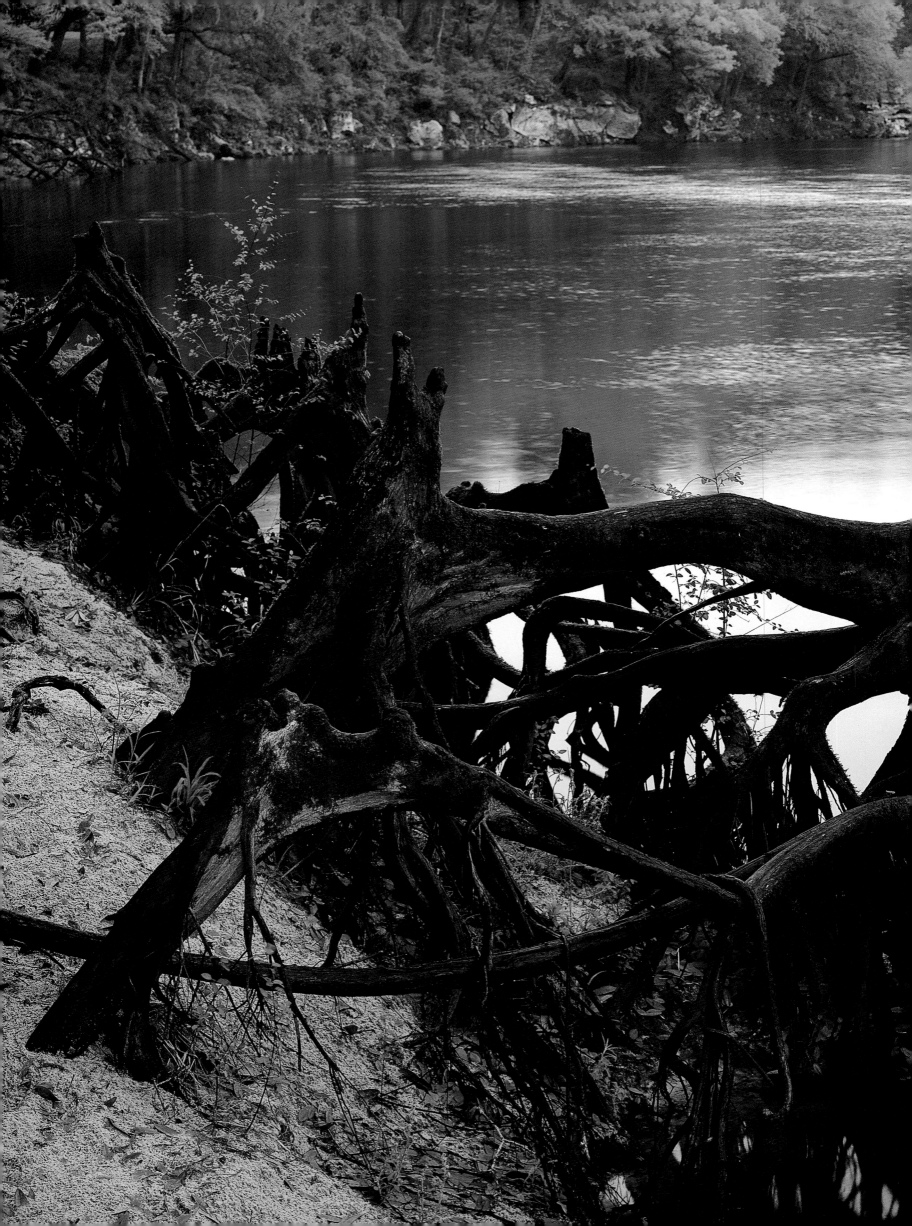

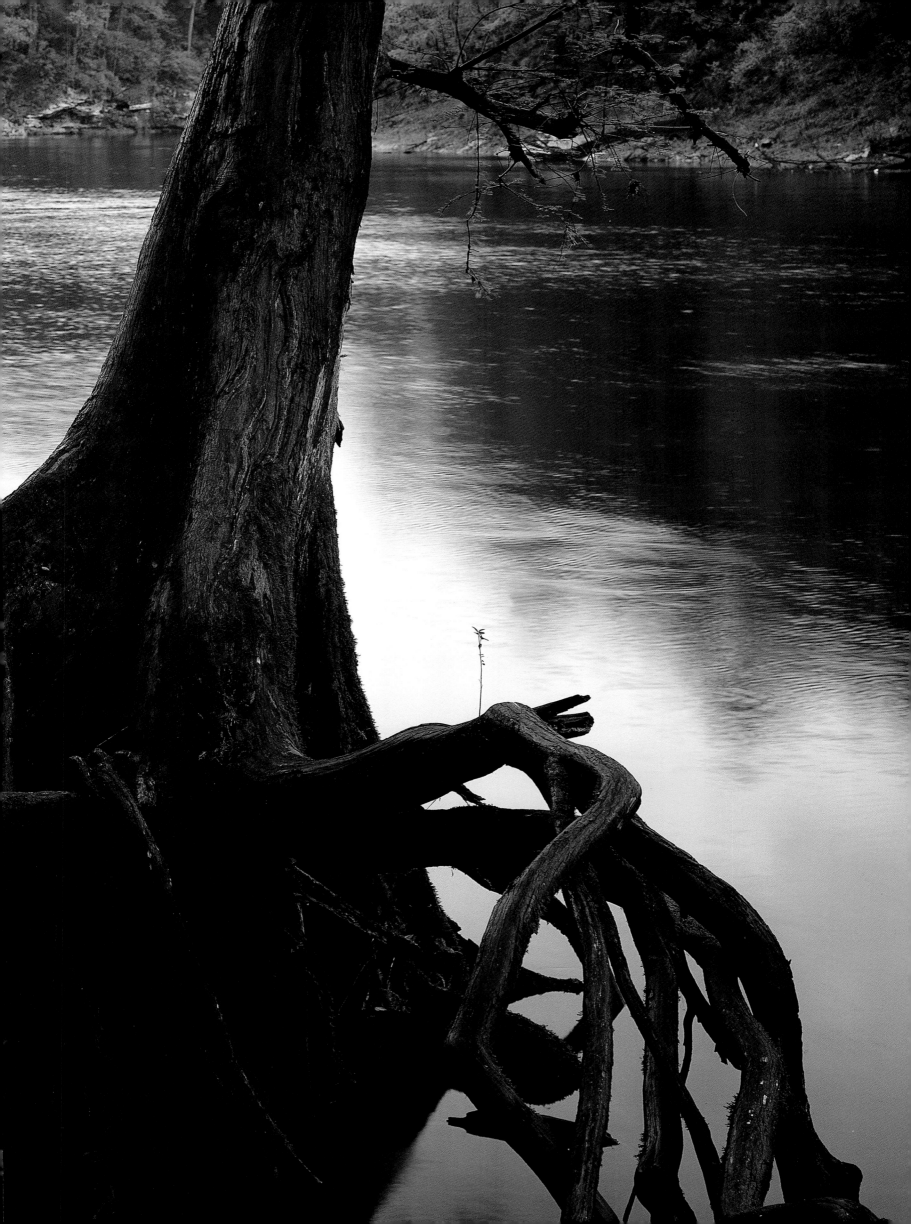

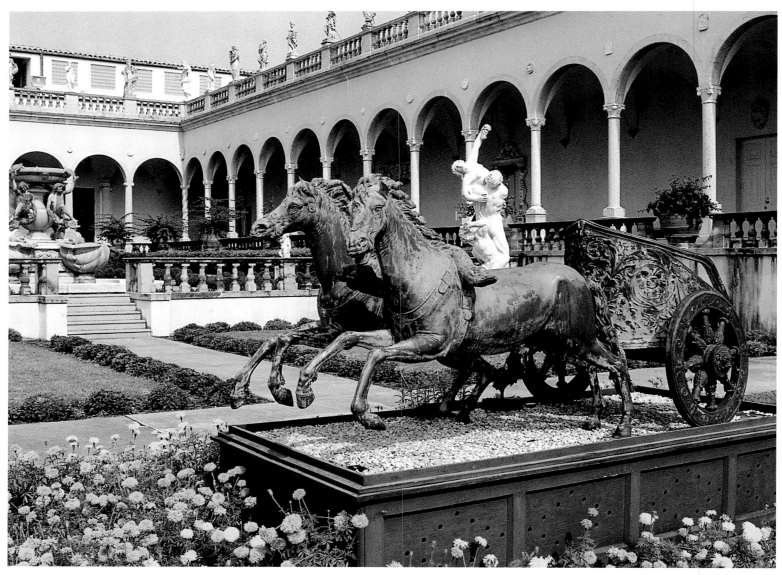

▲ In 1910 the great circus impresario, John Ringling, built this elaborate museum on Sarasota Bay to house his Italian baroque art collection. Oddly, the courtyards are full of copies, including Michaelangelo's *David* and this reproduction of a classical work. Nearby is Ringling's mansion, Ca d'Zan (prosaically translated as "John's house")—a thirty-room terra-cotta mansion in the style of a Venetian palace.

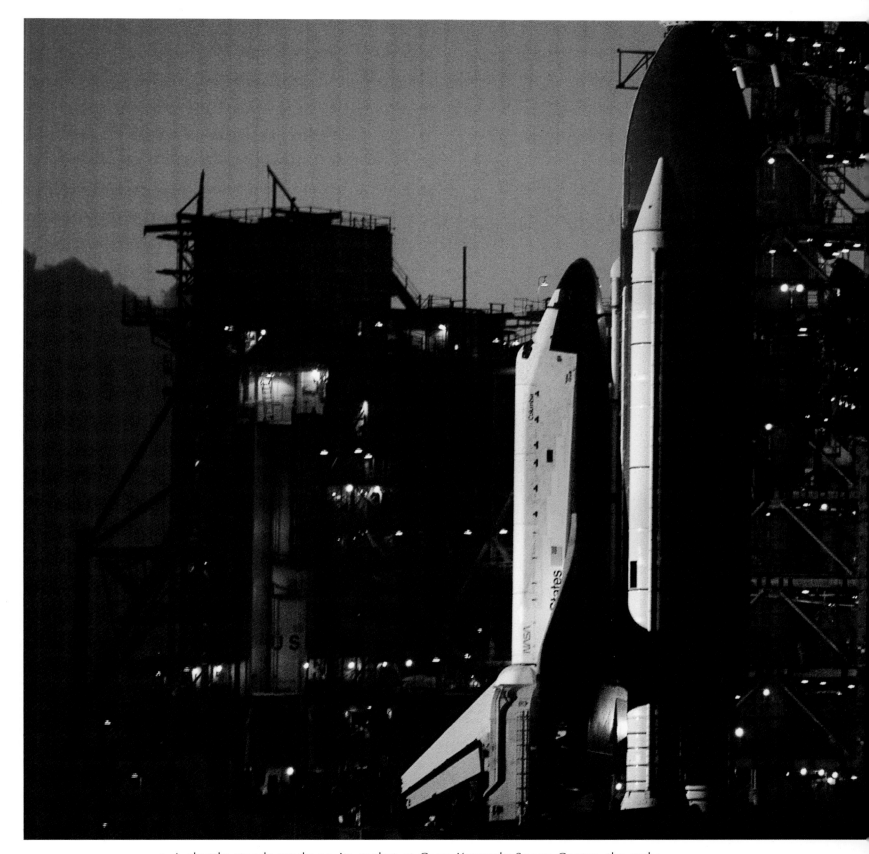

▲ A shuttle stands ready on its rocket at Cape Kennedy Space Center, the only place in the western hemisphere where humans are launched into space. The Center's most extraordinary moment was in July 1969 when Apollo 11 lifted off for the moon; its most tragic, in 1986 when Challenger exploded shortly after takeoff, killing all astronauts aboard.

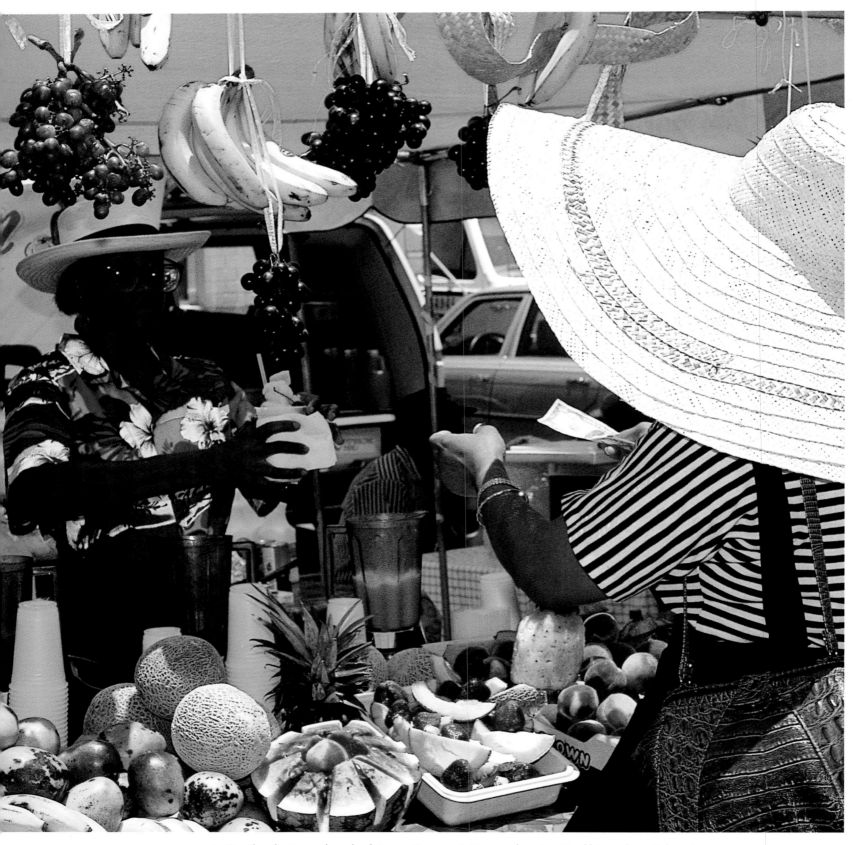

▲ On the first weekend of June, Coconut Grove devotes itself to a big Bahamian party. The Goombay Festival always includes good food and music. ▶ Connected to the mainland by a causeway, the Port of Miami is built on a three-hundred-acre landfill next to the shipping channel. A cacophonous port, it very much lacks serenity but is the departure point for many glamorous cruises into the Caribbean.

108

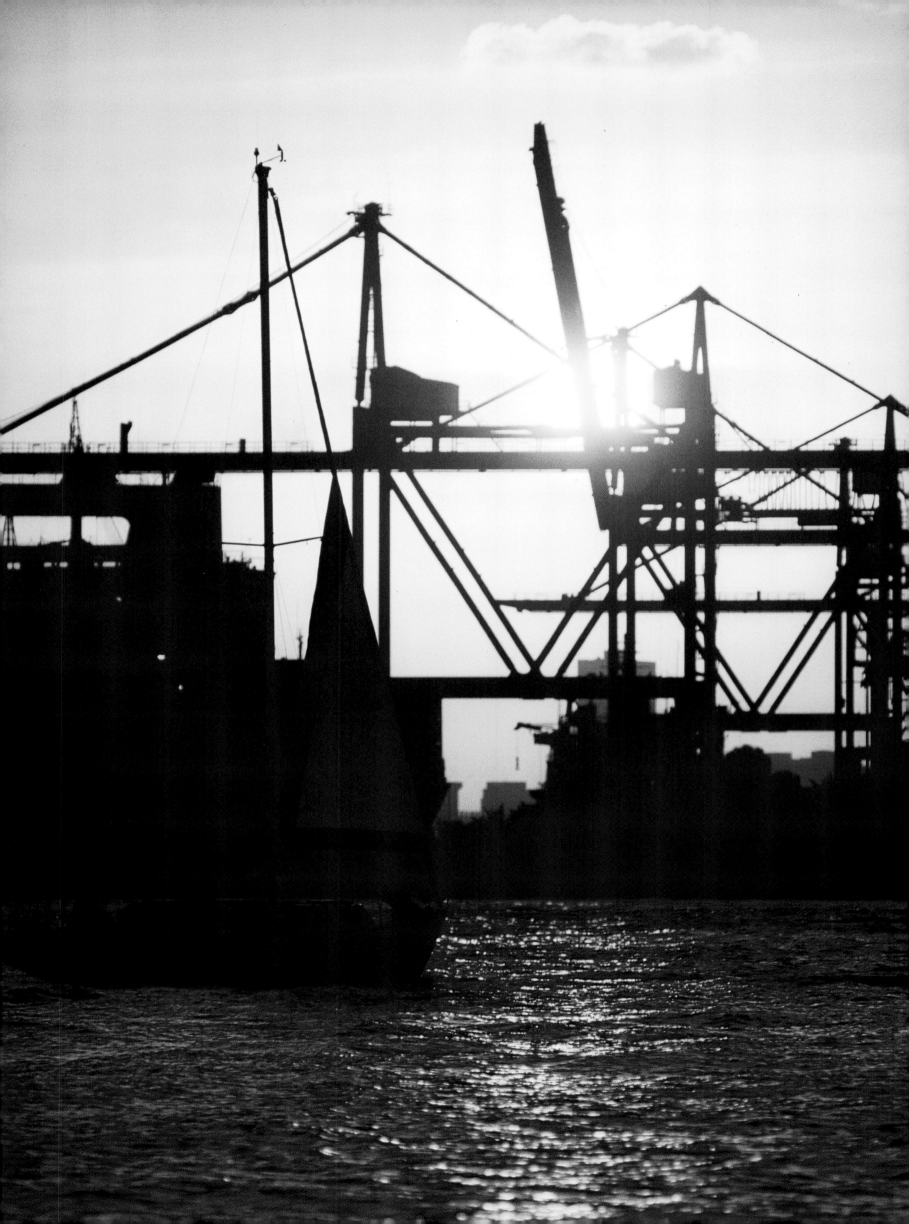

◄ The Florida Panhandle has more species *Sarracenia*—pitcher plants—than any area in the South. These are carnivorous plants whose leaves—which open into colorful hooded pitchers—trap not only insects but frogs, mice, and even small birds. ▲ The large, graceful fronds of the coconut palm can reach eighteen feet in length. One of nature's prettiest sounds is palm fronds rustling on the shore.

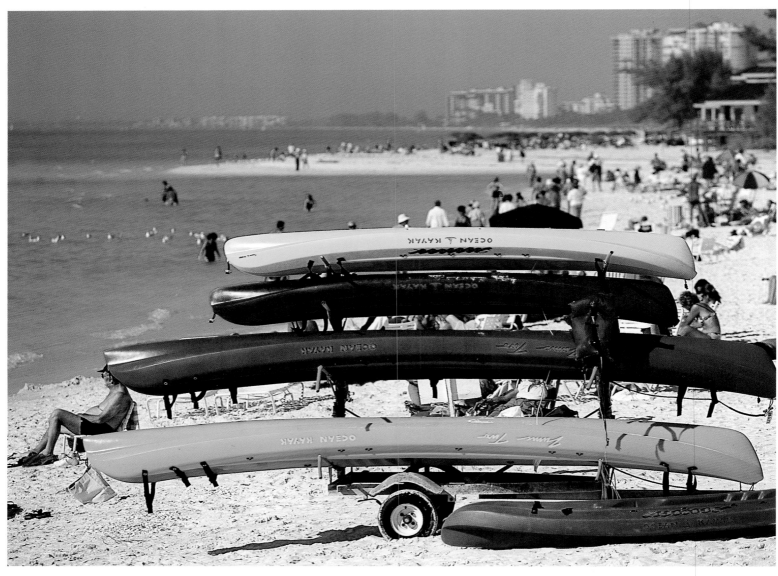

▲ Naples Beach is lined with condos and hotels. These sea kayaks are waiting for someone to take them away from it all. Sea kayaking is one of the most enjoyable and popular ways to see the natural wonders of sea life and hidden coves.

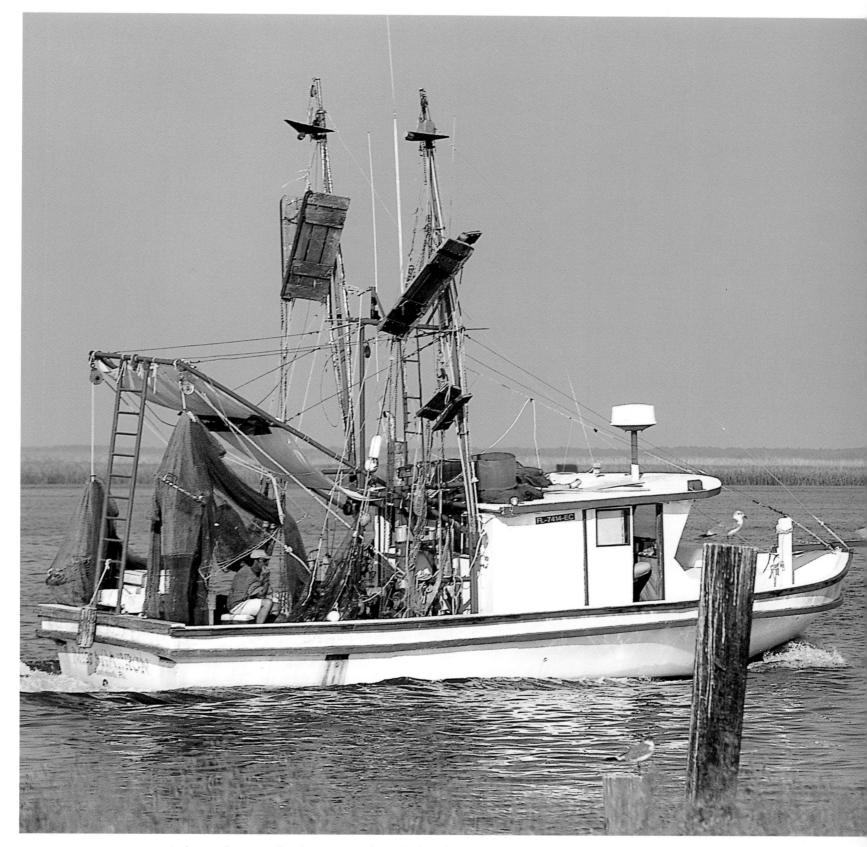

▲ A shrimp boat works the waters of Apalachicola Bay in northwest Florida, one of the most productive estuarine systems in the world. The bay, though known for its shrimps and crabs, is particularly famous for its oysters.

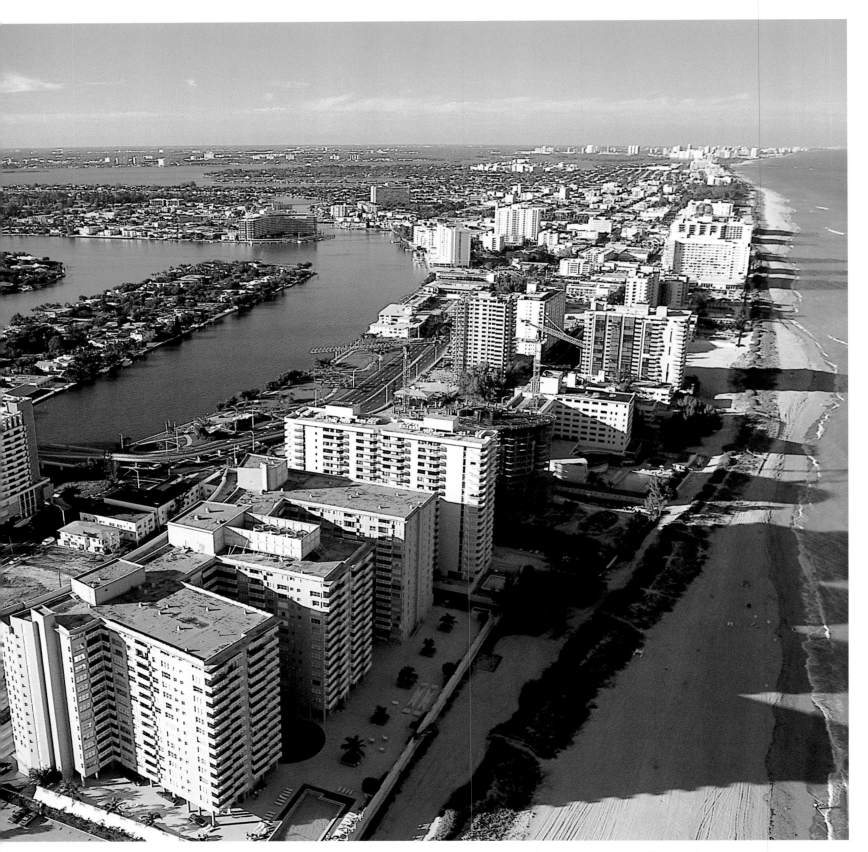

▲ In 1875, Miami existed only as a Seminole trading post, Fort Dallas. Today, greater Miami covers 2,040 square miles and has two million residents. ▶ During the Civil War, Tallahassee was the only uncaptured Confederate city east of the Mississippi. The old Capitol building, constructed in 1902, has been carefully restored. The new twenty-two-story Capitol office tower looms behind it.

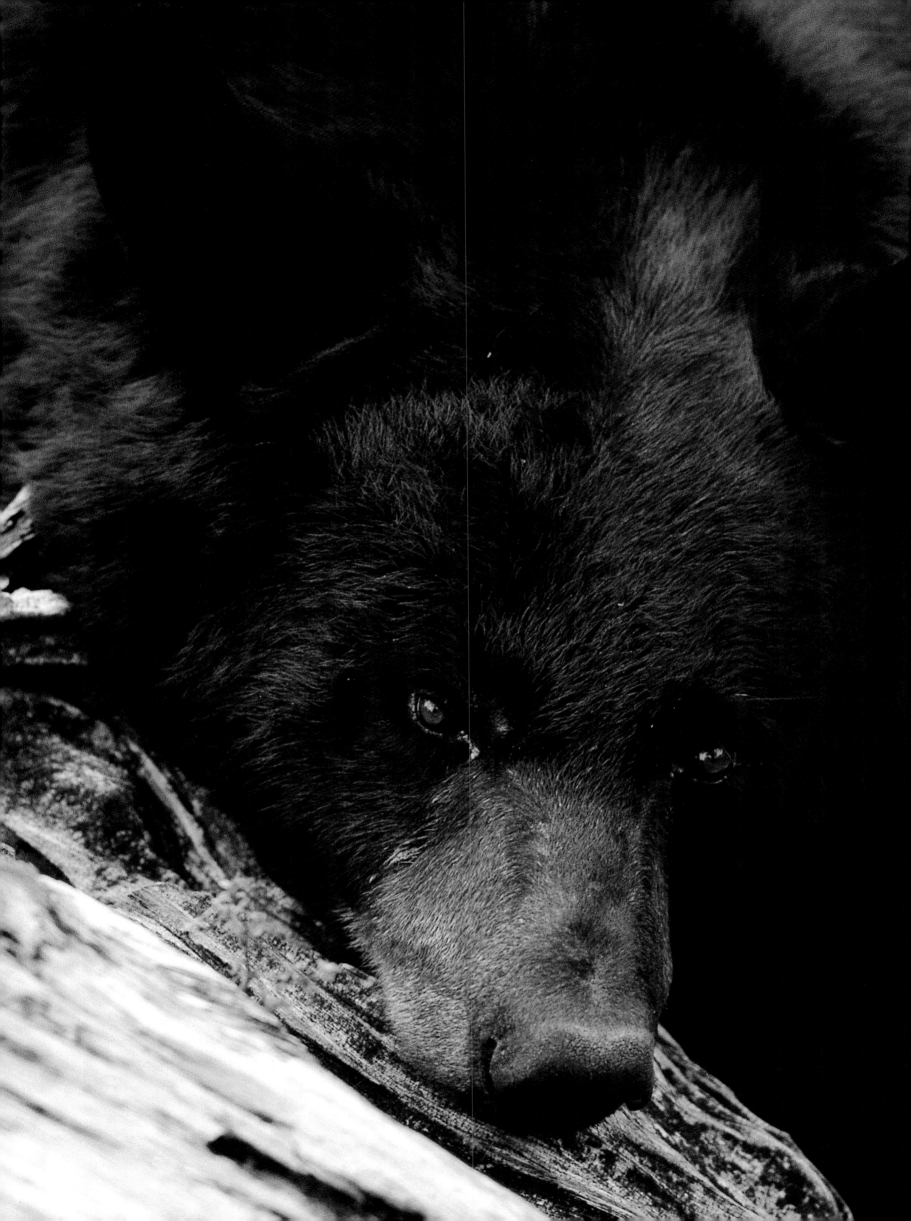

◄ A Florida black bear is safe but not wild in Tampa's Lowry Park Zoo. With only fifteen hundred remaining, bear hunting was prohibited in 1995. ▲ The most abundant air plant, or epiphyte, in Southern Florida is the bromeliad. Here, the stiff-leaved wild-pine flourishes with the resurrection fern, which in the dry season appears brown and dead but uncurls and turns bright green after rain.

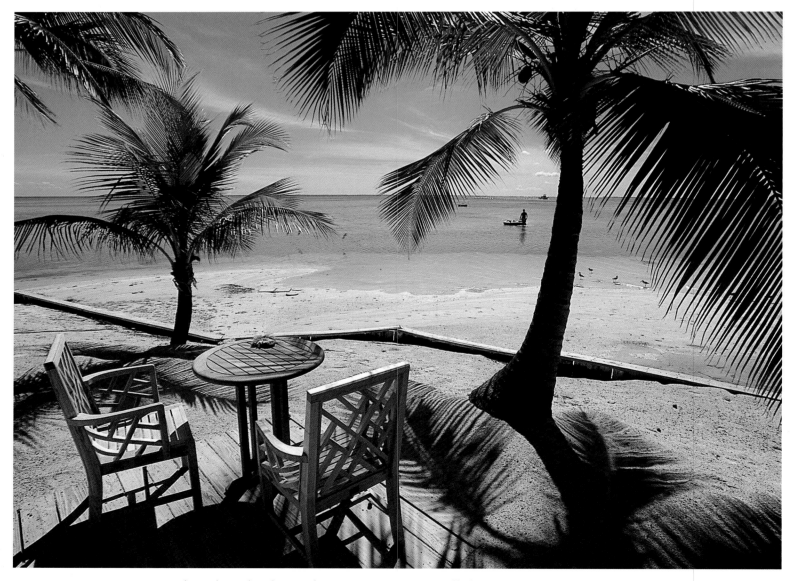

▲ Little Palm Island is a five-acre resort just off the Torch Keys in the Lower Florida Keys. Thatch-topped bungalows and a gourmet restaurant are only a few of the delights awaiting the vacationer.

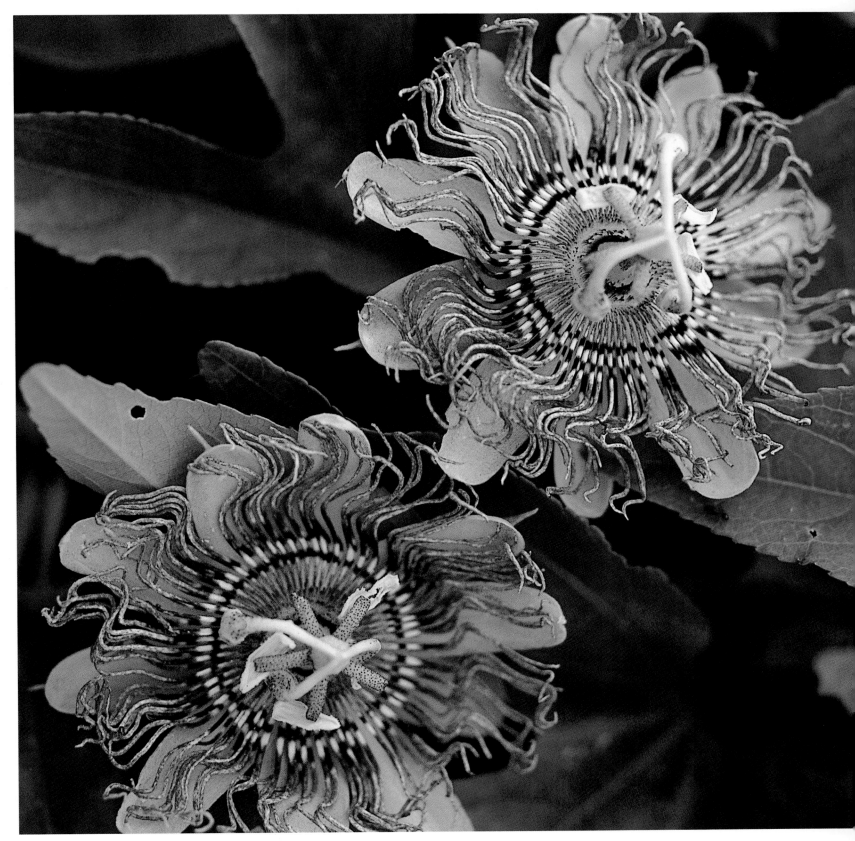

▲ The intriguing bloom of the spectacular passion flower was seen by religious members of the early Spanish explorers of the New World as a symbol of the suffering Christ. ▶ ▶ A sunset sky silhouettes pine trees in Everglades National Park.

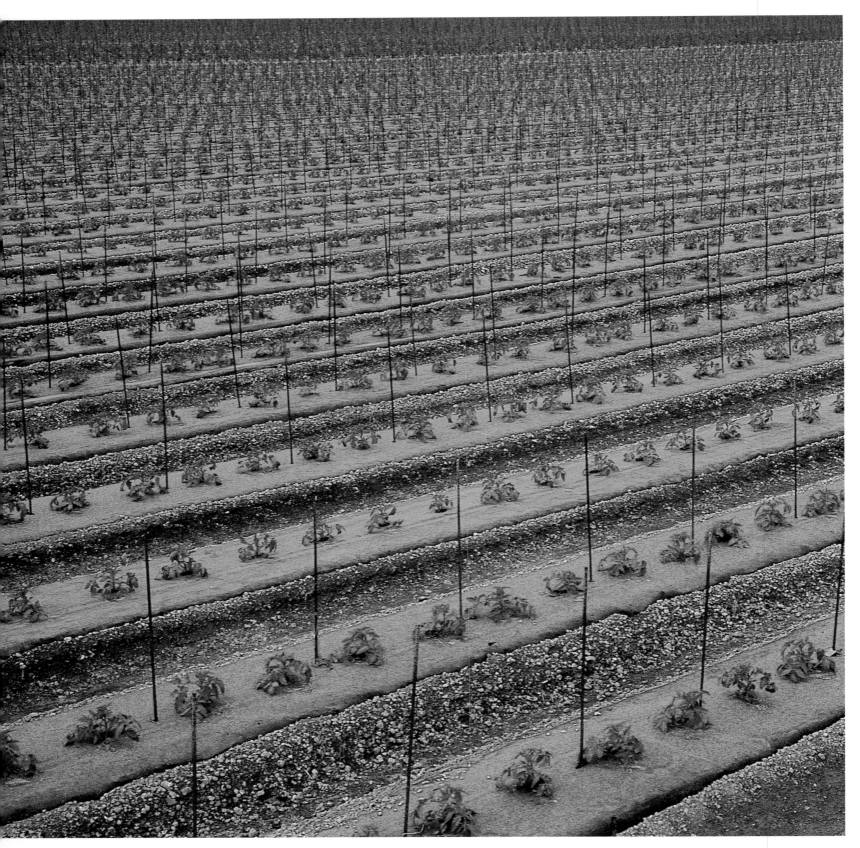

▲ Regimentalized fields nurture a wide variety of winter vegetables—including pole beans, tomatoes, strawberries, squash, and others. Such crops cover much of the historic Everglades that are not protected by the Park.

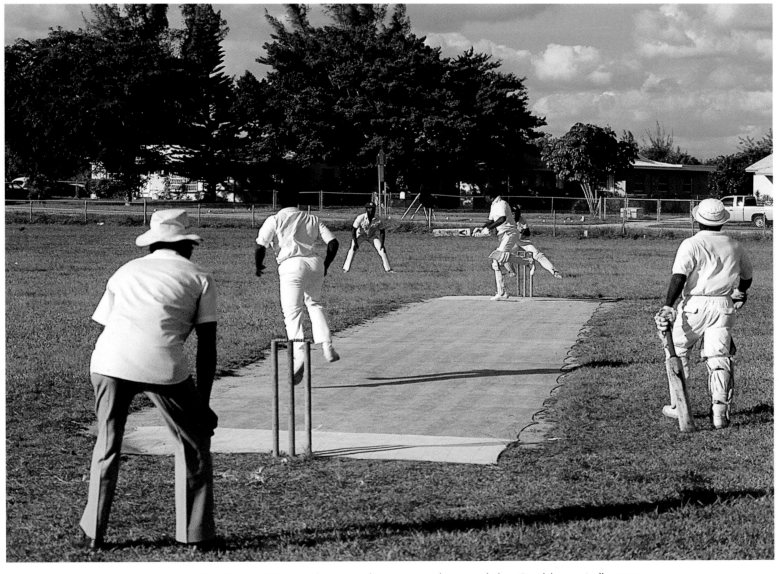

▲ Recreational activities such as cricket are evidence of the Caribbean influence on the lifestyle of Miami. Local teams, of eleven players each, play regularly, and a formal game of cricket can last anywhere from an afternoon to several days.

▲ The graceful sea oat contributes a great stabilizing influence to the dune.
Trapping large amounts of sand within their grassy hummocks, they are both a
desirable and a protected plant in Florida.

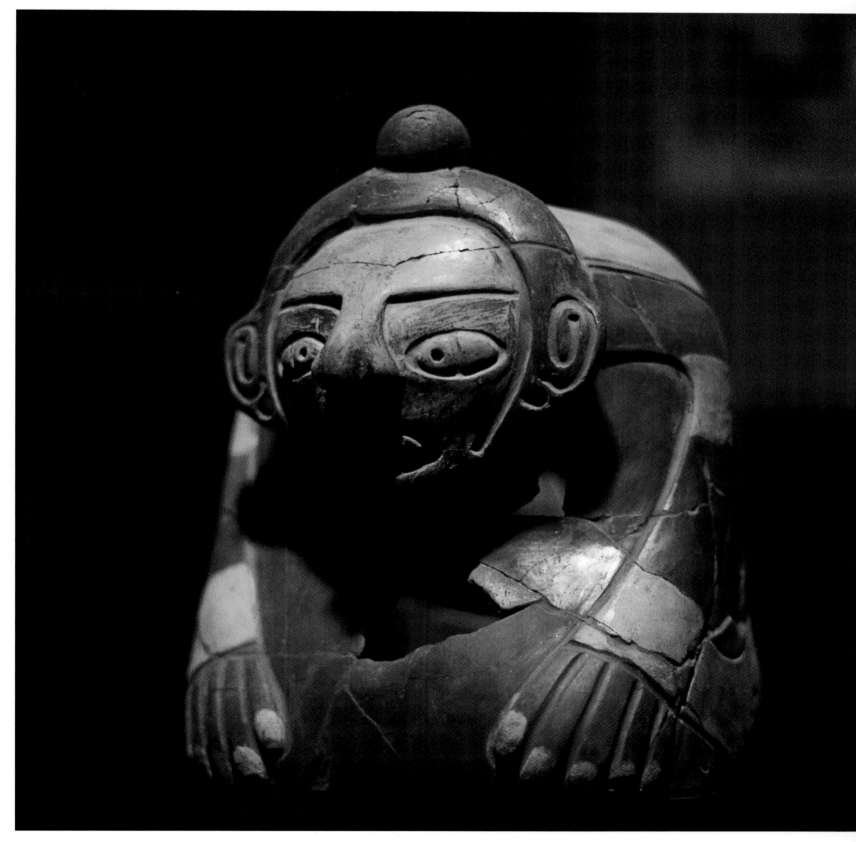

▲ Along Fort Walton Beach's busy main strip is the Indian Temple Mound Museum, where this mysterious human effigy urn resides. Probably dating from sometime in the first century, the urn was discovered in a mound, long since removed, near the city's present-day Chamber of Commerce.

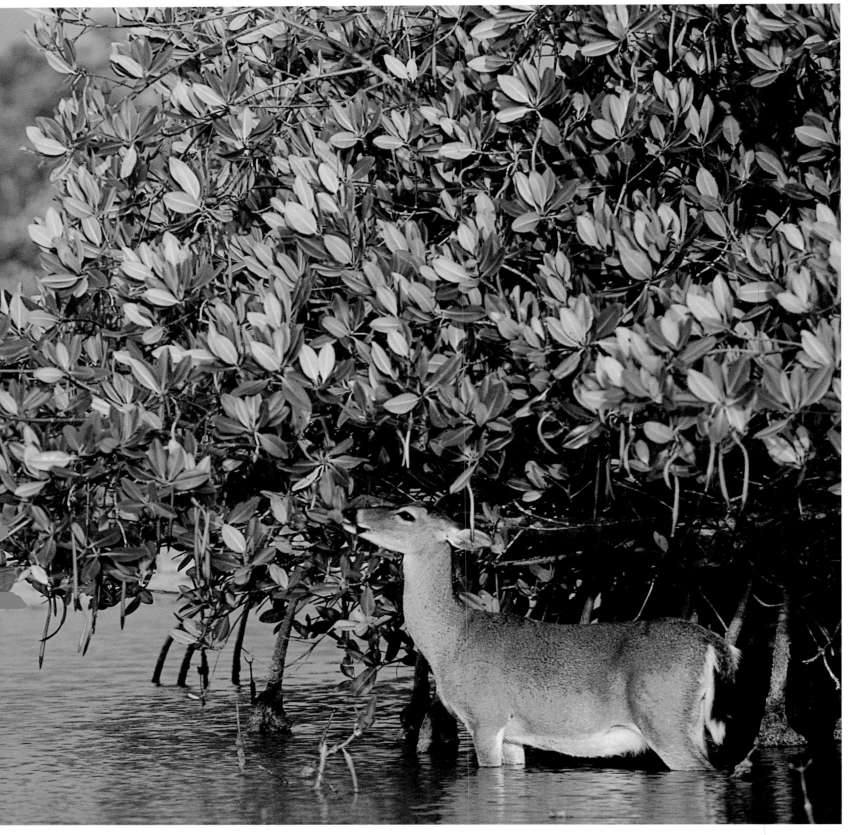

▲ The Key deer, which stands two and one-half feet high and weighs seventy-five pounds, is protected in the Key Deer National Wildlife Refuge. The fruit of the red mangrove makes up a great deal of the little deer's diet. ▶ A new palmetto frond is about to open in an Everglades hammock. A hammock is a typical south Florida landscape—its oaks, gumbo-limbo, and mahogany all shot through with palmetto.

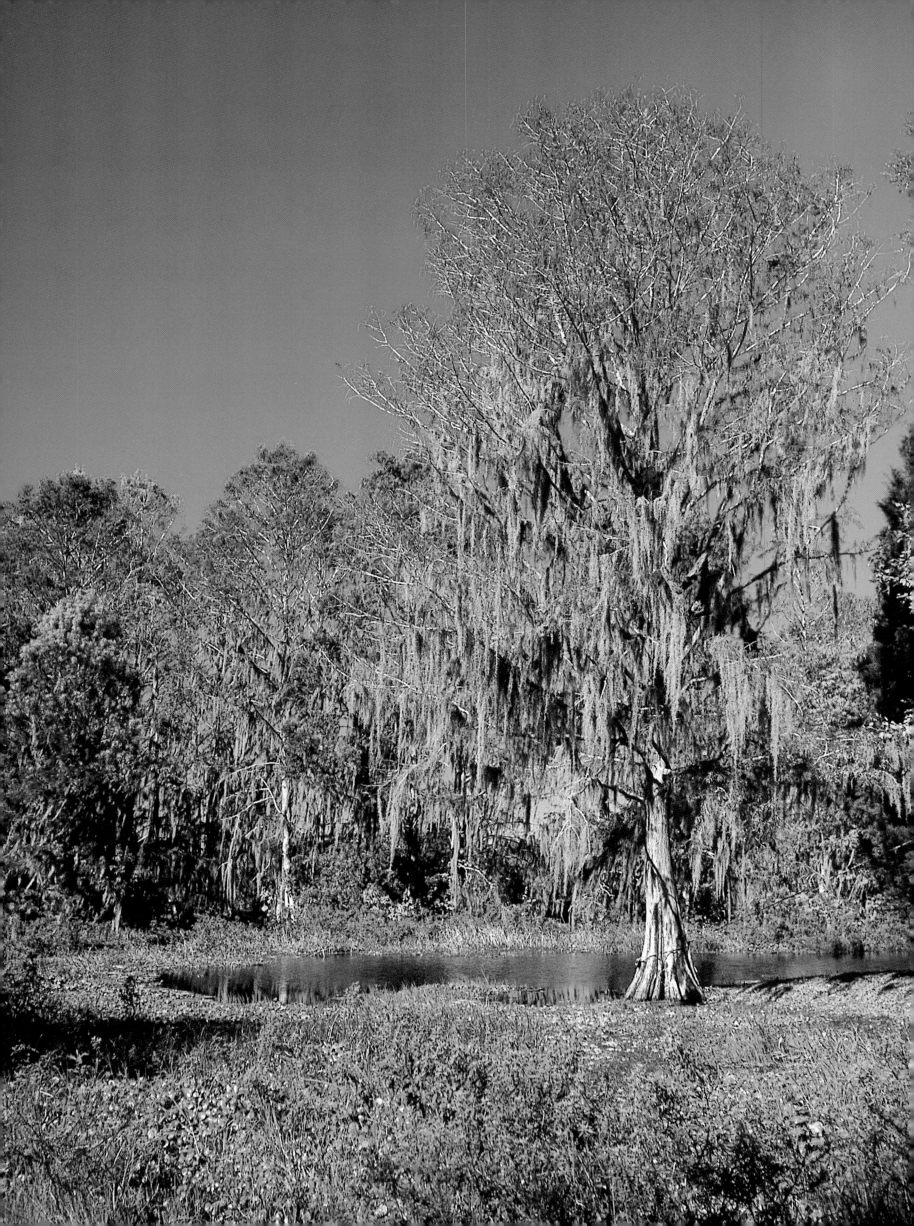

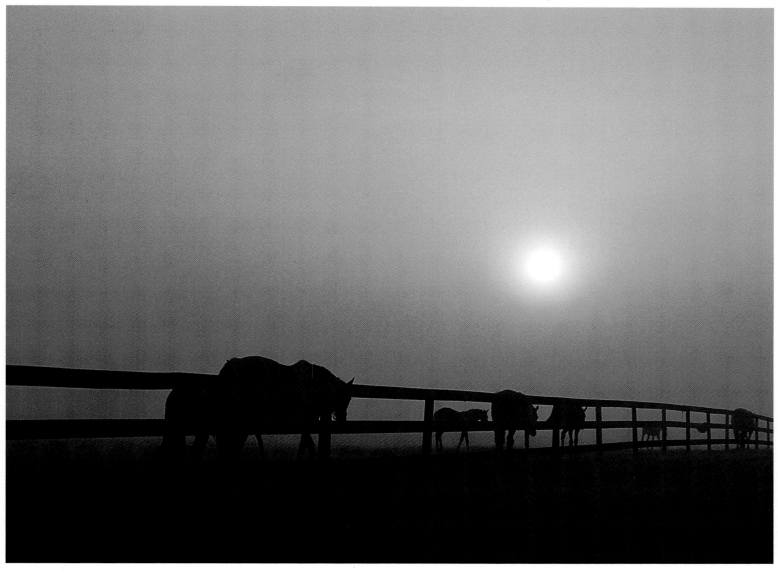

◄ Pond cypresses fared better than the larger bald cypresses of the Everglades, which were completely logged out by the 1940s. Pond cypresses play host to many epiphytes like Spanish moss, which, contrary to popular belief, is not a parasite; it is an atypical bromeliad. ▲ A two-lane road shaded by live oaks, Route 474 tranquilly passes some of the many horse farms in the area around Ocala.

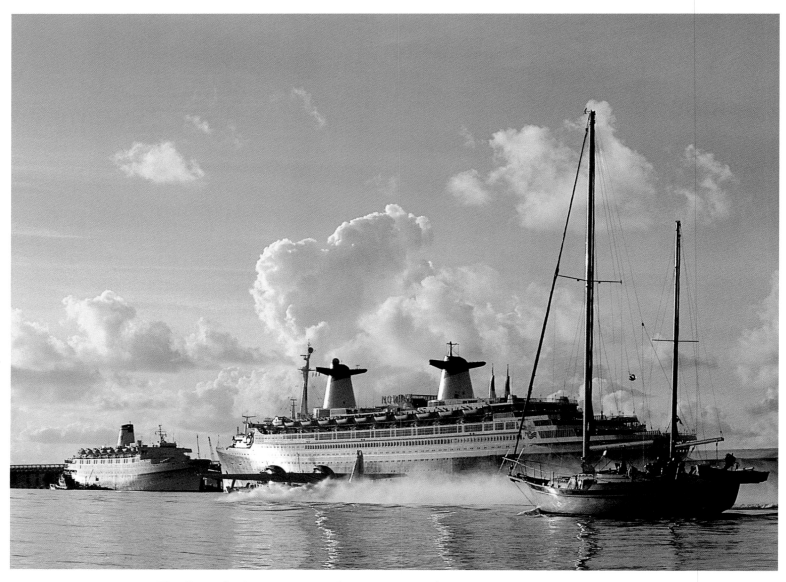

▲ The Port of Miami, a major departure point for cruises, sees a variety of types of traffic—from luxury cruise liners to schooners to amphibious planes. ▶ The splendid nurturing red mangrove is a haven for fishes and birds. Florida mangroves are among the most luxuriant in the world.

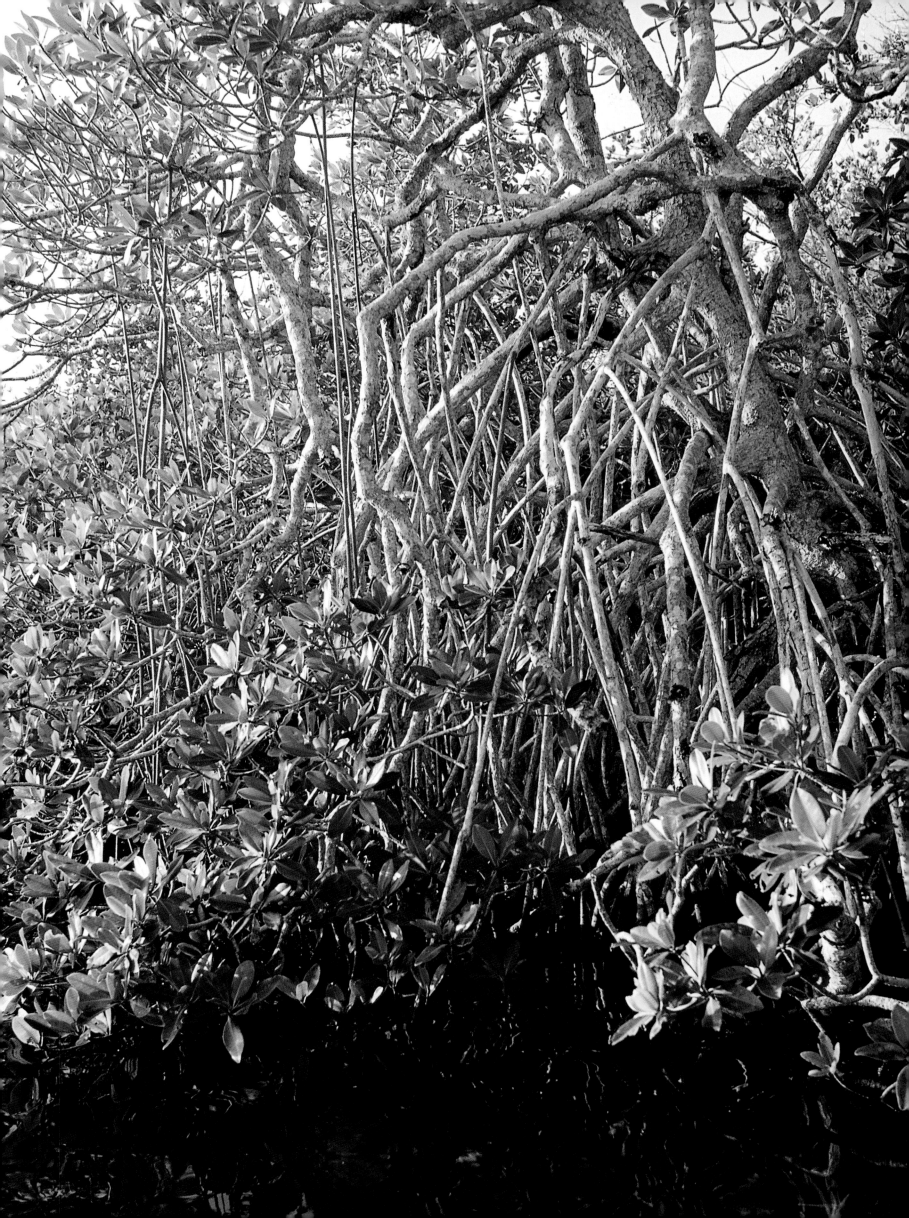

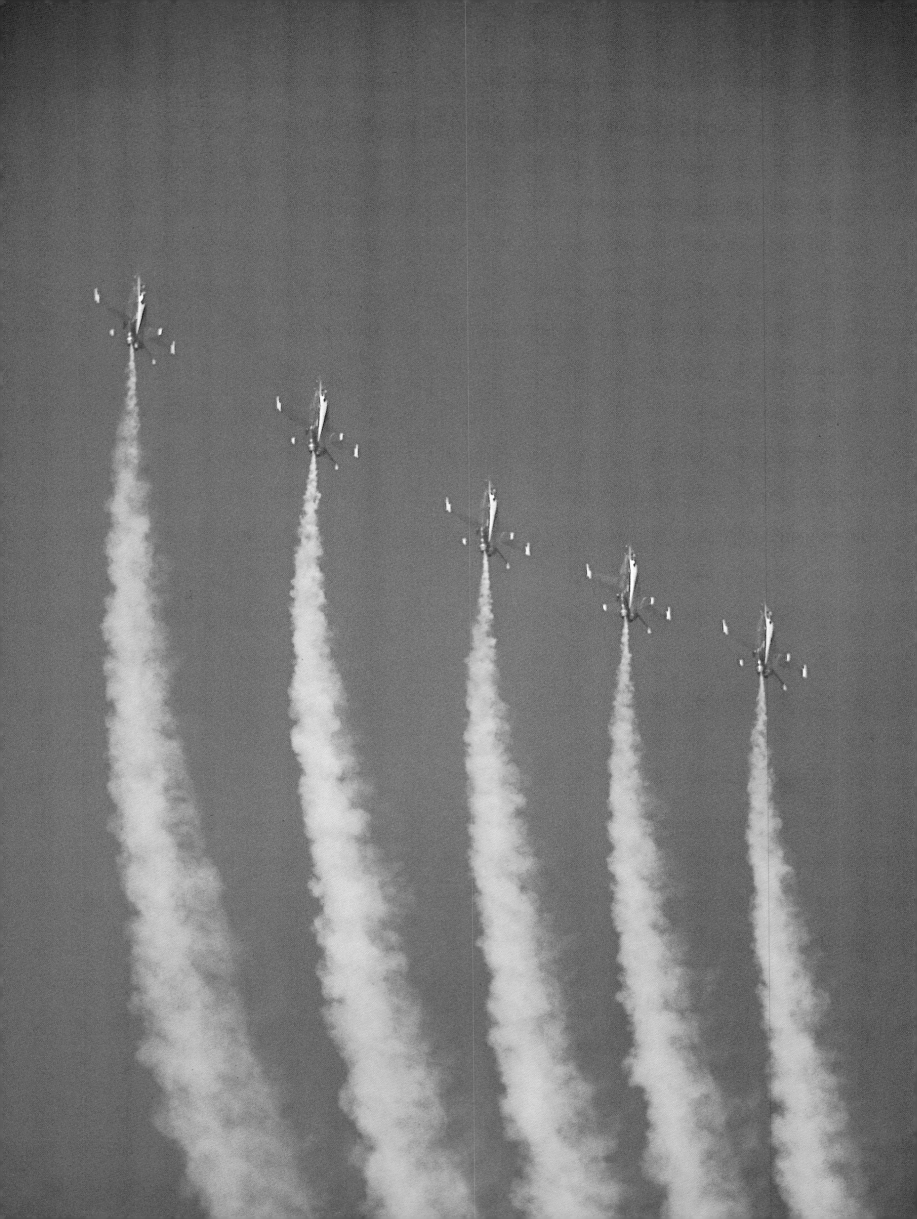

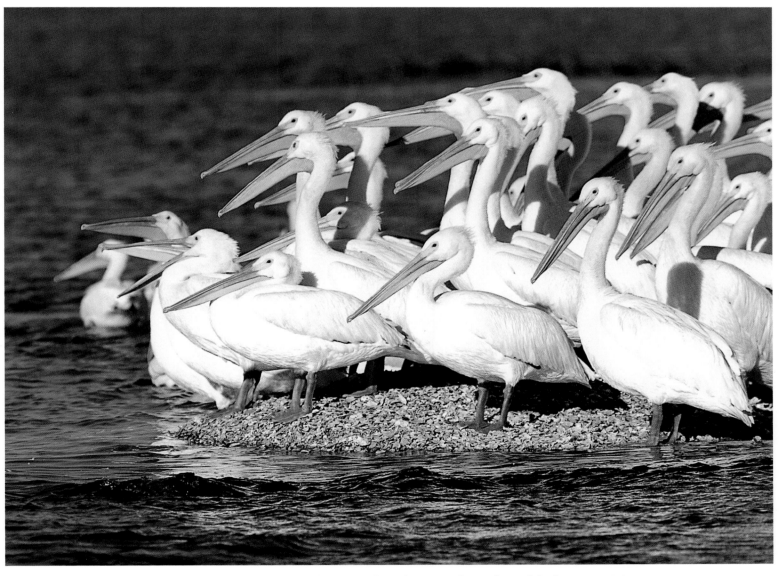

◄ An Air Force recruitment dynamo, the Blue Angels perform fabulous precision flying in air shows. ▲ The brown pelican is a year-round resident of Florida, but the white only winters here. White pelicans do not dive for their food like brown pelicans. Instead they form a semicircle of ten to fifteen birds and herd fish toward the shore. Then, while still on the surface, they use their pouches like fishnets.

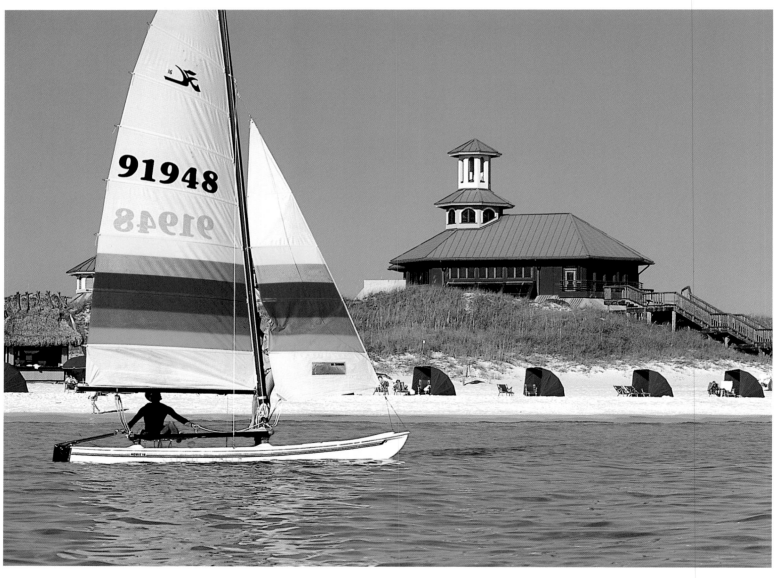

▲ Between Pensacola and Panama City in the Panhandle are numerous wide, white beaches. The season here is summer, atypical for Florida. Winter brings colder water and quieter days. The area is rapidly being developed, and all manner of boat trips and rentals are available at the various marinas.

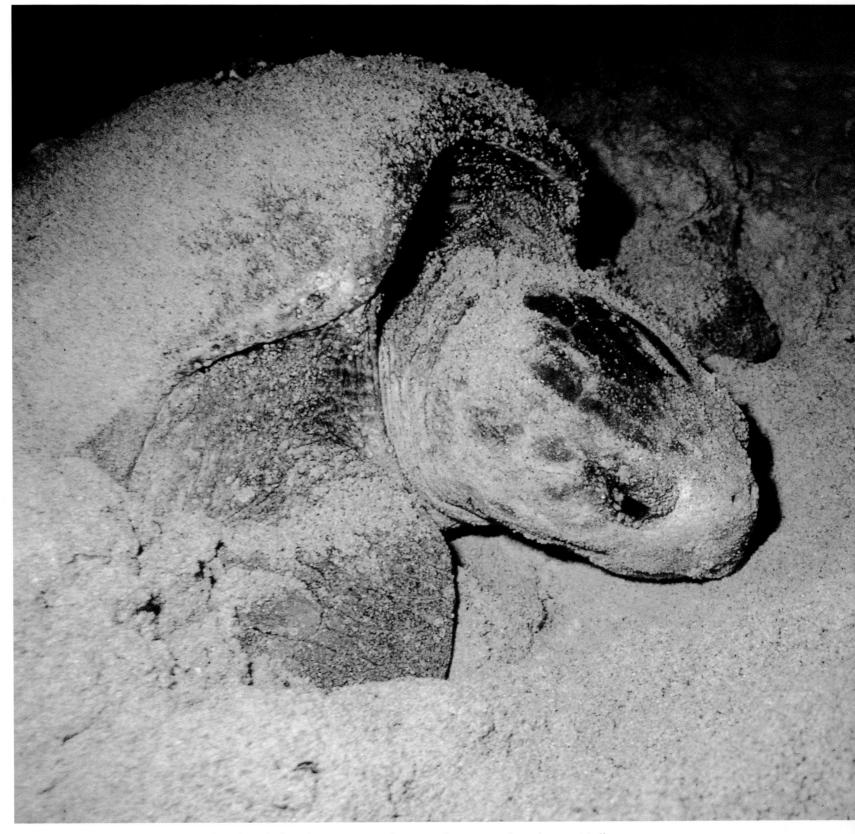

▲ A loggerhead turtle lays her eggs in a deep sand nest on a beach near Melbourne. She always nests on the same beach, and her female hatchlings return to the beach where they were born when it is their time to lay eggs. Males never return to land.
▶ ▶ Rising from broad marshlands twenty-five miles north of Lake Okeechobee, the St. Johns River flows three hundred miles northward to Jacksonville.

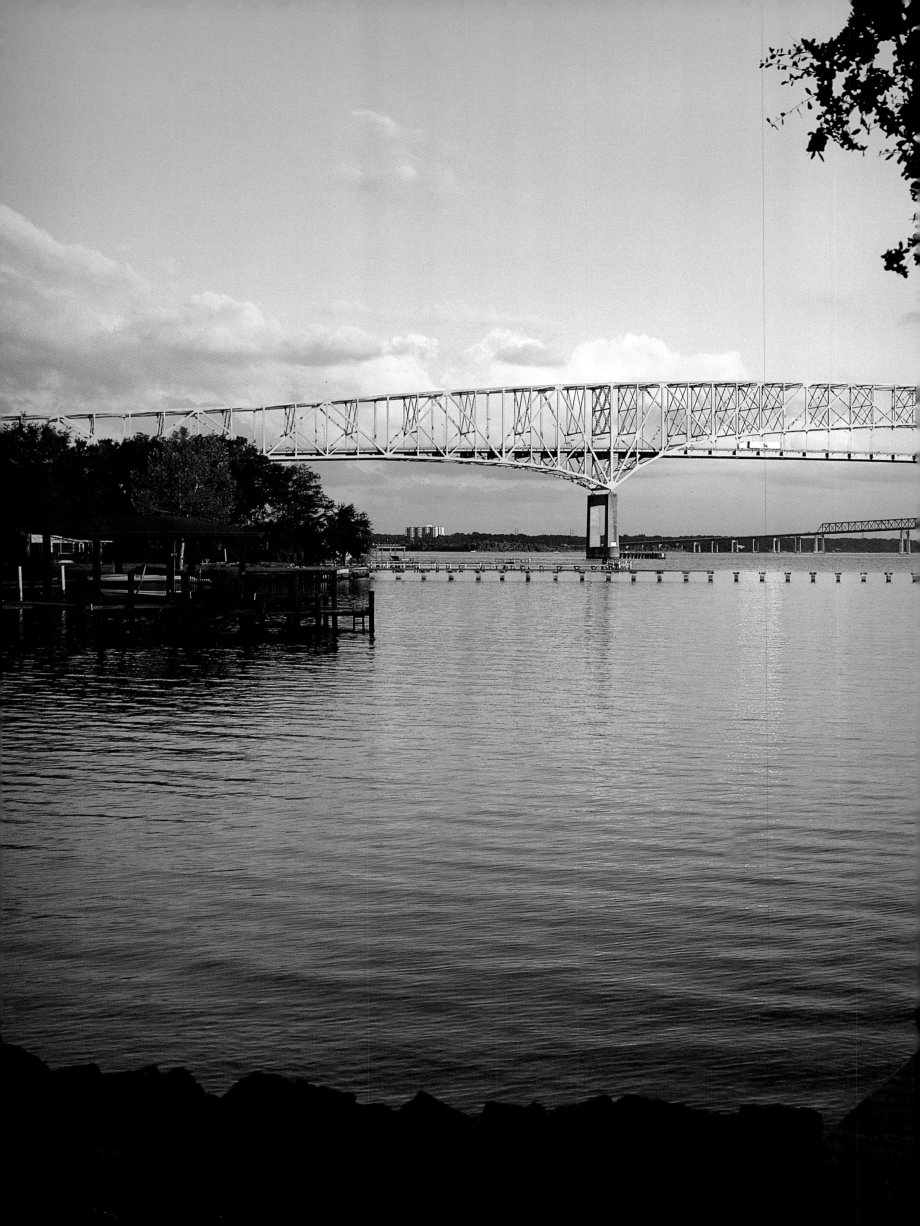

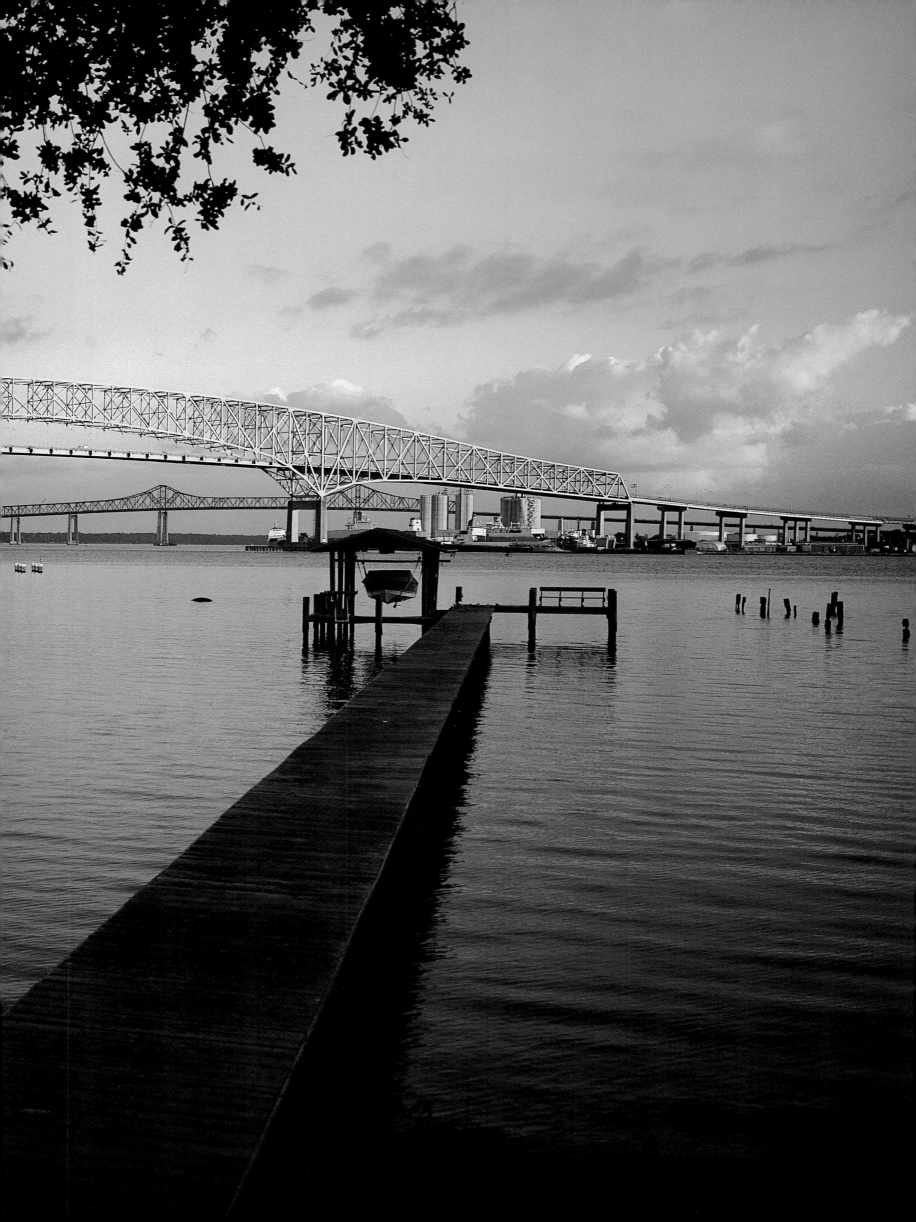

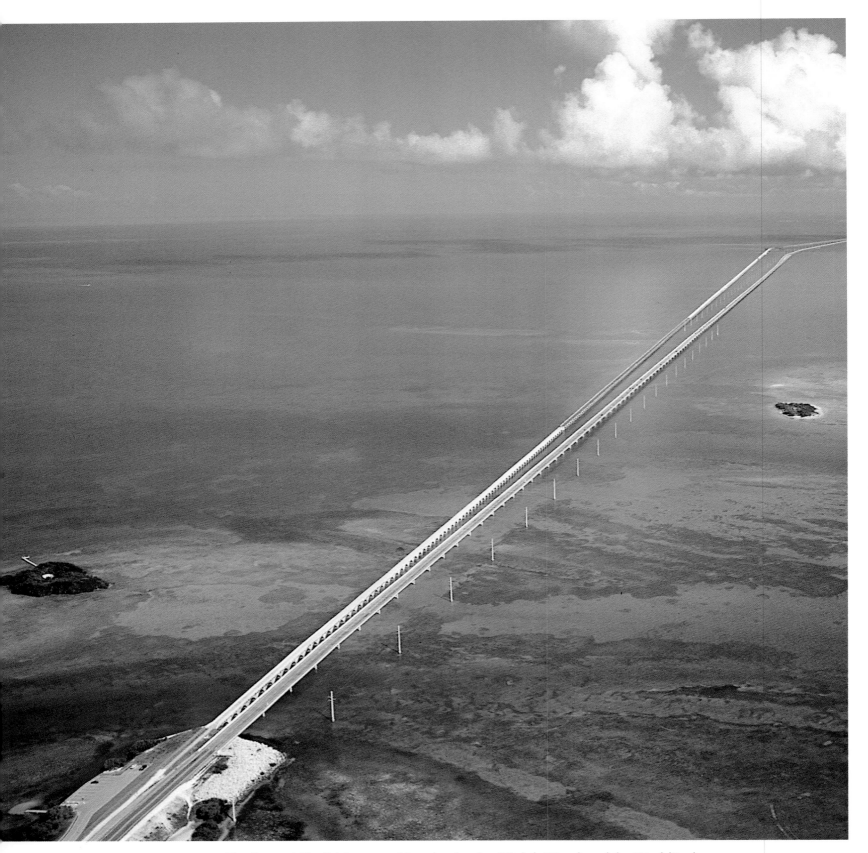

▲ The Seven Mile Bridge, considered to be the "Eighth Wonder of the World" when Henry Flagler completed it in 1911, links Marathon to the Lower Keys. After the hurricane of 1935 destroyed the viability of the railroad, the bridge served automobile traffic. In 1982 a new bridge was constructed alongside. Driving the bridge, enveloped not so much by your car but by sea and sky, is a wonderful experience.

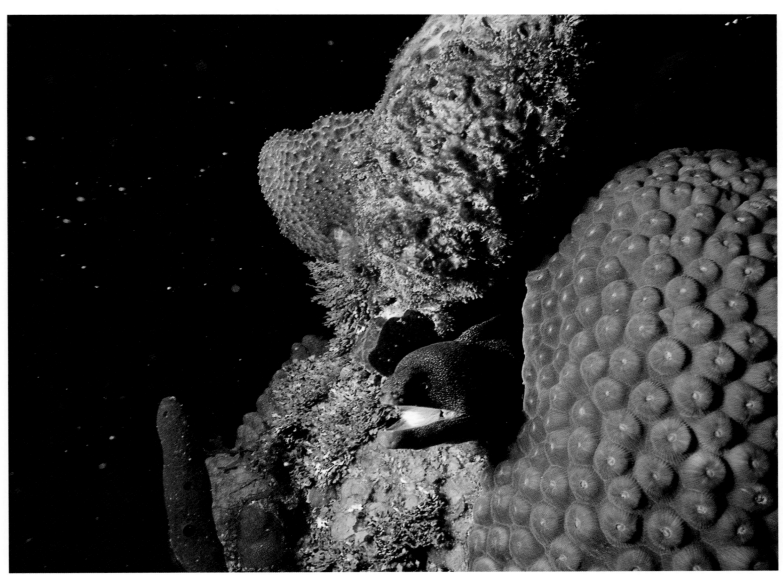

▲ Morays are the eels the snorkeler is most likely to see. These colorful, toothy reef dwellers seem to spend most of their daylight hours peering out from their caves in the coral, jaws agape and countenance most peculiar.

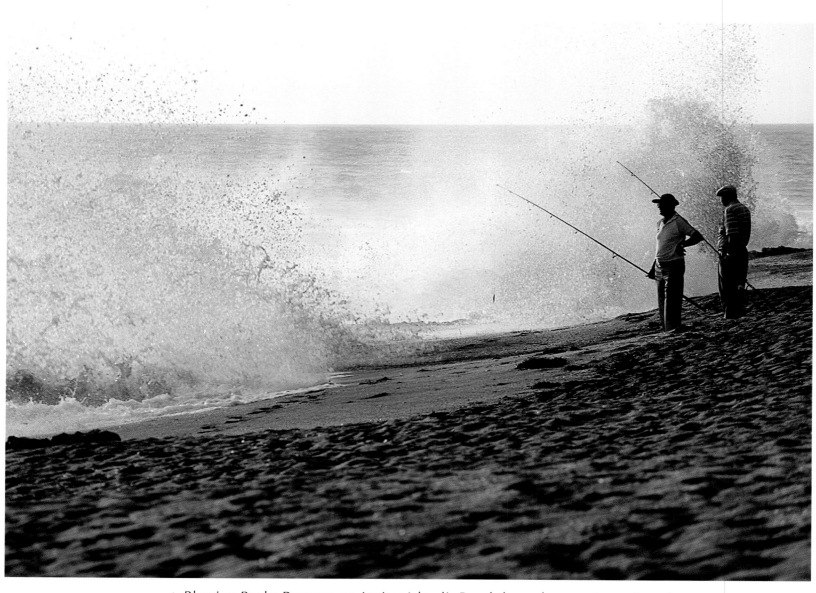

▲ Blowing Rocks Preserve on Jupiter Island's Beach has a large outcropping of Anastasia limestone, a rugged grey stone wall against which waves crash, carving out caves, tide pools, and blowholes. ▶ The snowy plumage of the whooping crane is a rare sight in Florida; most cranes winter on the Gulf Coast off of Texas.

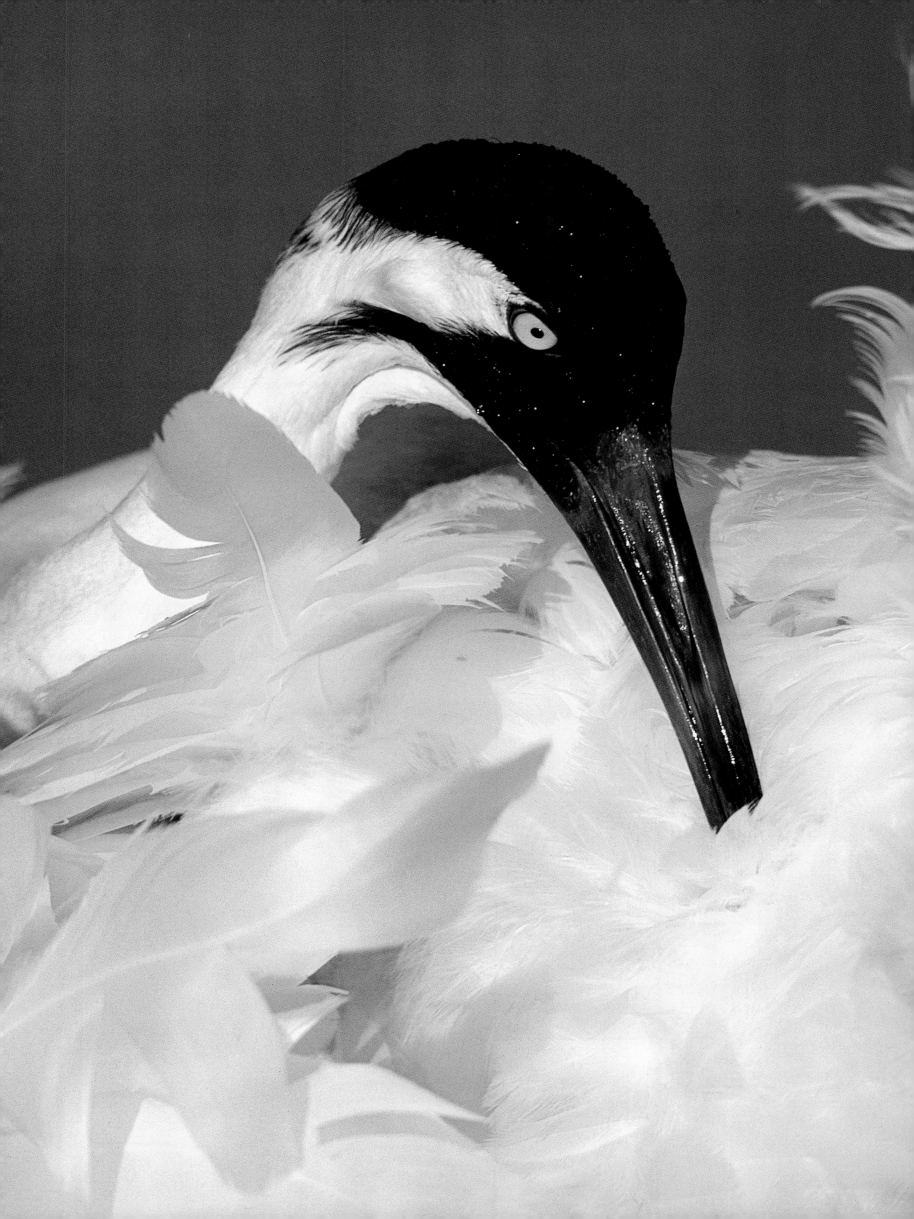

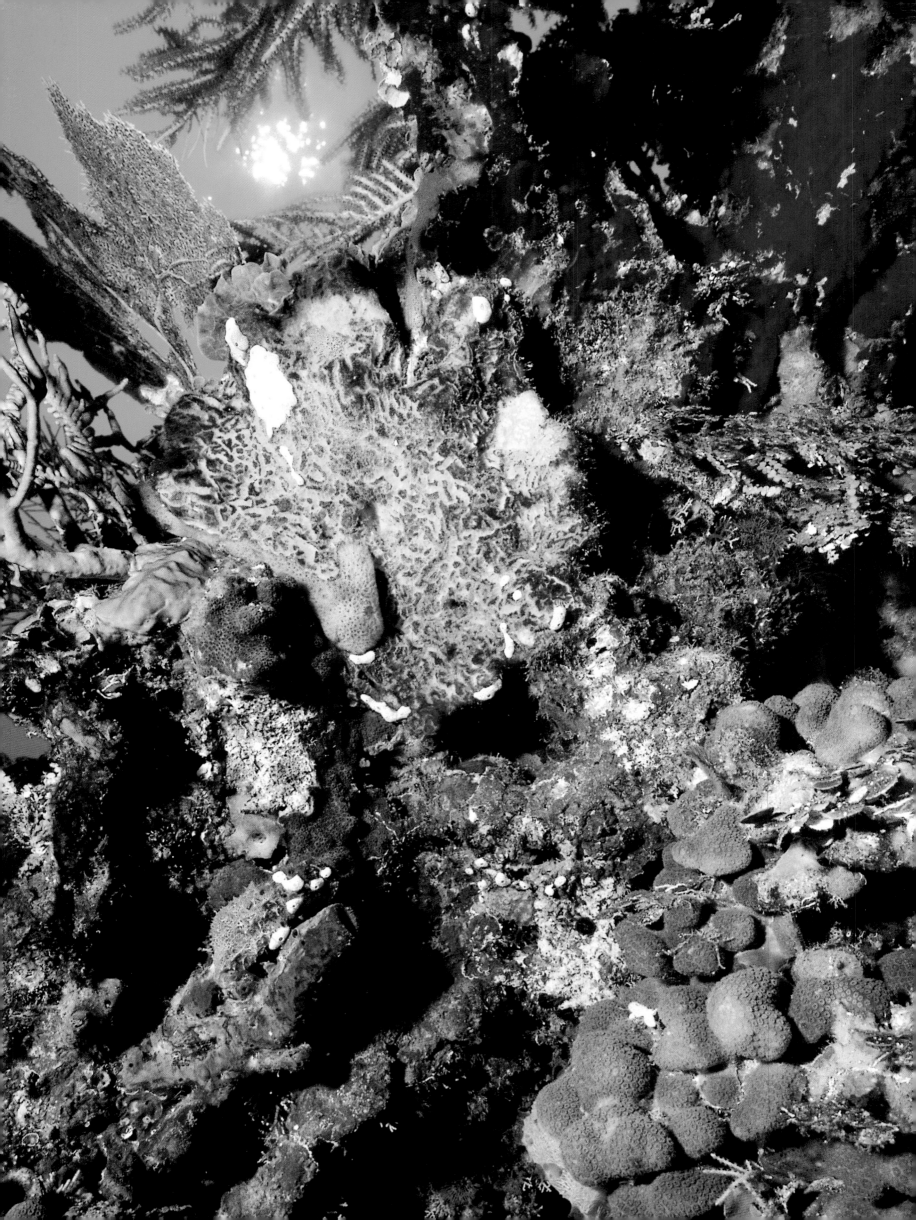

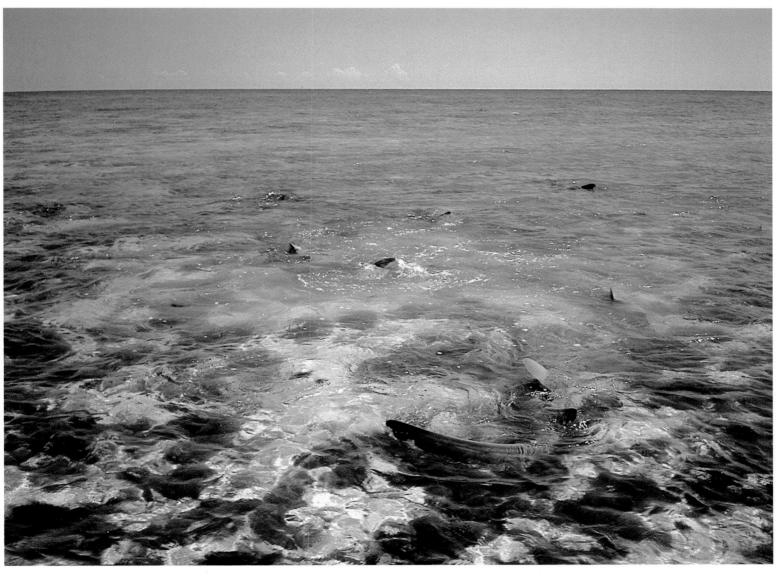

◄ A riot of color graces the coral wall and indicates a healthy reef. Healthy reefs, such as this one in the Florida Keys, form the basis of an ecosystem that enables a wide variety of marine life to flourish. ▲ A melee of nurse sharks is not feeding but mating in the wilds of the Dry Tortugas National Park.

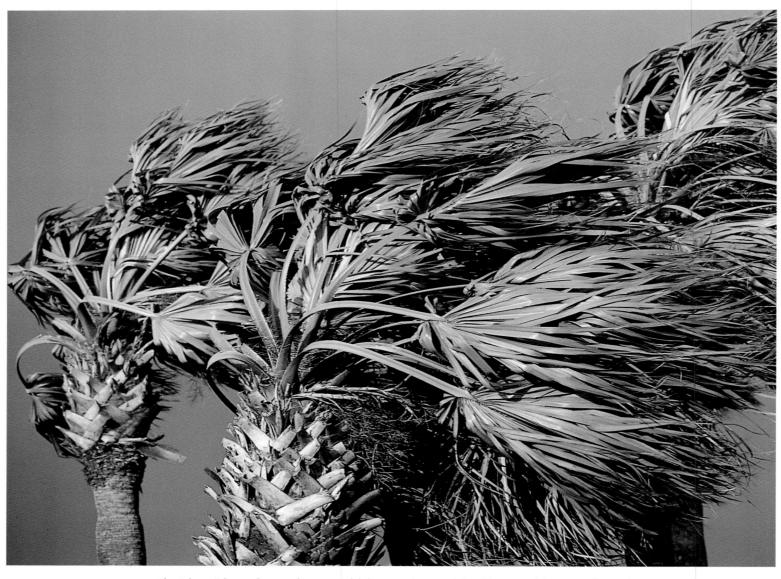

▲ Florida without her palms would be un-dreamable. Here, cabbage palms, the state tree, mix it up in a gale. The persistent, fan-shaped leaves with accordianlike pleats can be several feet long, and the trees themselves can reach fifty feet in height.